D0624070

# THE FUTURE OF
# FANTASY ART

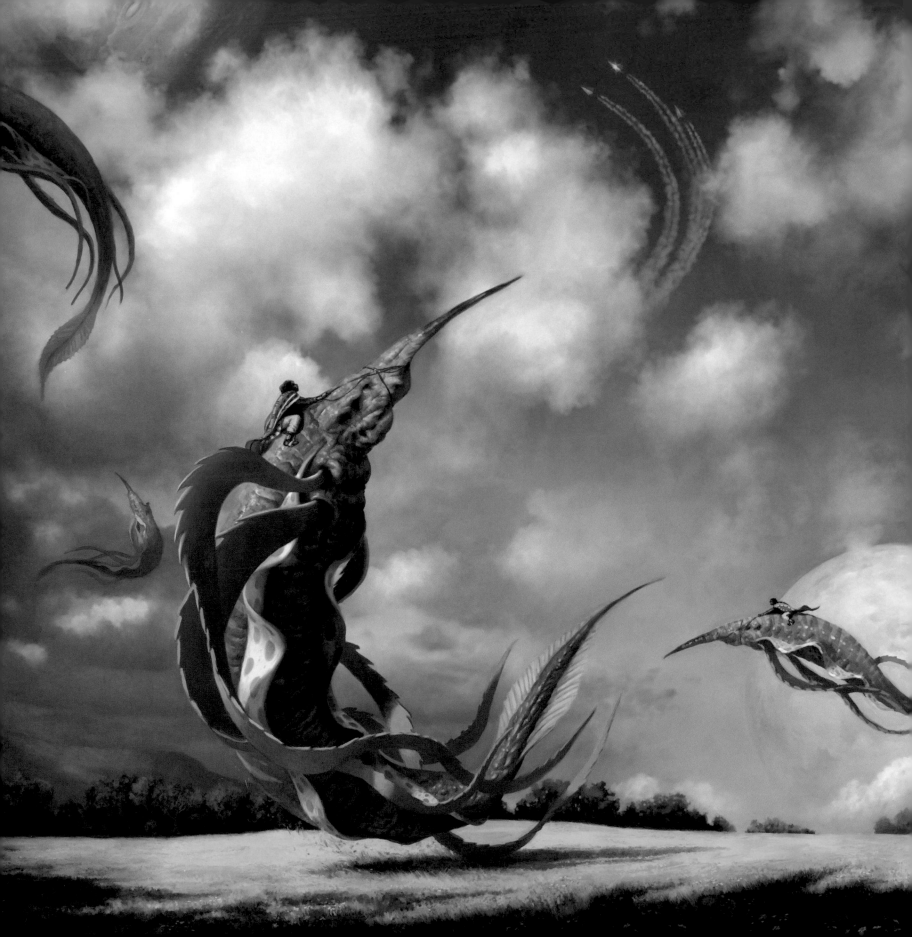

# THE FUTURE OF
# FANTASY ART

General Editors **ALY FELL AND DUDDLEBUG**
Foreword by **WILLIAM STOUT**

**COLLINS** DESIGN
*An Imprint of HarperCollins Publishers*

**THE FUTURE OF FANTASY ART**

Copyright © 2009 by The Ilex Press Limited

All rights reserved. No part of this book may be used or reproduced in any manner whatsoever without written permission except in the case of brief quotations embodied in critical articles and reviews. For information, address Collins Design, 10 East 53rd Street, New York, NY 10022.

HarperCollins books may be purchased for educational, business, or sales promotional use. For information, please write: Special Markets Department, HarperCollins*Publishers*, 10 East 53rd Street, New York, NY 10022.

First published in the United States and Canada in 2009 by Collins Design
*An Imprint of* HarperCollins*Publishers*
10 East 53rd Street
New York, NY 10022
Tel: (212) 207-7000
Fax: (212) 207-7654
collinsdesign@harpercollins.com
www.harpercollins.com

Distributed throughout the United States and Canada by HarperCollins*Publishers*
10 East 53rd Street
New York, NY 10022
Fax: (212) 207-7654

This book was conceived, designed, and produced by
I L E X
210 High Street
Lewes
East Sussex BN7 2NS
www.ilex-press.com

Publisher:  Alastair Campbell
Creative Director:  Peter Bridgewater
Managing Editor:  Nick Jones
Editor:  Ellie Wilson
Commissioning Editor:  Tim Pilcher
Art Director:  Julie Weir
Designer:  Simon Goggin
Art Editor:  Emily Harbison

Library of Congress Control Number: 2009925816

ISBN: 978-0-06-180990-3

Printed in China
First Printing, 2009

Every effort has been made to credit the artists and/or copyright holders whose work has been reproduced in this book. We apologize for any omissions, which will be corrected in future editions, but hereby must disclaim any liability.

*For Bryant Turner Fell 1934–2008*

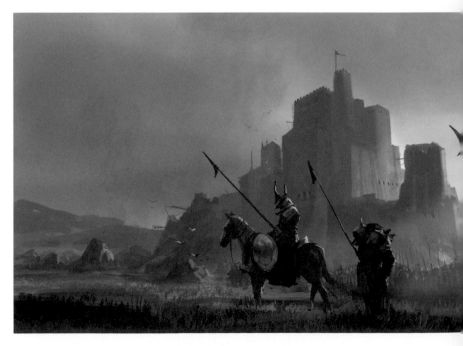

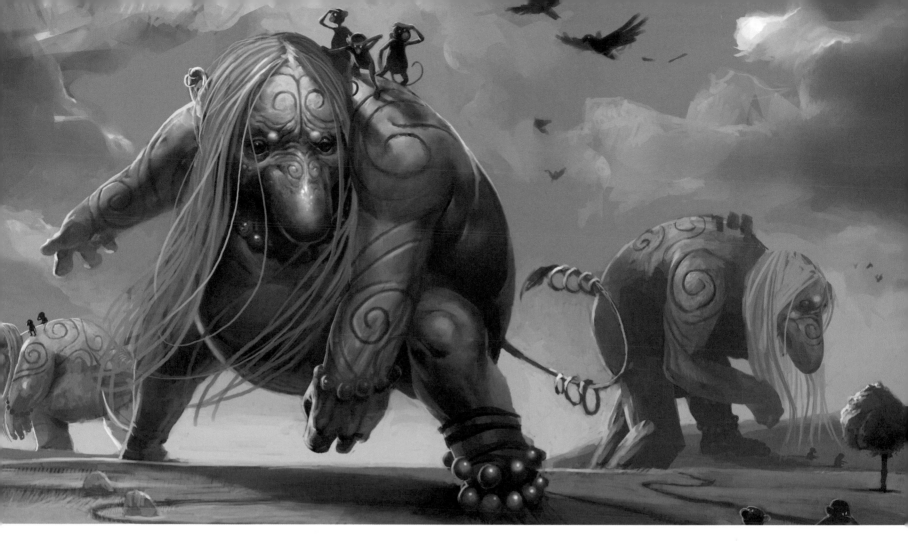

# Contents

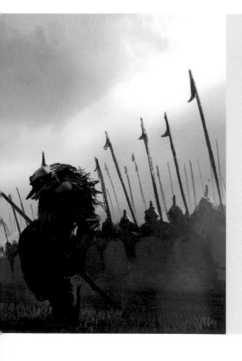

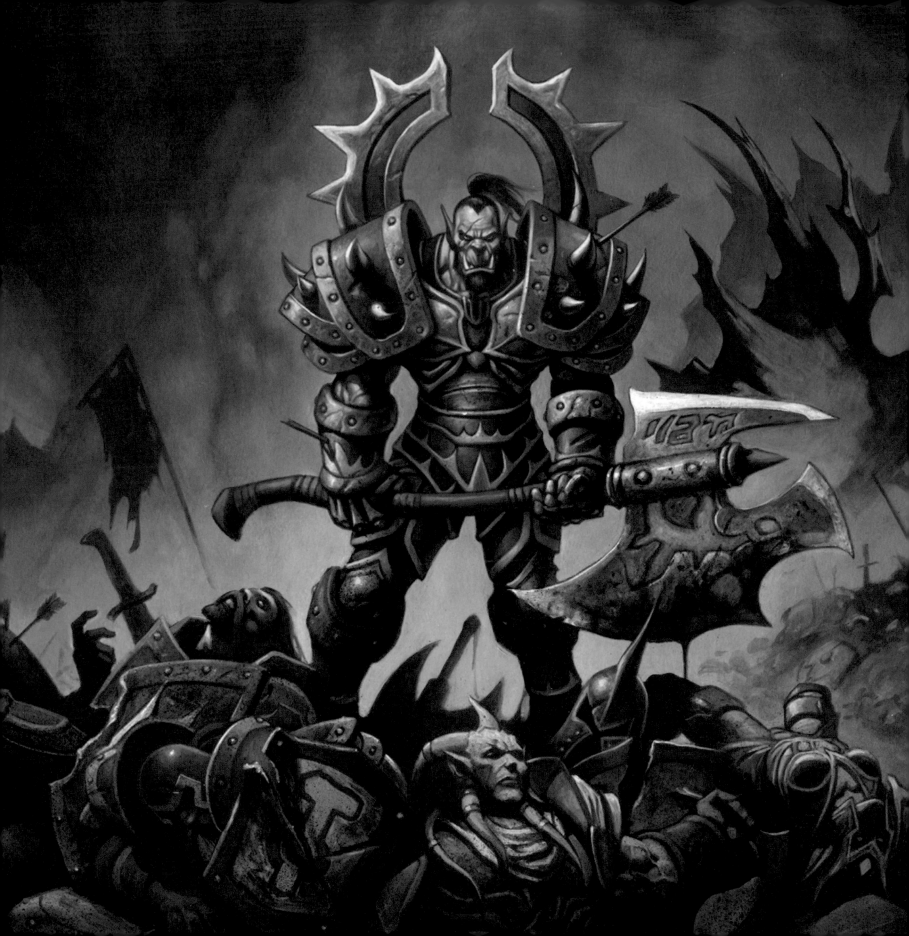

# Foreword: A New Golden Age

"If I have seen further it is only by standing on the shoulders of Giants."

*Sir Isaac Newton*

It has often been said that all Golden Ages are in the past. That is, it takes hindsight to recognize a Golden Age, usually long after that specific era has become history.

We may be in the beginning of a Golden Age of fantasy art. The planets seem to have aligned themselves just right at this point in art history.

This new Golden Age has its origins in the early 1960s with the Ace Books paperback covers for novels by Edgar Rice Burroughs. These covers by Frank Frazetta and Roy G. Krenkel captured a visual sense of wonder in paint (and in pen and ink; in addition to their stunning covers, each book hosted a fantastic title page illustration) that had not been seen in the print medium for decades. The appeal of their images reached far beyond the insular illustrations being produced by other artists toiling within the science fiction and fantasy genres. Frazetta's inspirational seeds came into full bloom with his covers for the Robert E. Howard *Conan* books.

Ray Harryhausen had cinematically accomplished this sensation, this visual capture and display of a sense of wonder, a few years earlier with stop motion fantasy classics like *The Seventh Voyage of Sinbad*, *Jason and the Argonauts* and *Mysterious Island*. These works had been inspired in a large part by Harryhausen's mentor, Willis O'Brien, the effects creator of 1933's film classic, *King Kong*.

The success of the Frazetta and Krenkel covers was rooted in making the old seem new. The two artists were not guided and inspired by their contemporary peers (except for each other). They primarily drew from the well of late 19th century art and early 20th century American illustration. On a subliminal level they revived public interest in what was known as Academic art, an art built on a solid foundation of good, strong drawing, design, color, and composition. For the most part, these fundamental skills were no longer being taught in art schools.

Not only was this basic traditional knowledge not being conveyed at art schools, it was being ridiculed by the art school establishment. If a young artist wanted to learn old, out-of-current-fashion Academic skills, that knowledge had to be self-taught.

Frazetta's work launched a legion of imitators. The best of those imitators were soon getting to the root of what makes a Frazetta a Frazetta by sleuthing out the origins of Frank's various influences.

The young artists who studied Frazetta and Krenkel realized that they had been given the Keys to the Kingdom. Their research uncovered long lost artistic worlds, much of it outside Frazetta's direct scope of influence (but not Krenkel's; Roy was encyclopedic in his knowledge of artists from the stated era), providing additional skills to further convey a startling sense of realism, veracity, and awe in the depiction of fantasy subject matter.

This was (and is) no easy task. Being an effective fantasy artist in our contemporary world requires the knowledge of a great landscape painter, an innovative architectural artist,

a rock solid figure draftsman, and an animalier par excellence. While photography functions as an occasional tool for the fantasy artist, there is abundant subject matter within that genre for which photography is not possible. Depiction of such requires great skill and sheer imagination.

The colorfully sensuous and atmospheric landscapes of Thomas Moran, the grand cataclysmic visions of John Martin, and the immensely over-the-top scale of Albert Bierstadt's depictions of Yosemite and the Rocky Mountains inspired the otherworldly settings of this new generation of fantasy artists, resulting in a kind of realism on steroids.

Today, cinema influences the fantasists; fantasists in turn influence a diversity of film worlds. The lush, steamy, multi-layered jungles of *King Kong* (themselves inspired by the finely engraved illustrations of Gustave Doré) set a high inspirational bar for fantasy artists. The vast scope and scale of David Roberts' Middle Eastern landscapes influenced David Lean's epic *Lawrence of Arabia* and persist in films like *Star Wars*, a film also influenced by the elegant drawings of E. C. comic book artist Al Williamson. Jean "Moebius" Giraud's comic book art and the gouache paintings of automotive illustrator Syd Mead defined the look of Ridley Scott's science fiction classic *Blade Runner*. *Blade Runner* launched the imaginations of hundreds of illustrators who would later apply their own similar visions to science fiction and fantasy illustration, game design and motion picture design. In the film business, a new title, "concept designer," became common.

Sometimes the inspirational source and film designer are one and the same. Director Peter Jackson fell in love with Alan Lee's visions interpreting J. R. R. Tolkien's literary works and hired Lee as the key designer to Jackson's *Lord of the Rings* film trilogy.

Many artists remain inspired by the icons of their childhood. The popular fantasy artists known as The Brothers Hildebrandt gathered much of their illustration spirit and style from the American classic book illustrator Newell Convers Wyeth as well as from the meticulous and colorfully appealing background paintings of the 1930s and 1940s animated films of Walt Disney.

With the good timing necessary to any Golden Age, a constant attempt to differentiate their work from their peers collided with the public's embrace of icons from a variety of world cultures. The influence of the powerfully distinct visions of Akira Kurosawa's samurai epics and Hayao Miyazaki's personally unique and inventive animated features now occur with frequency throughout Western works of fantasy, while the late 19th century Symbolist movement that briefly flourished all over Europe still functions as a source of mysterious and spiritual evocations for the world's more discerning fantasy artists.

Today, there are art schools that teach young art students who are hungry for the fundamentals of an Academic art education. As you can tell by thumbing through the pages of this book, the competition is fierce and the quality of these contemporary artists is high—much higher percentage-wise than in almost any other artistic genre. Today's fantasy artists draw and paint better than most of the artists of the last several decades; with such abundance of quality, the market and public demand it.

Within this volume you will see the influences of art from over one hundred years ago—and from films that were released during the last few months. We, the public, are the beneficiaries of the culmination of this modern cultural potpourri.

The compendium you hold in your hands gives, indeed, every indication of the dawning of a new Golden Age.

*William Stout as well as being a world-renowned painter of prehistoric life, is highly in-demand as a concept and production designer, having worked on more than 35 feature films, primarily in the science fiction, fantasy, and horror genres. His latest book is* William Stout— Prehistoric Life Murals.

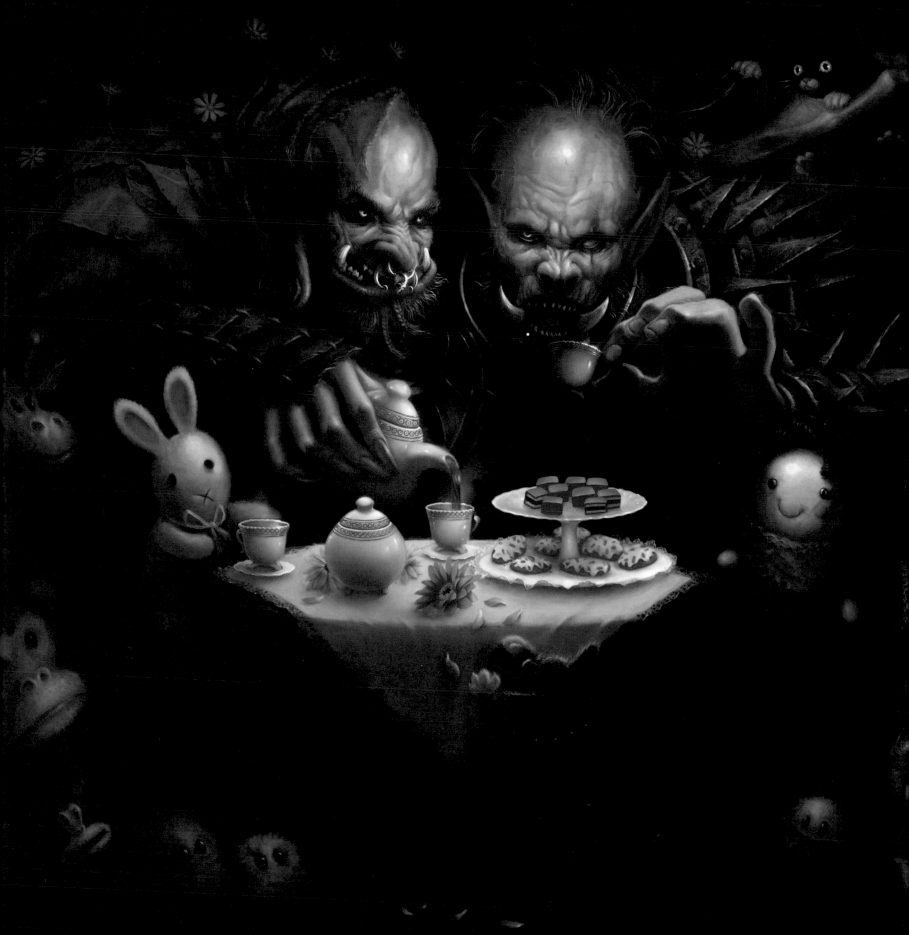

# Introduction

When starting to compile this collection of truly fantastic art from around the world, Jonny and I were initially presented with the daunting task of defining what "fantasy-art" actually means to us. Yes there are literal definitions; encyclopaedic ones that specify the groups and sub-groups that exist within the "genre." We decided we didn't want to stick to predefined themes, other than convenient ones for dividing the book up into chapters. So as the art started to come in, we looked at them on an image-by-image basis, rather than how they might fit in to what "fantasy" dictates. We were of course restricted to some degree by the parameters the publishers specified, but these were very generous, so as a result you will find images some might prefer to describe as "science-fiction," as "adventure," or "horror," or whatever. They are all however "beyond reality." In doing this we decided to trust the artists we had contacted. They knew what they were doing and were more than capable of deciding what we wanted in our definition of fantasy. You will of course find mythical creatures, fairies, demons, orcs, and the bizarre beings that are common to fantasy and so beautifully realized here. But there is much more…

When I was a child my parents rarely plonked me and my sister down in front of the TV to watch Saturday morning cartoons. Sure, I had a fill of such programs too, but their much-used phrase was "go and draw me something." I would sit at the kitchen table with an HB pencil and a cartridge pad and draw. I would create whole worlds, sometimes set in space, sometimes set in World War I or II, sometimes set in ancient jungles or the deserts of H. Rider Haggard. At school I would do the same. My sketchbooks were littered in the margins with Baron von Richthofen's Tri-plane plunging to fiery doom, or Luke Skywalker's X-wing fighter victoriously destroying the Death Star. As I got older I discovered girls and from then on my sketchbooks started to be filled with Amazonian women and Arabian princesses.

My mother would pin these images on the walls of her office, and they would act as a sort of barometer as to how my tastes changed and the places my imagination would explore. She kept many of them, and since last November when my father died whilst Jonny and I were compiling this book, she has unearthed many of these scribbles. Yes they are embarrassing and naïve, but they are part of the process, and all art is a process. Imagination is a process. Every artist who has kindly submitted to this book followed a process, and everything they have absorbed and added as grist to their creative mill has led to the product that "process" has informed: The wonderful art within.

What my parents had done, along with allowing me to read almost anything, was provide me with the ability to develop my imagination. I could see the real world every time I walked out the door, every time I got on the bus to school. Every time I had to do homework. My drawings and stories were the fantasies I had to escape to, and they were all mine. I could, like Calvin in *Calvin and Hobbes*, make them what I wanted them to be, and as my drawing skills improved I could realize those worlds all the better.

This collection of wonderful art is from other artists who I imagine, were at some point given a similar

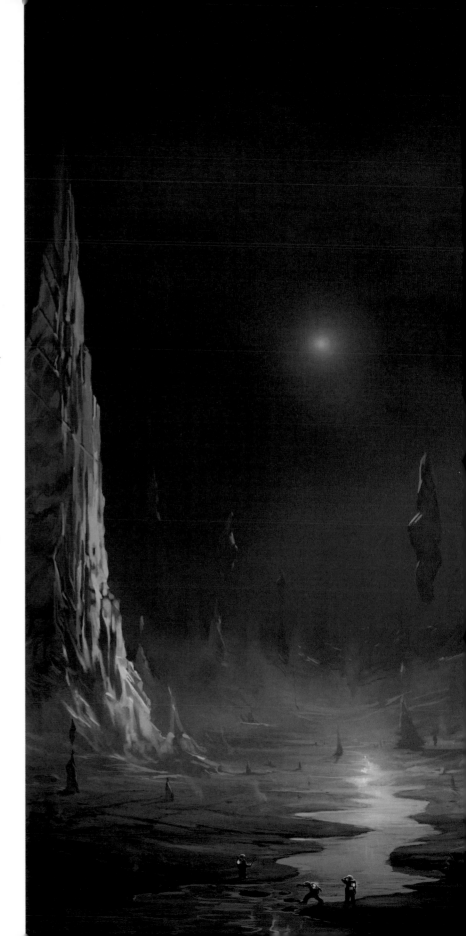

encouragement and motivation to develop their own imaginations. Whether from a parent, or a teacher, or a friend, or loved one, somehow they were able to realize the worlds they saw in their minds eye. Here the collection ranges from their own personal imaginings to illustrations created to accompany an existing story or narrative. From concept art and book covers to advertising and graphic design. But all go beyond that which we associate with day-to-day existence, and if they do deal with this, it is tangentially, with a twist of reality.

Fantasy can also be a dirty word. It can sometimes be seen as an excuse to divorce from reality, and to escape in some sort of schizophrenic way to a place where responsibility is removed. However, every culture, whether technologically advanced or less so tells stories. And those stories are filled with strange beasts, heroes and heroines, exotic landscapes and quests, challenges and monsters. These creations become metaphors for reality, for the every day world, and through those tales we can learn much about ourselves, our relationships to each other, and the tests we must all face throughout our lives.

Thank you to all the artists who submitted to this book. This is your collection, and it allows us a glimpse into other realities, other worlds and possibilities, all of them realized by you.

*Aly Fell, 2009*

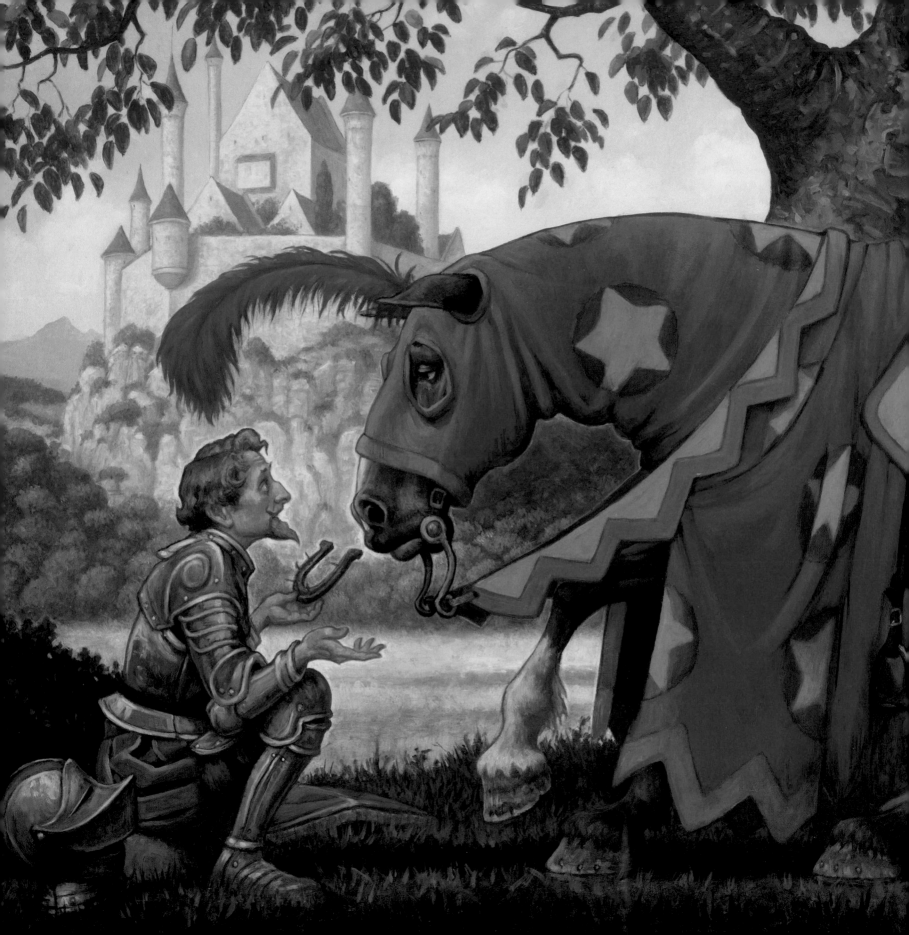

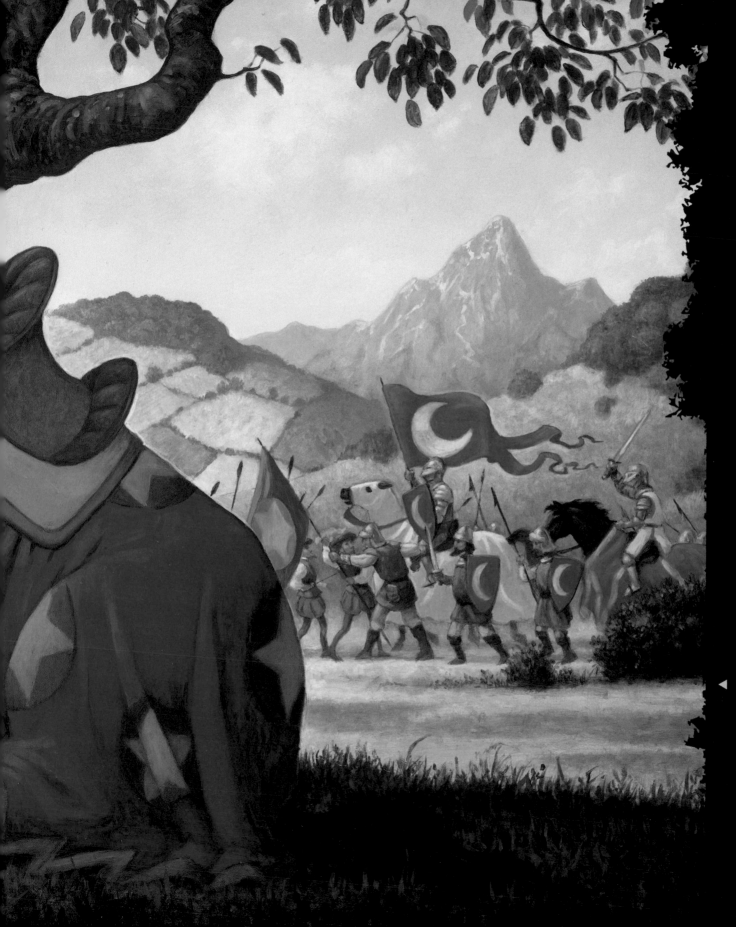

◄ **For Want of a Nail**
*Scott and Pat Gustafson*
The Greenwich Workshop Press
Oil on panel
*www.scottgustafson.com*

*This illustration is part of*
Favourite Nursery Rhymes
from Mother Goose. *Scott's
use of bold color and strong
characterization are no better
represented here than by the
wonderful expression on
the horse.*

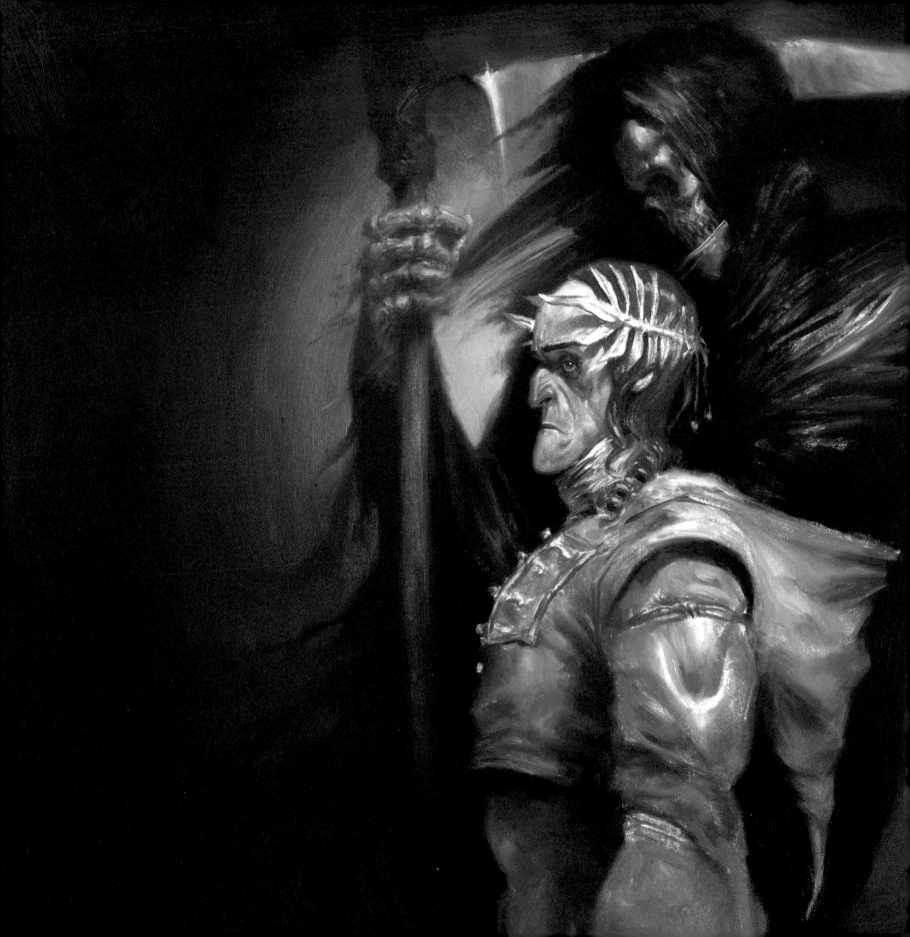

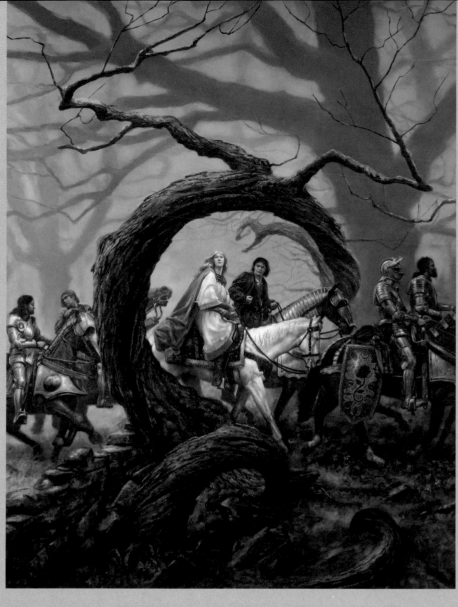

◄ **Dante**
*Adrian Smith*
Personal work
Oils
*www.adriansmith.co.uk*

*"I'm a big fan of Gustave Dore's work, and he was a very early inspiration for me, especially his illustrations for Dante's Divine Comedy. This oil painting is roughly 12 inches by 8 and painted on watercolor paper, which I find has a nice texture to work on."*

▲ **Serpent and the Rose**
*Donato Giancola*
Book cover
Oil on panel
*www.donatoart.com*

*"The Serpent and the Rose was the first War of the Rose novel by Kathleen Bryan, and helped to establish the feel for the series. The principle design focused on masses of curvilinear shapes and atmospheric effects in wrapping the serpentine tree around the line of knights. Trees are dynamic compositional elements and lend themselves to shape shifting, especially when they are dragons in disguise!"*

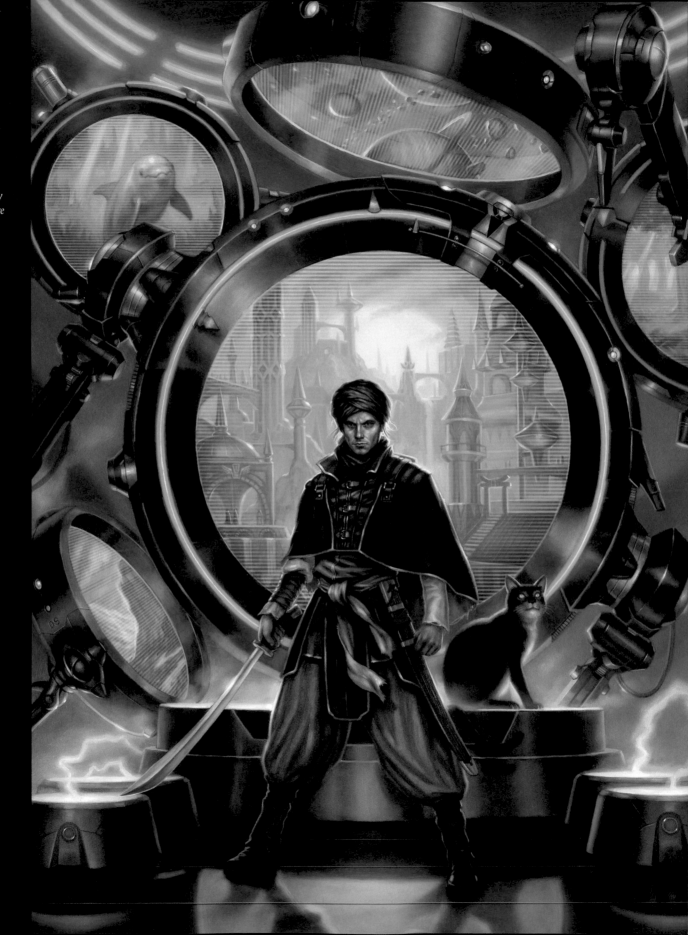

**Implied Spaces**
*Dan Dos Santos*
Book cover
Night Shade Books
Oil on board
*www.dandossantos.com*

*This cover art by Dan mixes both science fiction and fantasy elements. The mechanical nature of the environment and the high-tech equipment contrast with the more basic utilitarian nature of a sword and an Arabian-inspired costume.*

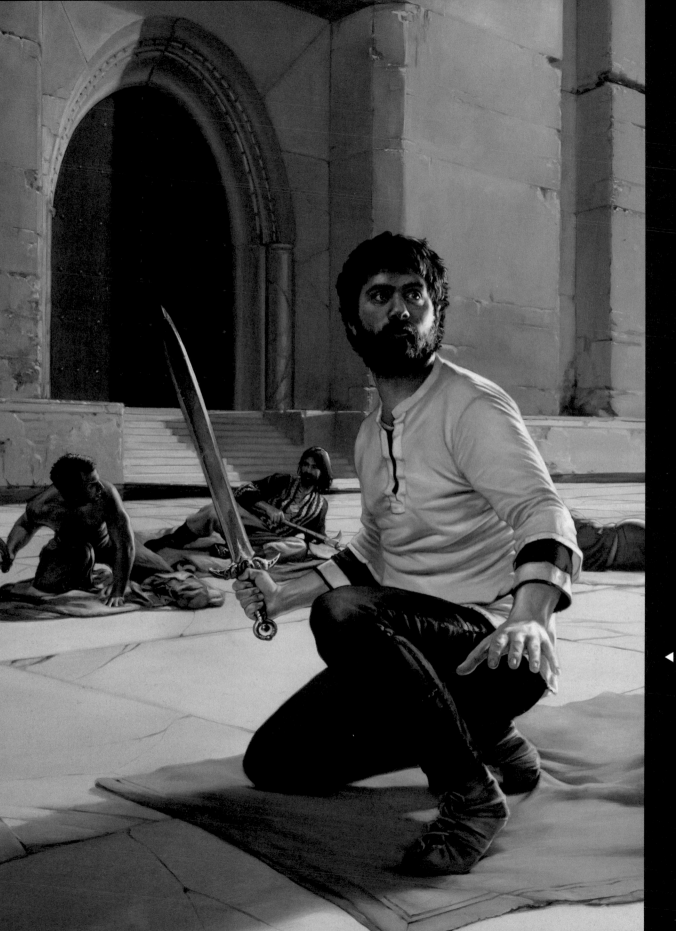

◀ **Footsteps in the Dark**
*David Palumbo*
Portfolio work
Oil on board
*www.dvpalumbo.com*

*"In this painting, I was aiming to capture a moment of anticipation. These men, camped in the ruins of a city or fortress, have heard an unexpected noise, but are not sure who or what was the source of it. I wanted to achieve a tense stillness, where you can feel the key figure holding his breath."*

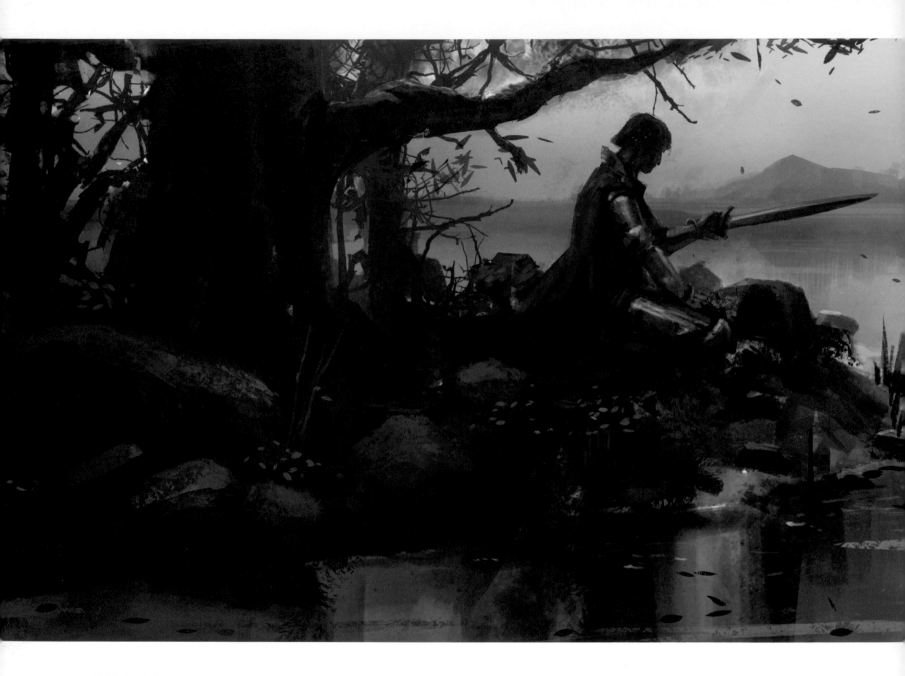

▲ **Knight by the Lake**
*David Hong*
Personal work
Adobe Photoshop
*www.davidsketch.blogspot.com*

*Borrowing on age-old subject matter and inspired by the Pre-*
*Raphaelites, David developed this piece from a pencil drawing.*
*"With this painting, I started from a little thumbnail sketch out*
*of my sketchbook. I tried to create a 'Waterhouse-like' mood."*

▲ **Areo Hota**
*Henning Ludvigsen*
Fantasy Flight Games
Adobe Photoshop
*www.henningludvigsen.com*

*This piece was made for a card game for* A Game of Thrones.
*"Card game illustrations are a lot of fun, but can have limited deadlines. I was fairly satisfied with this painting and I learned a lot from it, like how to paint a beard. I loved the description of this guy, which explains that he wields a tall, wicked-looking axe that he has been 'wedded' to, and is rumored to sleep with."*

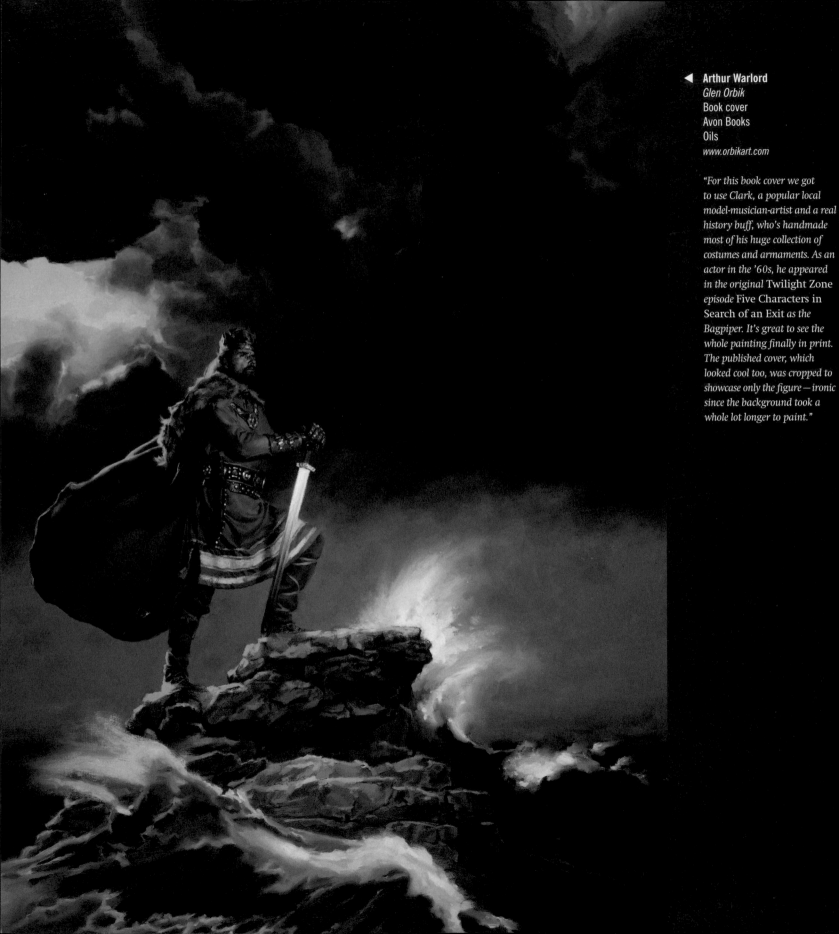

**Arthur Warlord**
*Glen Orbik*
Book cover
Avon Books
Oils
*www.orbikart.com*

"For this book cover we got to use Clark, a popular local model-musician-artist and a real history buff, who's handmade most of his huge collection of costumes and armaments. As an actor in the '60s, he appeared in the original Twilight Zone episode Five Characters in Search of an Exit as the Bagpiper. It's great to see the whole painting finally in print. The published cover, which looked cool too, was cropped to showcase only the figure — ironic since the background took a whole lot longer to paint."

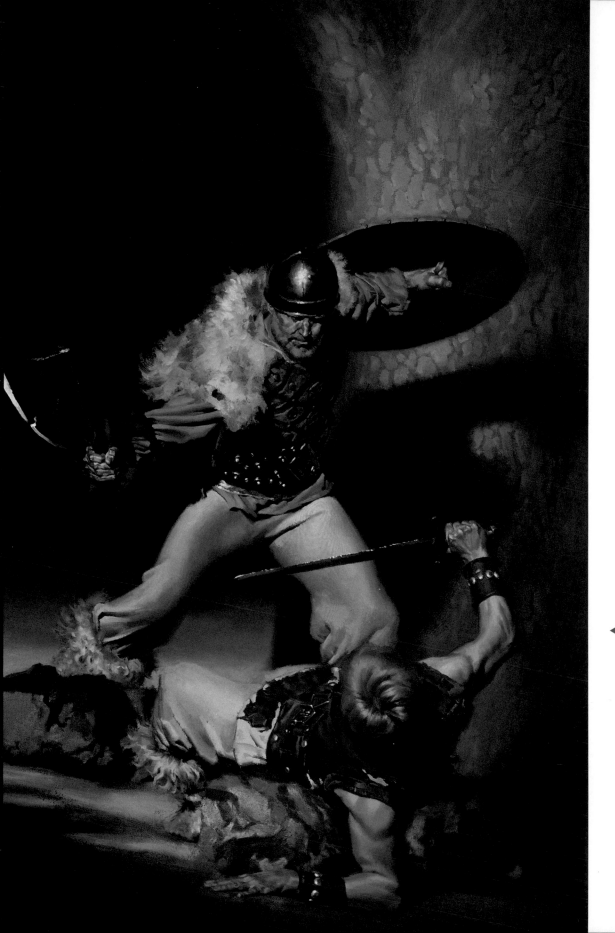

◀ **Viking Battle**
*Glen Orbik*
Portfolio work
Oils
*www.orbikart.com*

*"This is one of the few pieces
I painted for myself, inspired
by costumes with a touch of N. C.
Wyeth thrown in. We live near
a world-famous costume rental
warehouse that offers one of the
largest collections of classic, old
movie costumes, often with the
original actor's name tag still
under the collar. It's a blast to
use 50-plus-year-old garments
that actually look battle worn!"*

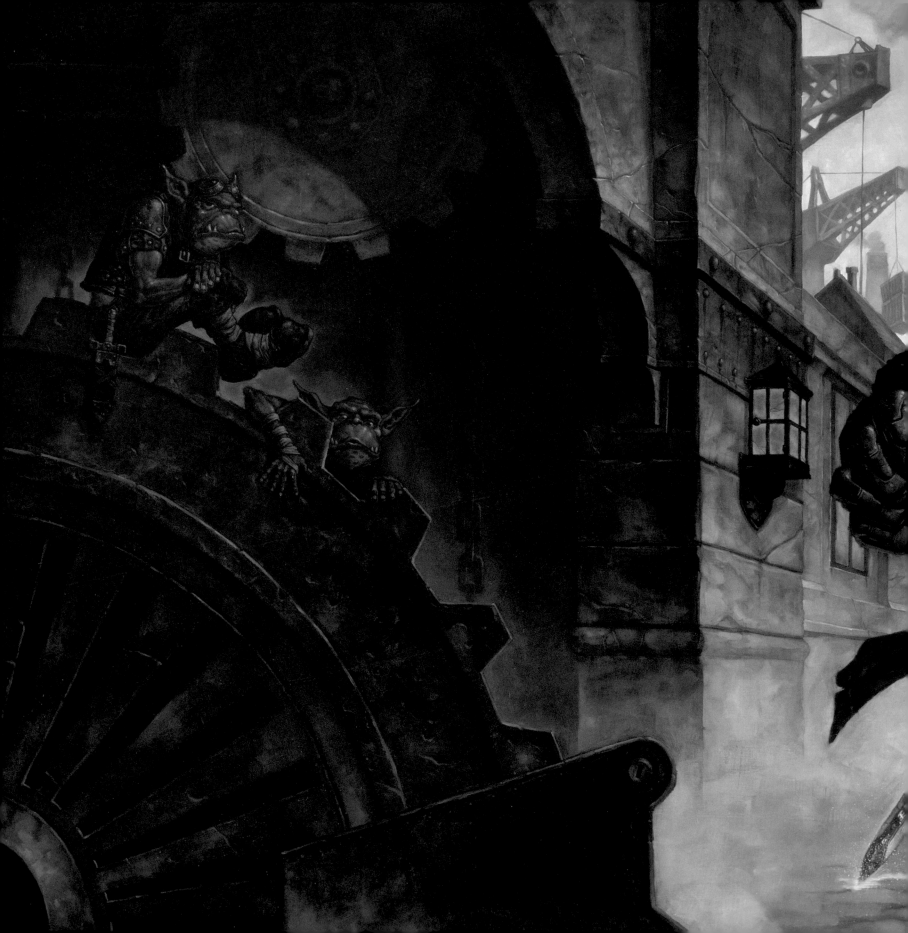

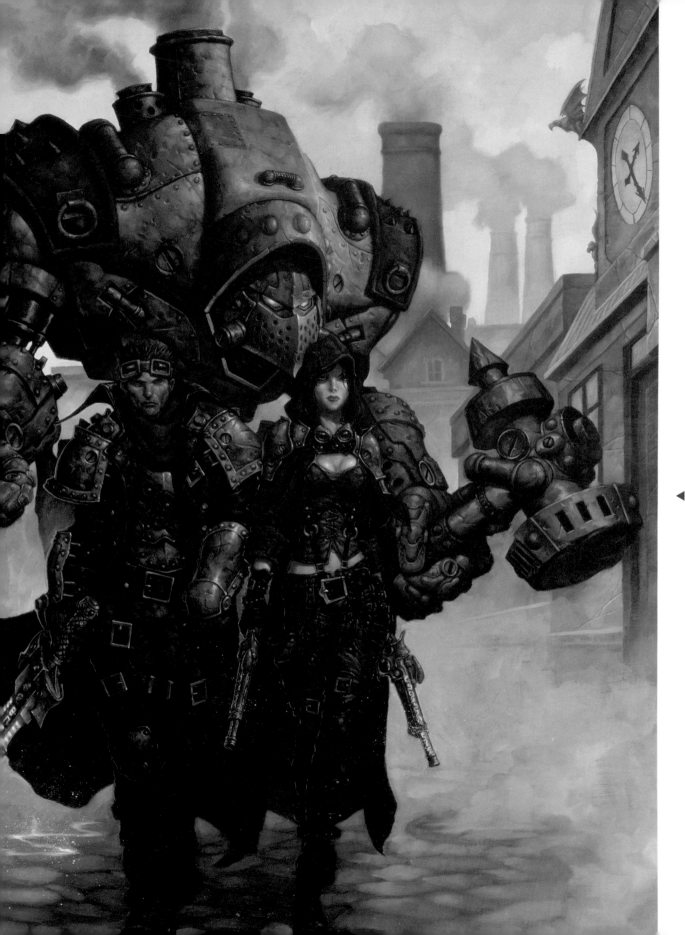

◄ **The Walk**
*Matt Wilson*
Book cover,
*Iron Kingdoms Character Guide:
Full-Metal Fantasy*
Privateer Press
Oil on board
*www.mattwilsonart.com*

*"This painting began a phase
for me where I did everything as
large as I could possibly make
it. After years of doing card art
at six inches wide, I broke out
and started doing things much
larger. The Walk is about four
feet wide; painting so large
was incredibly liberating and
allowed me to put quite a bit
of detail into the characters. At
the same time, it took forever!
The composition on this piece is
wonky, as it was a wrap-around
book cover, so it splits down the
middle, dividing the little goblin
characters on the back from the
bad-ass trio on the front."*

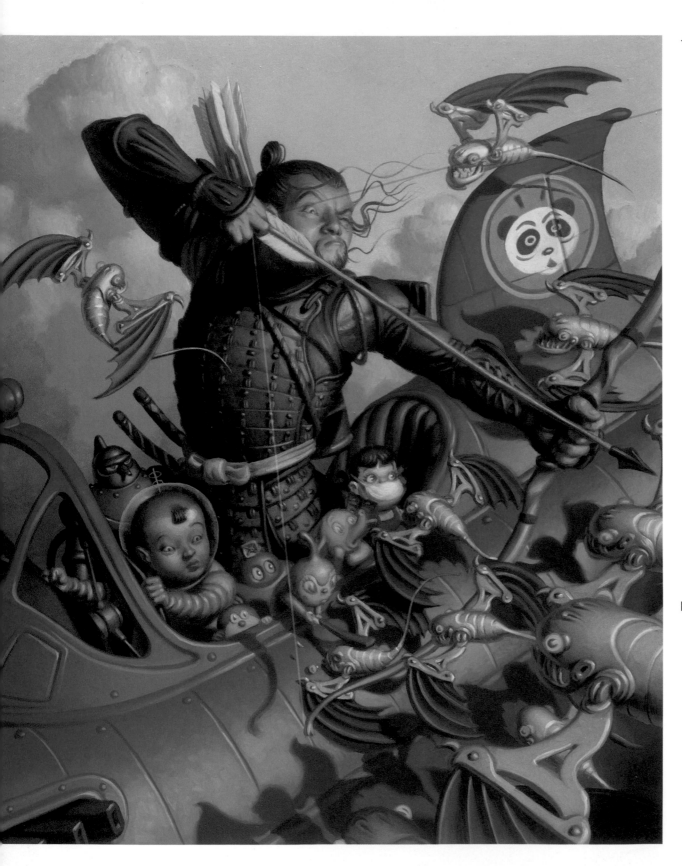

**◄ Fantasia**
*Peter Ferguson*
Fantasia Film Festival
Oils
*www.uberpete.jitterjames.com*

*"This piece was done in oil for the Fantasia Film Festival, an annual event in my hometown of Montreal that focuses on genre movies, with an emphasis on Asia. For a while, I was doing these posters yearly."*

**► The Shadows Past**
*Patrick Jones*
Roc Books
Oils and Corel Painter
*www.pjartworks.com*

*This was Patrick's third artwork for the author Lorna Freeman, and the third part of her* **Borderlands** *trilogy. It features a young soldier of royal lineage who discovers he has magical powers. The illustration is full of rich fantasy archetypes; the warrior, fantasy creatures, and exotic landscapes combined in a rich color palette.*

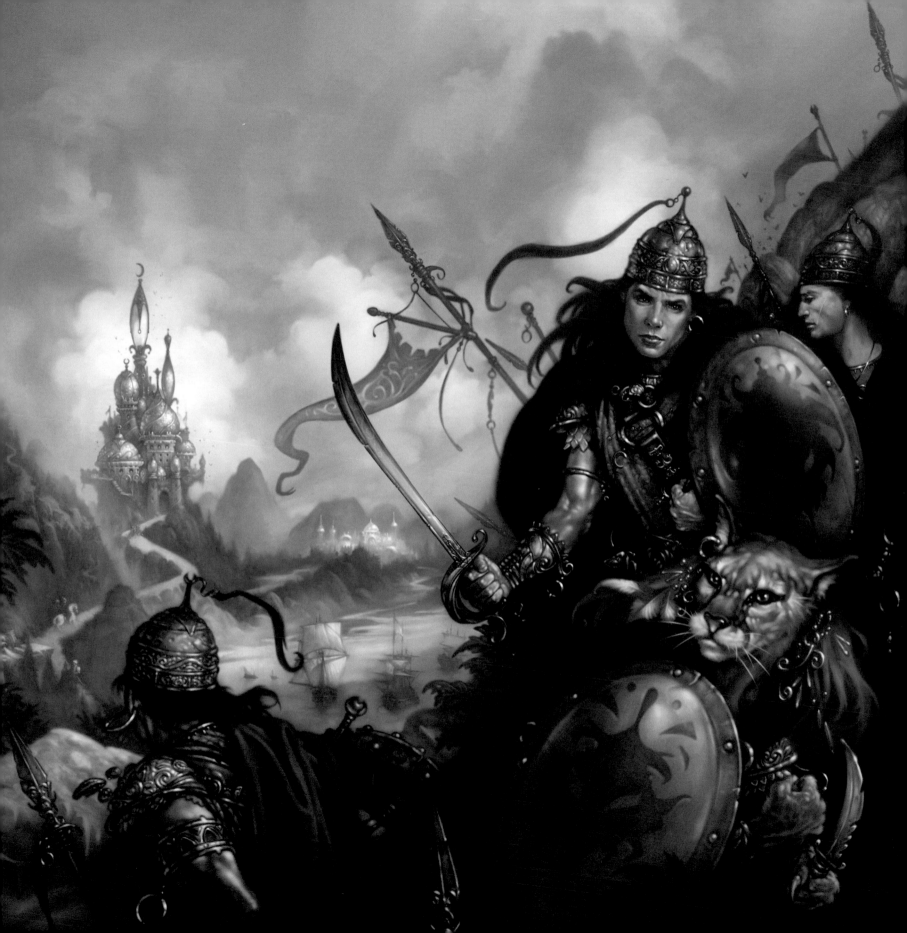

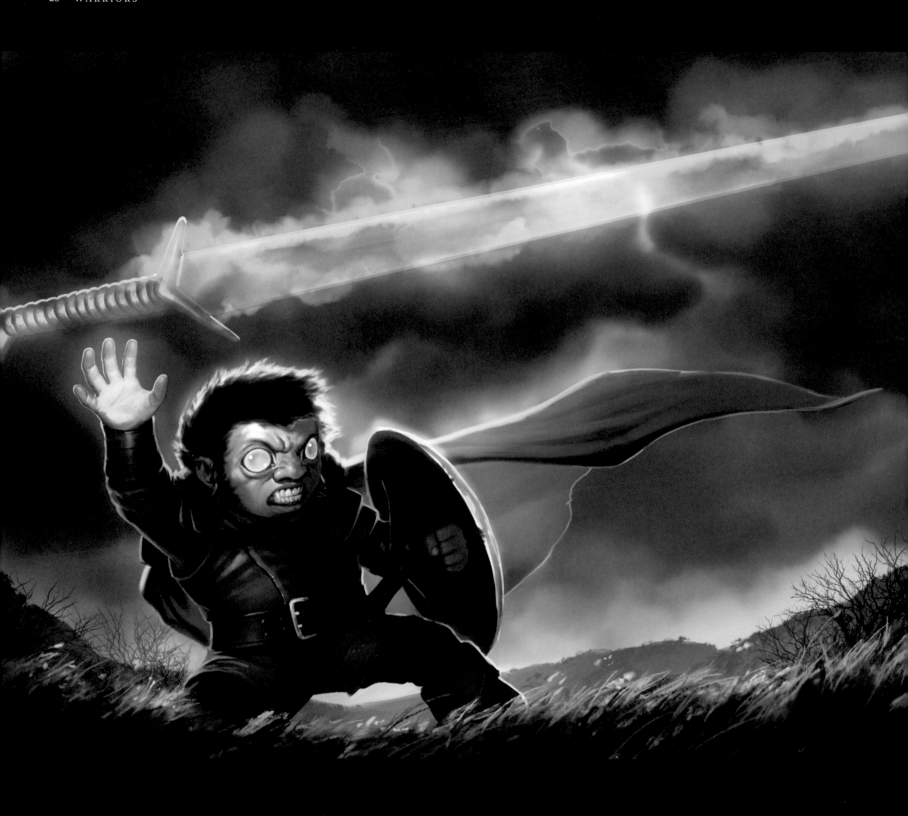

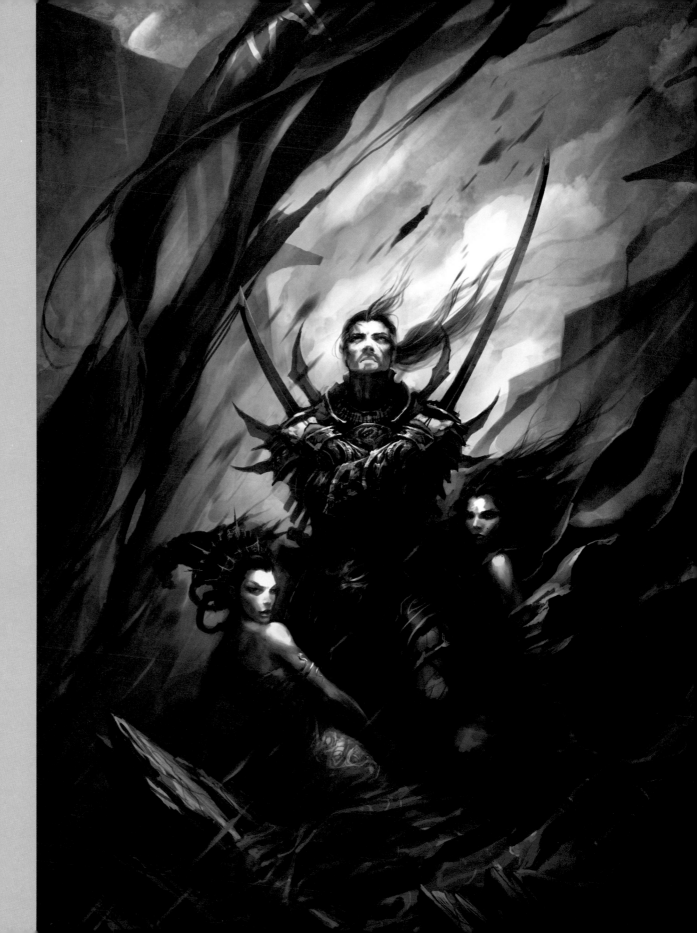

**Steel of the Godhead**
*Jason Chan*
Magic: The Gathering—
Shadowmoor
Wizards of the Coast
Adobe Photoshop
*www.jasonchanart.com*

Jason has a great knack for
depicting drama, movement,
and emotion. His use of color
and light accentuates the
magical nature of the sword
in this painting, which he says,
"depicts a kithkin wielding the
Steel of Godhead. This piece was
done for Wizards of the Coast's
Magic: The Gathering—
Shadowmoor."

**An Empire Unacquainted
with Defeat**
*Raymond Swanland*
Book cover
Night Shade Books
Digital
*www.raymondswanland.com*

"In the past few years, my
artwork has adorned the covers
of Glen Cook's fantasy novels.
With each cover, I find myself
inspired by Cook's sense for
the gritty, realistic details of
medieval life and warfare, and
by his view on the ambiguity of
the politics of power. There is
very little pure good or evil in
Cook's novels and this aligns very
closely with my view of human
nature and history. I see the past
as an infinitely layered and
textured place in both a tangible
and cultural sense—and I
endeavor, always, to capture
this in the imagery I create."

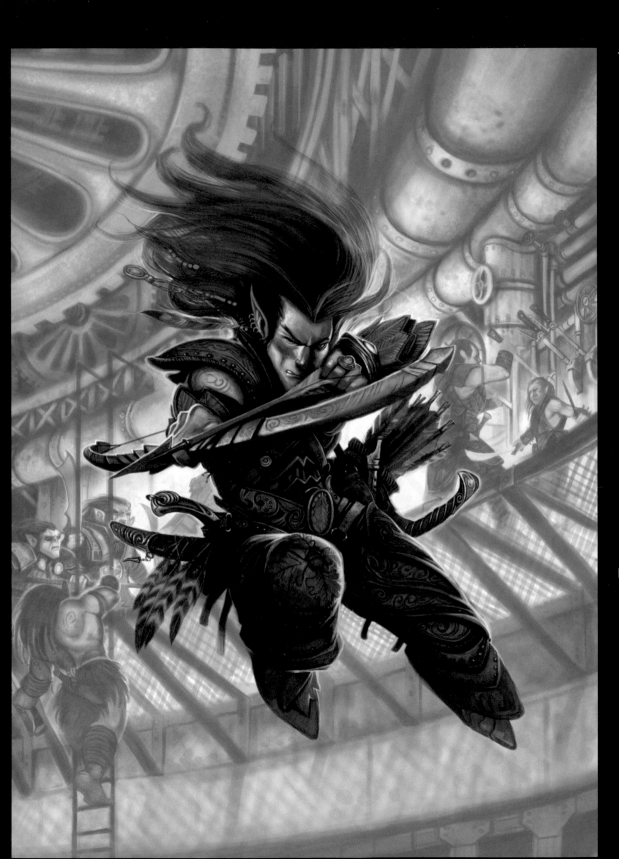

◀ **Nexus**
*William O'Connor*
*Dungeons and Dragons*
Digital
*www.wocstudios.com*

*"Throughout most of 2007 and 2008 I was involved in the concepting and illustrating of the Dungeons and Dragons 4th Edition online forums. I tried to capture a sense of drama and action in all of my images. Working in the fantasy genre for most of my career, it has been a great thrill to portray the combat and adventure of these worlds. I find that creating believable characters is in the details. Small aspects of a person's personality can be discerned by looking at what he or she wears. Belt buckles, hairstyles, weapons, bags and pouches, jewelry, and clothes all help describe real people, and are a lot of fun to create!"*

▶ **Proximity**
*Larry MacDougall*
Personal work
Watercolor, gouache, and pencil
*http://mythwood.blogspot.com*

*"I don't actually know what this picture is about but I like having these two characters together. Why are they together? Maybe she is his prisoner, or perhaps he is her bodyguard, or they could just be waiting. There's no way of knowing. However, they are bound together by a twisting vine. This, again, is a personal piece. It is watercolor tightened up with gouache and pencil crayon, and done strictly for the pleasure of art directing myself."*

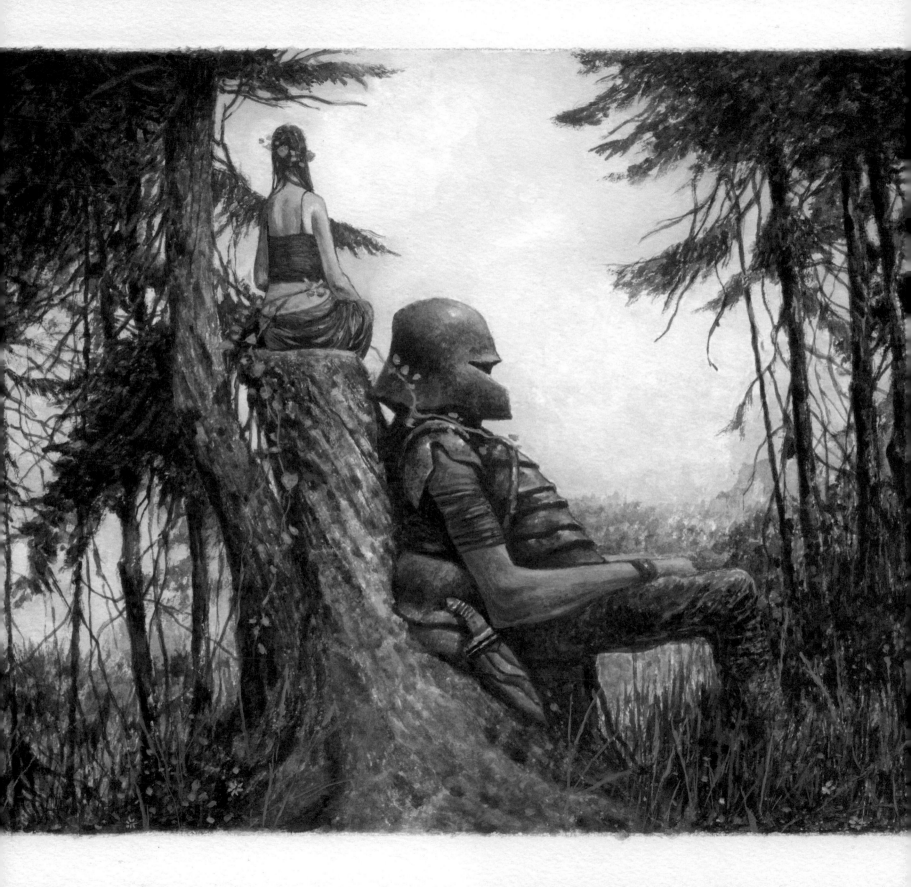

► **Barbarian King**
*Patrick Reilly*
Personal work
Adobe Photoshop and
Corel Painter
*www.preilly.deviantart.com*

*A classic warrior portrait from
Patrick. Intense, brooding, and
thoughtful, the expression drips
with character; the deep scar a
sign of battles fought. Patrick
says the image started out as a
practice sketch, but about a third
of the way through he decided to
produce a full character study.*

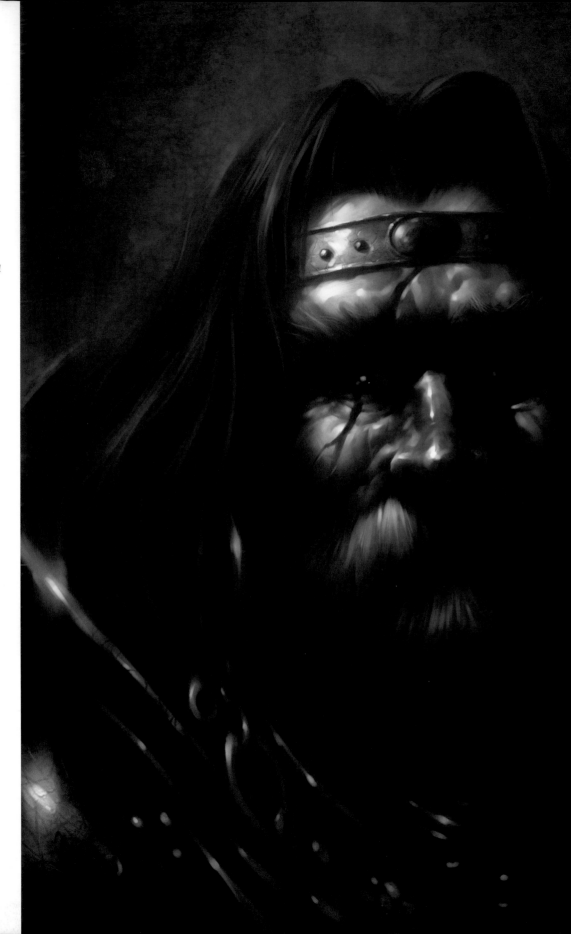

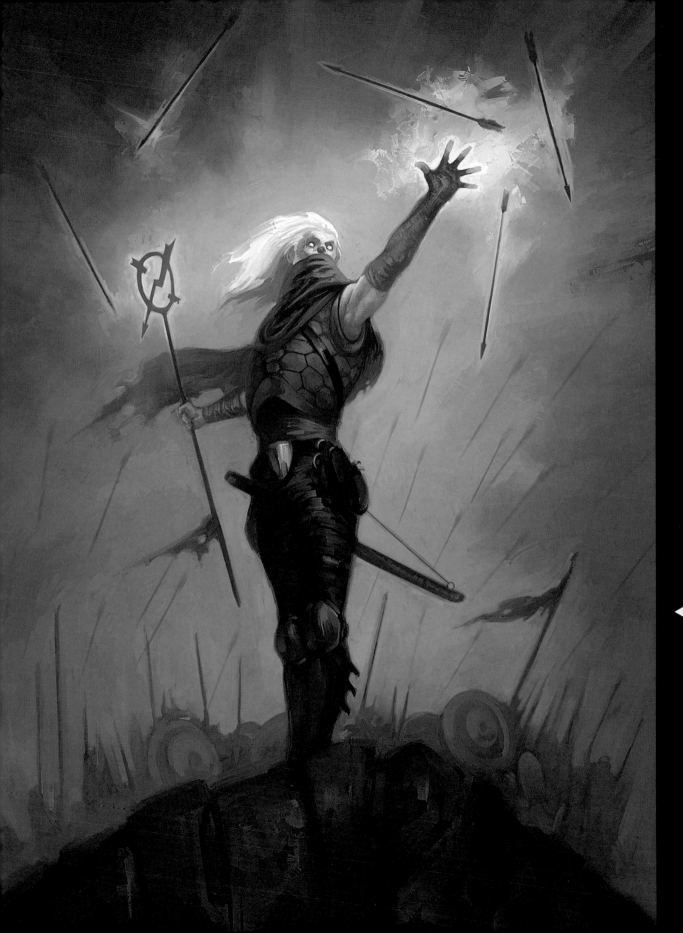

◄ **Spell**
*Julian Totino Tedesco*
with *Marcelo Sanchez*
Personal work
Digital
*www.totinotedesco.blogspot.com*

In this image Julian presents
a magical and emotional
moment from a joint project
with fellow artist Marcelo
Sanchez. The warrior or maybe
magician seems to be stopping
the arrows in the air against
a battlefield. The composition
is classical fantasy with a
strong central pose fading off
to secondary elements behind,
focusing the viewpoint.

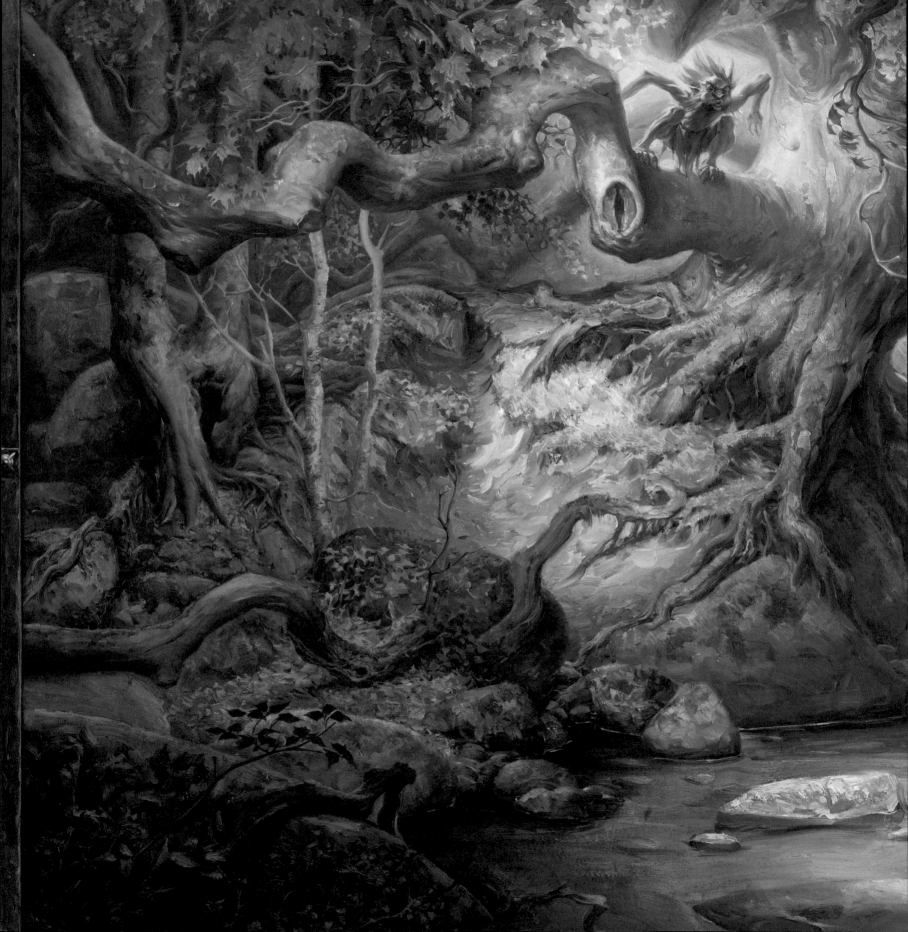

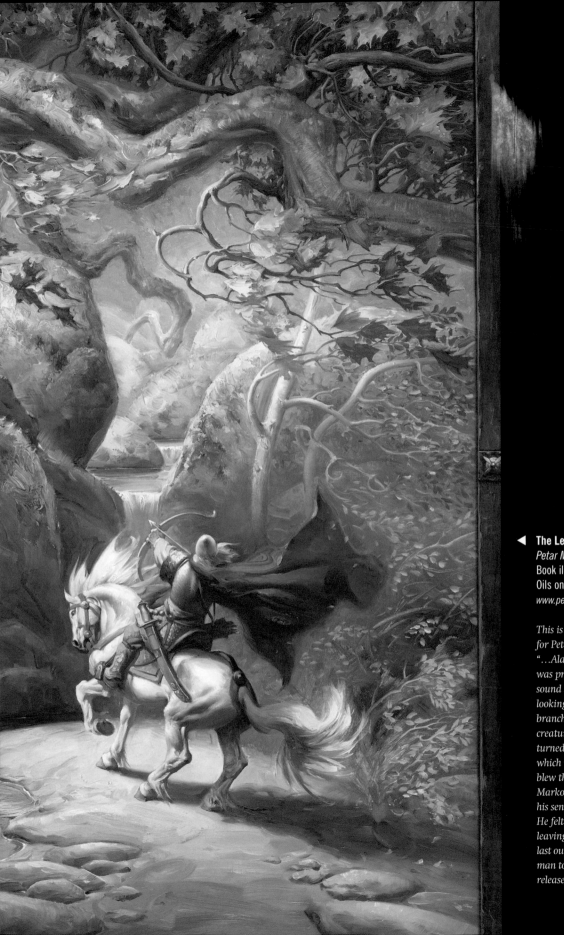

◀ **The Legend of Steel Bashaw 2**
*Petar Meseldzija*
Book illustration
Oils on Masonite
*www.petarmeseldzijaart.com*

This is one of 16 illustrations
for Petar's fairytale book.
"…Alas, it was not a bird that
was producing the enchanting
sound but a rather unpleasant
looking fellow sitting on the
branch of a tree. When the
creature saw the king his song
turned into a raging whistle,
which was so powerful that it
blew the trees to the ground.
Marko came immediately to
his senses but it was too late.
He felt that his strength is
leaving his body…With the
last ounce of strength the young
man took the magic bow and
released an arrow."

◄ **Dead Dragon**
*Jonny Duddle*
Future Publishing
Digital
*www.duddlebug.com*

*"After many workshops and other contributions to Imagine FX magazine, this was my first full cover commission and so an exciting opportunity. My brief was to combine fantasy, humor, and a foxy barbarian-type lady. So my character, Misty, has slain the dragon and is using her 50 Uses for a Dead Dragon book to make some new lipstick. I liked the idea of subverting some of the usual fantasy clichés and slapping a lady's make-up requirements into the narrative."*

**Medusa**
*Aly Fell*
Personal work
Adobe Photoshop
*www.darkrising.co.uk*

*"Produced for a ConceptArt.org Character of the Week challenge, this is a personal version of the Gorgon Medusa, actually based on my partner! She liked it… phew…Another much maligned caricature of femininity, I gave her the sword instead of Perseus. It is inspired by Mucha, which is fairly obvious."*

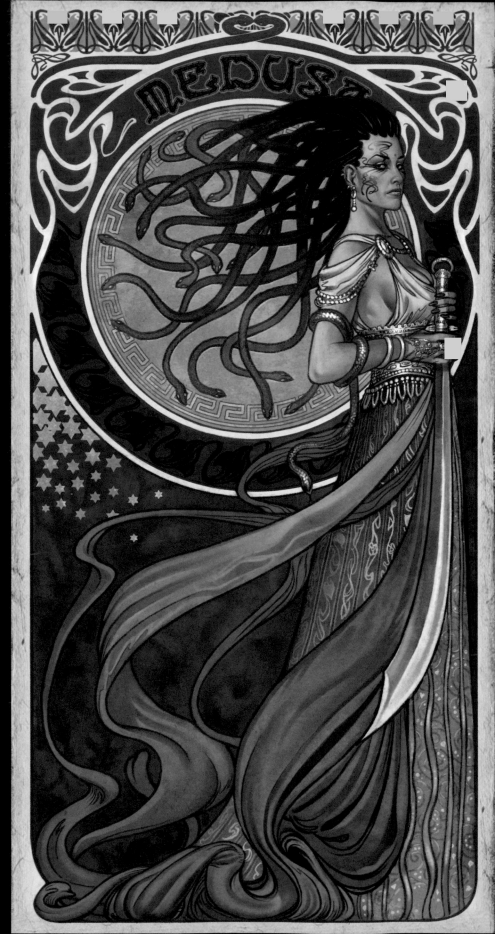

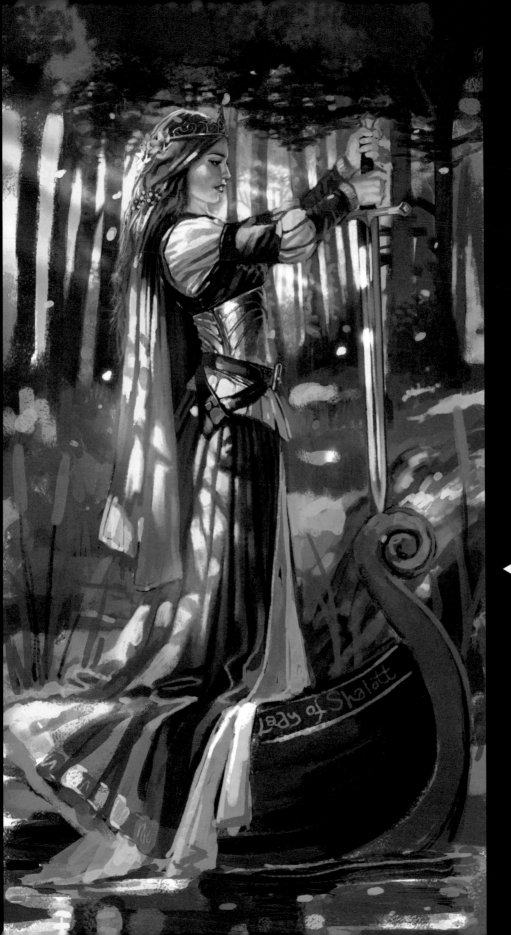

◀ **The Lady of Shalott**
*Aly Fell*
Personal work
Adobe Photoshop
*www.darkrising.co.uk*

"This was another Character of the Week image for ConceptArt. org. As much as anything this was an experiment in lighting and immediacy. She was one of two versions I completed. This is not the usual palette I often find myself using, so in the end I was quite pleased with the results, for something that is actually quite sketchy. I wanted her to be someone with a bit of 'oomph'; more gutsy than the fey, 'ooh, I broke a nail' versions you often see her presented as. Not that she's real or anything!"

▶ **Farseed**
*Dan Dos Santos*
Book cover
Tor Books
Oil on board
*www.dandossantos.com*

*Covers are Dan's forte, and this is no exception. He is always good at presenting strong female characters in his art, rarely a pouting prima donna, his women are strong and independent, and full of personality. This example is defiant and self-sufficient, and again a mixture of sci-fi and fantasy.*

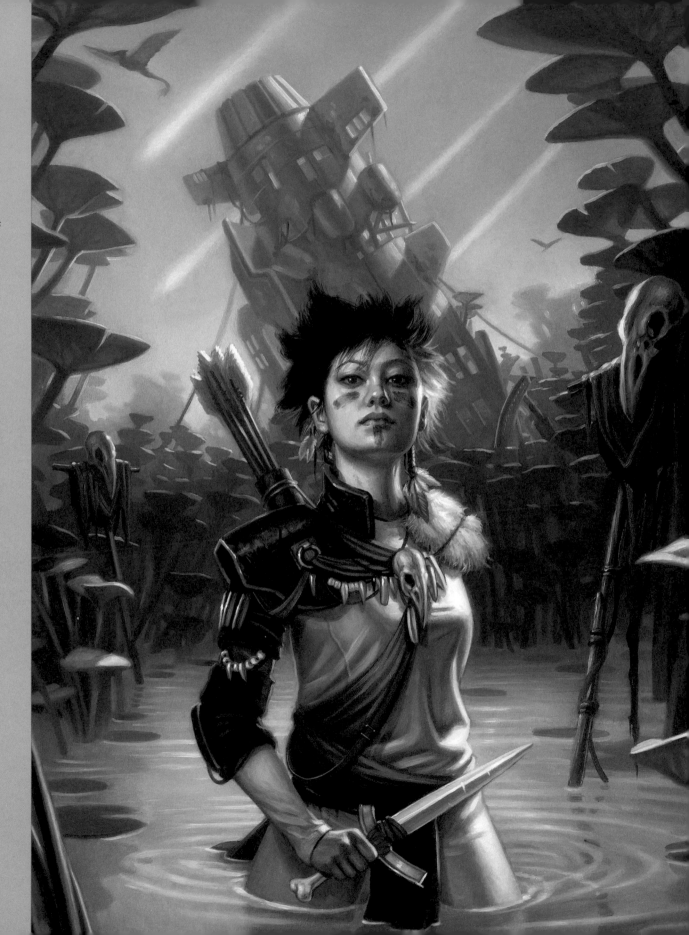

◀ **Annabel Lee**
*Kip Omolade*
Personal work
Digital and oils
*www.kipomolade.com*

*Annabel Lee is Kip's tribute to
the Edgar Allan Poe poem of the
same name. Poe used words and
rhythm to produce drama and
tension. Kip does the same thing
here with paint. It's also one
of the few pieces with a cameo
from Kip!*

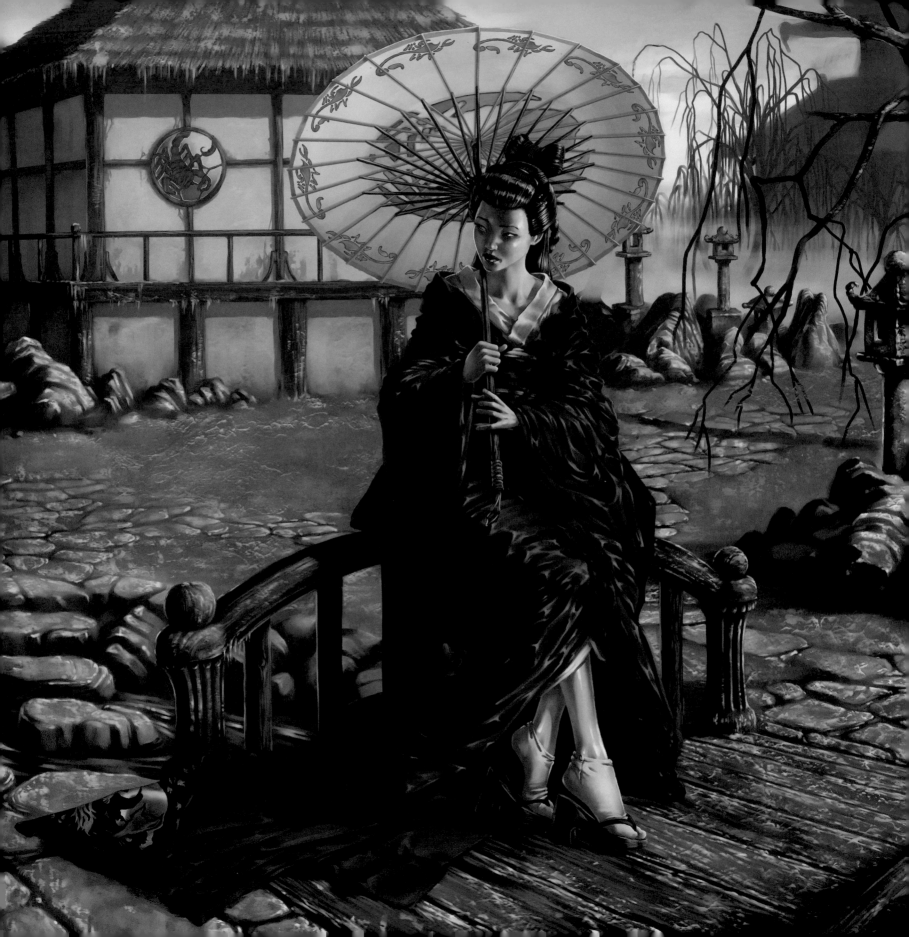

◄ **Yogo Fox-Wife**
*Andy Hepworth*
Alderac Entertainment Group
Corel Painter
*www.andyhepworth.com*

*"My old Ma had some of those classic 'willow pattern' plates for display when I was a nipper, and they were foremost in my mind while painting this one. I almost went the whole hog and included some blowing blossom, but decided that might be one step too far. I love doing drapery, and think I spent far more time on the clothing than anything else."*

▶ **Vengeance**
*Jon Sullivan*
Personal work
Adobe Photoshop
*www.jonsullivanart.com*

*"This picture was designed as reference for a painting I was about to start. I wanted her to be beautiful, yet conquering in her pose. Coiling its tail around her body, the dragon is ready for battle and to protect its rider with its own life. I tried to get away from the typical female warrior look that you regularly see depicted in fantasy art. Clad in armor, she is looking down from high up on a mountain ledge at her foe. This is a scene just before her battle, but she shows no fear."*

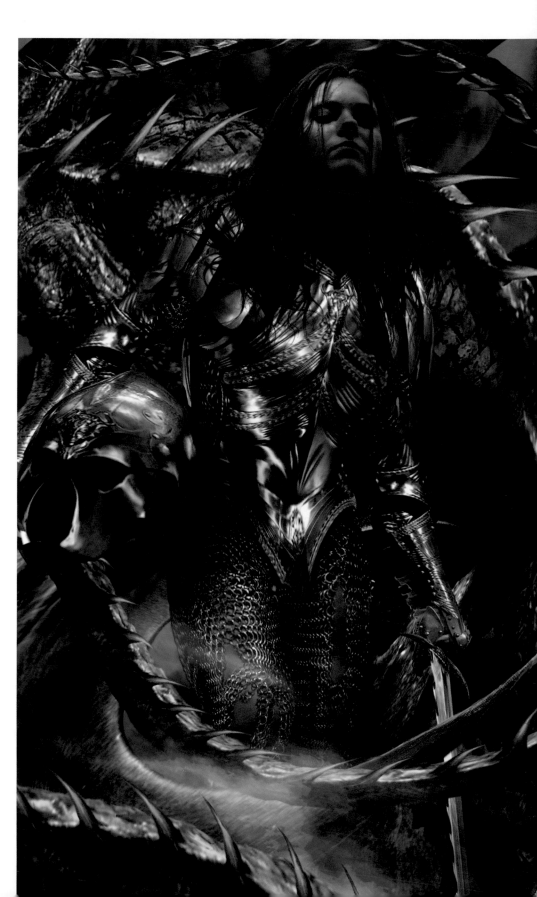

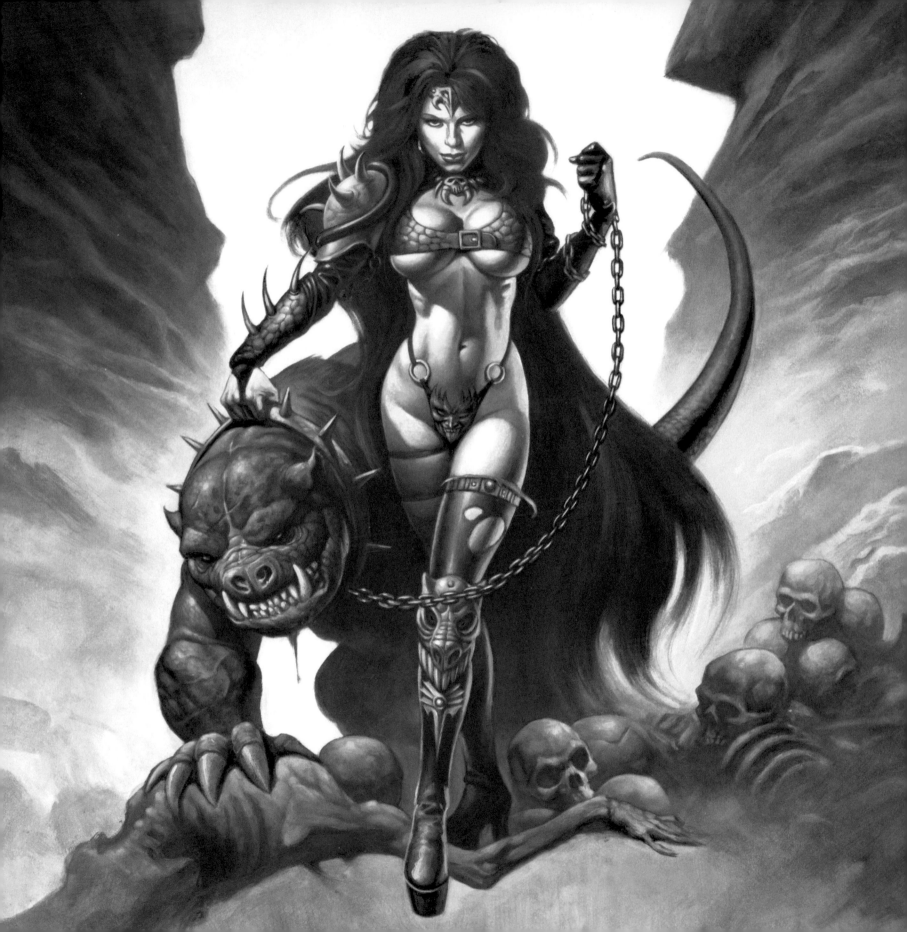

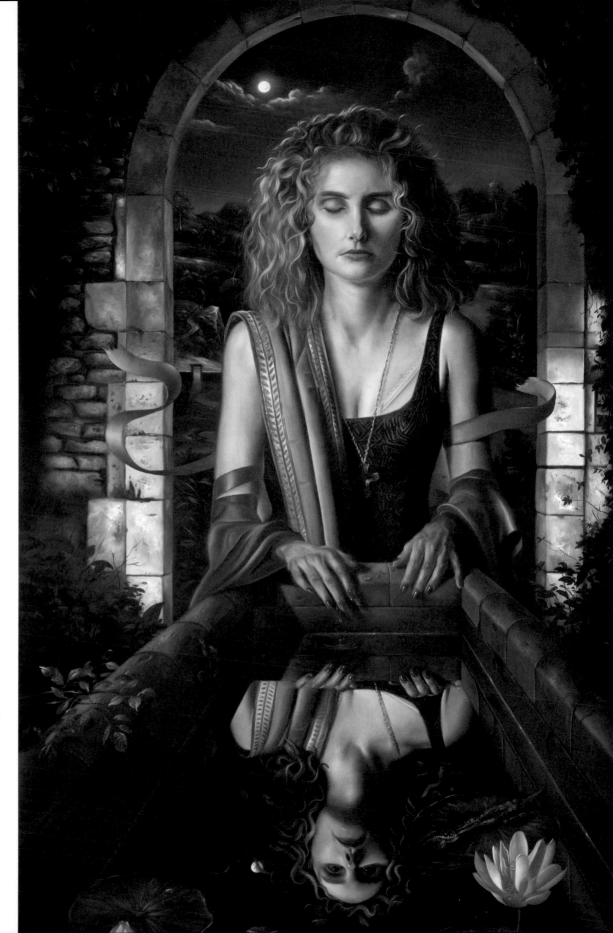

**The Glenn Keeper**
*Alex Horley*
HEAVY METAL magazine
Acrylic and oils
*www.alexhorley.com*

*"This was a special collaboration between myself and the model Stacy E. Walker for Gene Simmons of KISS. We took elements from his costumes to create the look for the main figure and then added a few more features from some of Stacy's favorite characters to complete the look. The hair is inspired by Medusa from Marvel Comics and the beast is inspired by the cave troll from* The Lord of the Rings. *Stacy has been the inspiration behind many of my paintings and this is by far one of my very favorites."*

▶ **Mysteries of Medusa**
*David Bowers*
Portfolio work
Oil on linen
*www.dmbowers.com*

*David's paintings combine his expertise and knowledge of art history, and the techniques of the Old Masters, with a surrealism and modern fantasy sensibility to create a unique vision. As with most of his work, it takes some time for the viewer to absorb the various elements that make up the composition and begin to interpret the symbolism. The eye is initially pulled towards the downcast face, then to the water where we are confronted by the Medusa's gaze, the coiled serpents, and the frog clinging desperately to life.*

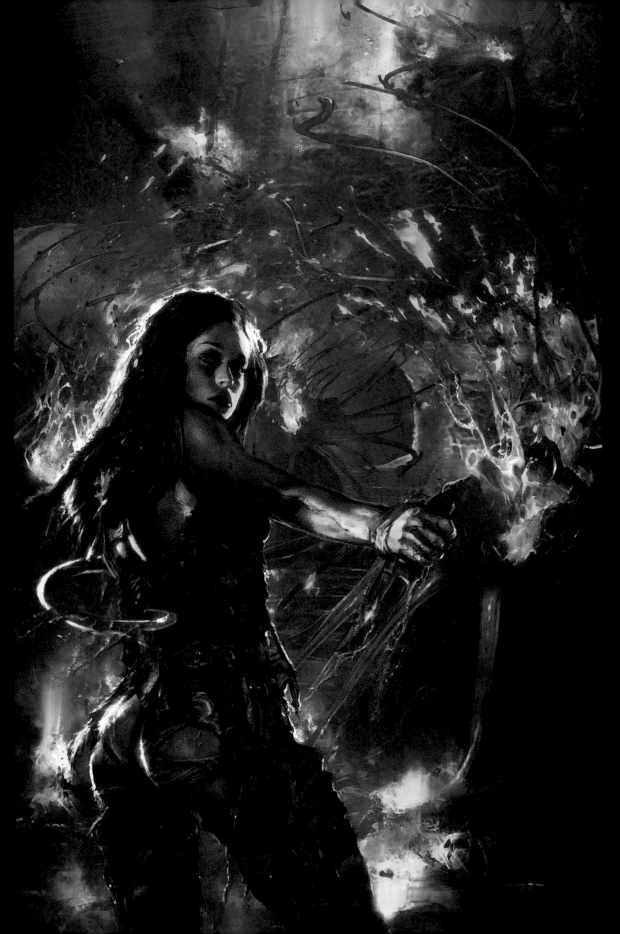

◄ **The Clockwork King of Orl**
*Mark Harrison*
Book cover
Abaddon Books
Adobe Photoshop and
Corel Painter
*www.2000ad.org/markus*

*"Typically the turn around on
these covers is pretty quick; they
have to be conceived and finished
within a week. The most difficult
part is trying not to repeat
yourself and varying the color
palette. Authors and the editor
have an input, but ultimately
I have to go with what I think
works and what I can do within
the time constraints. This was
another 'Frankenstein' cover of
various bits and pieces grabbed
here and there. Not that the
heroine of the book looks a bit
like Frankenstein!"*

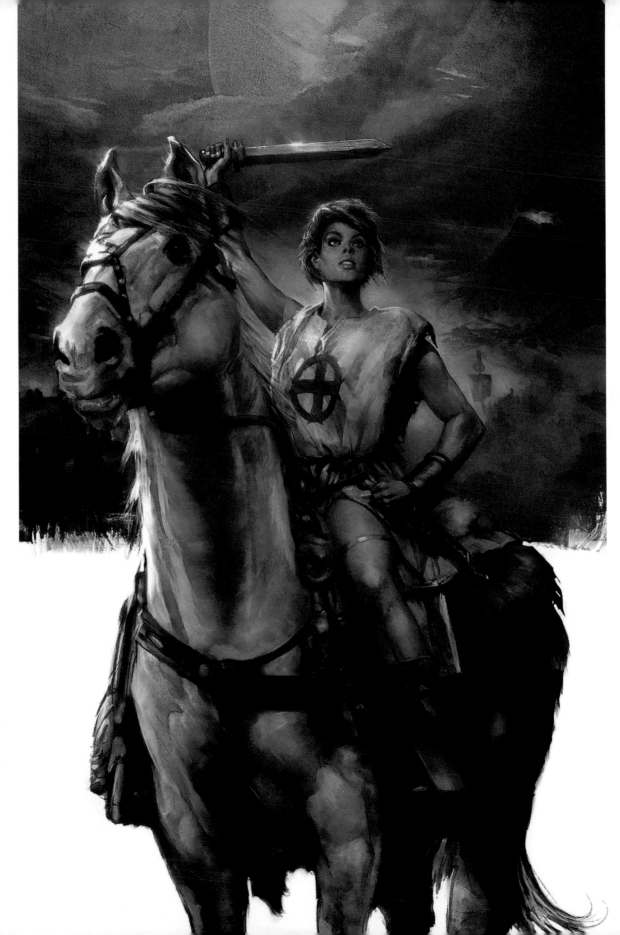

▶ **The Light of Heaven**
*Mark Harrison*
Book cover
Abaddon Books
Adobe Photoshop and
Corel Painter
*www.2000ad.org/markus*

"*I avoid drawing or painting
horses as much as possible
because I find them difficult to
do. But sometimes it's fun to take
on the challenge. Half painting
the background was referencing
the posters of the* **Dollars** *movies
that the author wanted. Had
there been more time available
I might have gone with a looser,
more 'drawn' look but I had
to fall back onto what I know.
Ironically, after this cover I got
pitch work doing a whole load
more horses!*"

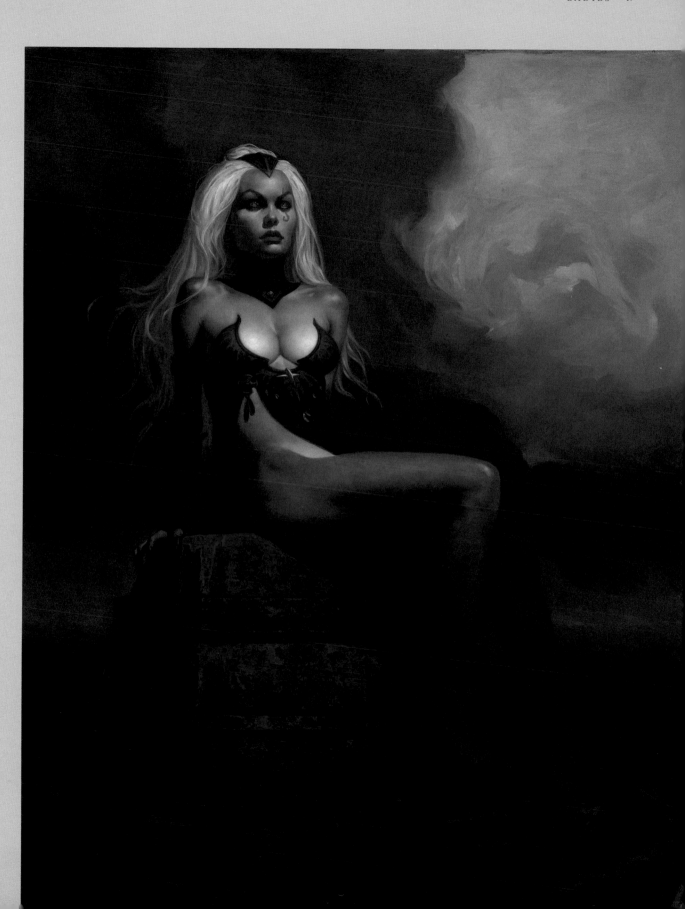

◄ **Drow of the Underdark**
*Francis Tsai*
Book cover
Wizards of the Coast
Digital
*www.teamgt.com*

*"This image was created for the cover of the Wizards of the Coast book called* Drow of the Underdark, *and was also used as the cover to my own book,* 100 Ways to Create Fantasy Figures," *explains Francis. His Drow is dark and moody with an air of menace provided by the billowing cape, sword, and crossbow that form the strong diagonals around the figure.*

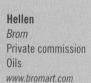

► **Hellen**
*Brom*
Private commission
Oils
*www.bromart.com*

*"This was a private commission produced for Conny Valentina, (also a gifted artist in her own right). This image features a character from a novel Conny is working on; a succubus lounging around Hell."*

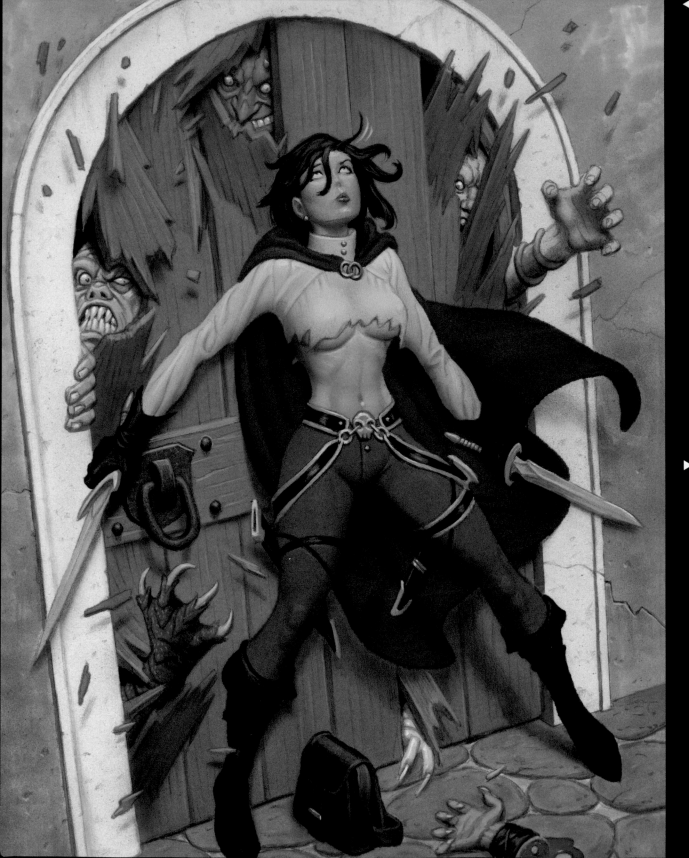

◄ **Gatecrashers**
*Fastner & Larson*
Commission
Mixed media
*www.fastnerandlarson.com*

"Some images almost paint themselves — especially when the commissioner comes up with the setting, action, costume, character details, and the heroine's expression of 'here we go again,' while blowing a lock of hair out of the way, for us. Steve used marker, airbrush, watercolor, color pencil, and gouache...and he had a lot of fun painting the splintering wood."

► **Tranquil Waters**
*Malachi Maloney*
SQP
Digital
*www.liquidwerx.com*

"SQP had asked me to do a couple of mermaids for an upcoming project and this is one of the two resulting paintings. This is the first time I had ever tried to paint a mermaid, so it was a new experience for me. I wanted the mood of the piece to be very haunting and still, like those photographs you see of whales under water. The ocean's so vast and empty that it can look really scary at times. I also tried to focus on a more realistic design than is usually seen with mermaids, while also trying to maintian that feeling of fantasy that they are loved for."

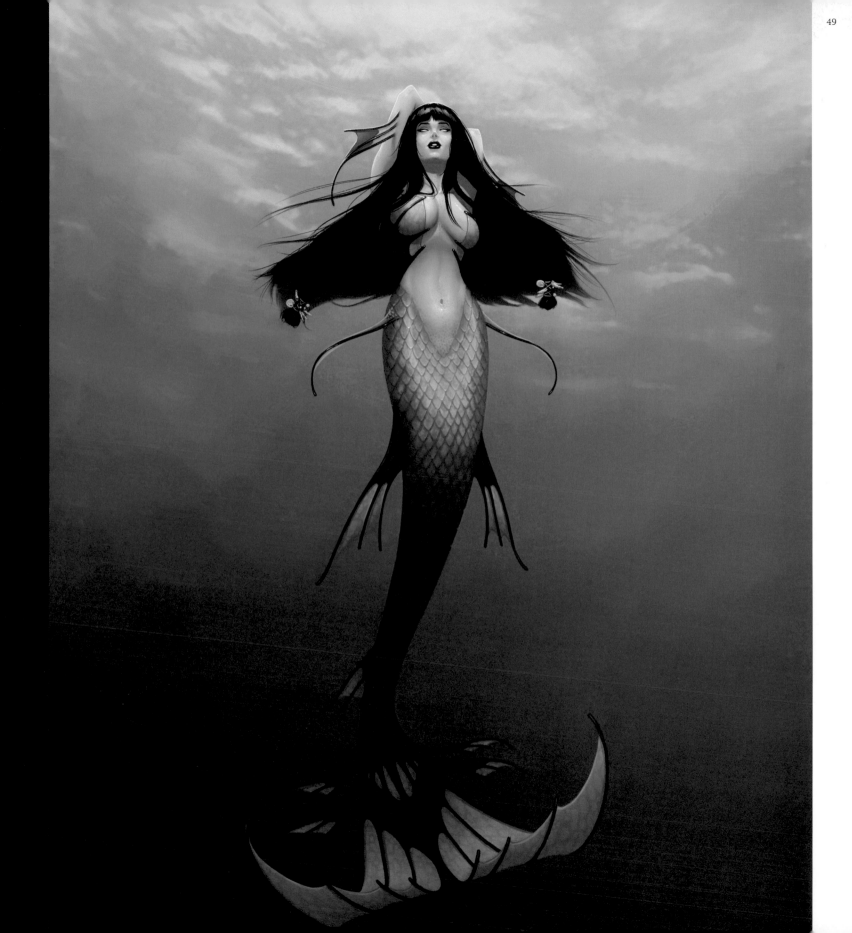

▶ **Warrior Princess**
*Min Yum*
Personal work
Digital
*www.minart.net*

*Another image produced for Character of the Week on ConceptArt.org, a weekly friendly challenge between artists where a subject is proposed and then the individual artists interpret that subject to produce a finished image. This proved to be a very popular one and Min won with this superb characterization. Simple mark-making and just the right amount of detail make this a wonderful image.*

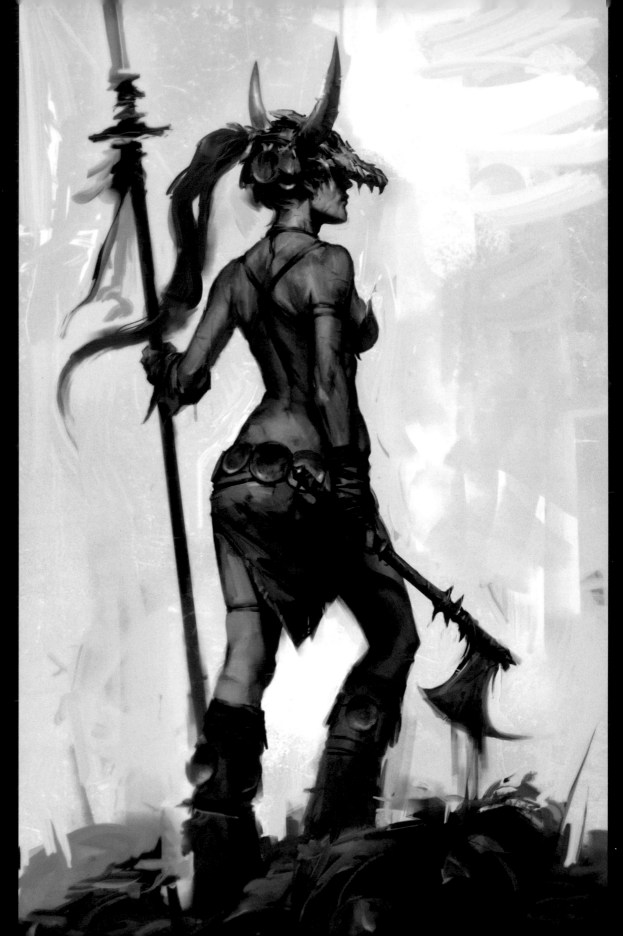

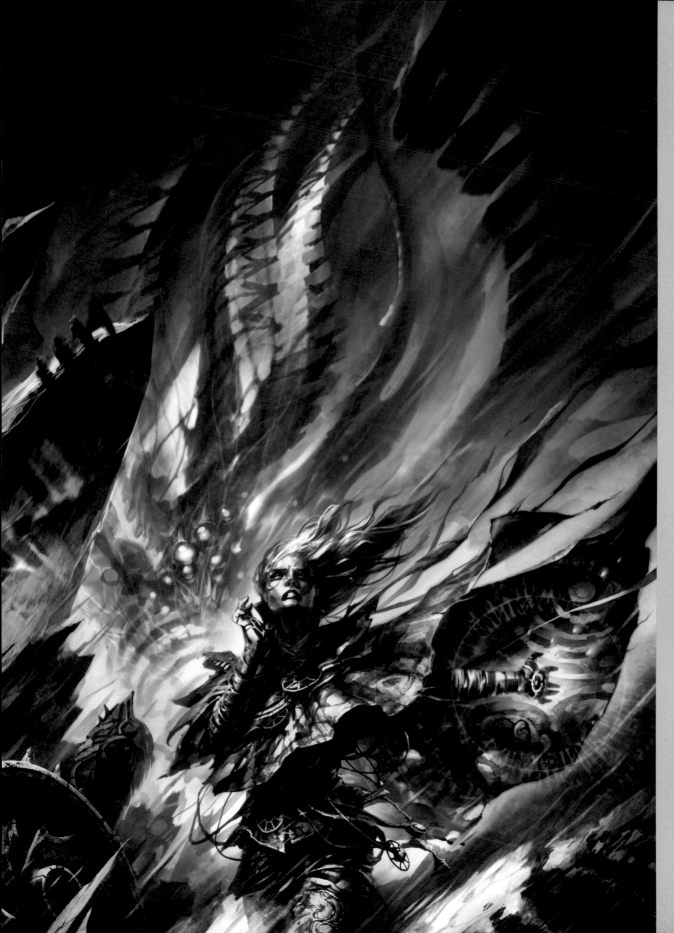

◀ **Surrender to the Will of Night**
*Raymond Swanland*
Book cover
Tor Books
Digital
*www.raymondswanland.com*

*"In Glen Cook's most recent series of novels, The Instrumentalities of the Night, he has created a world influenced as much by the mystical power of nature as by the power of human politics. As with many of my paintings, this recent cover features the weather itself as a third character that comes between the protagonist and the antagonist. Conflict arises not only from enemies, but also from the will to face the indifferent natural forces that serve to remind us of just how small we are."*

◀ **Archer**
*Tim McBurnie*
Personal work
Adobe Photoshop
*www.timmcburnie.com*

*"This is a character design for one of my comic books. I was aiming for a complex costume that wouldn't be too hard to endlessly redraw. Besides being an archer I don't know anything about her yet. The story tends to flow from the drawing and not the other way around."*

▶ **Blue Petal**
*Tim McBurnie*
Personal work
Adobe Photoshop
*www.timmcburnie.com*

*"This was done as a style test for one of my comic books, mostly to figure out if I could draw my lines as well as color digitally, which turned out to be no problem. Whereas a lot of my work tends to involve scanned pencil drawings, this one is 100 percent Adobe Photoshop."*

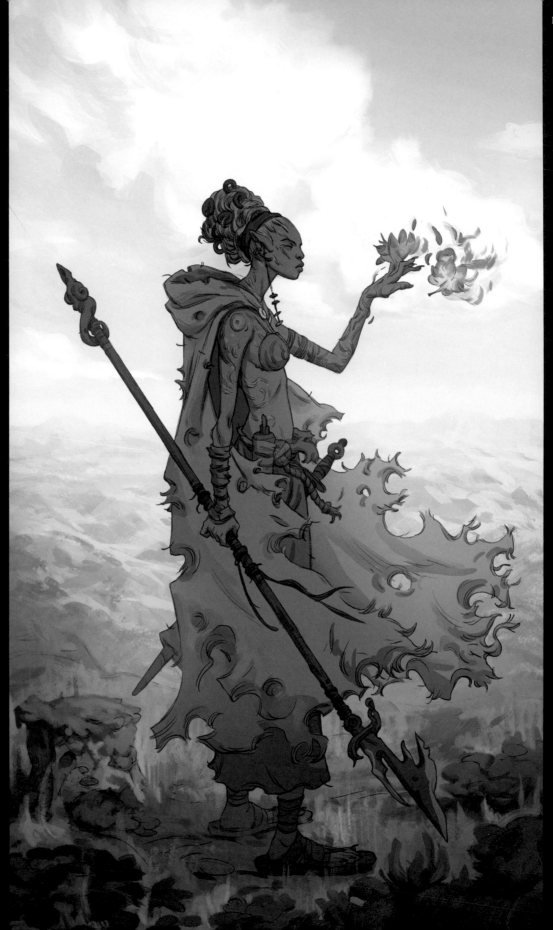

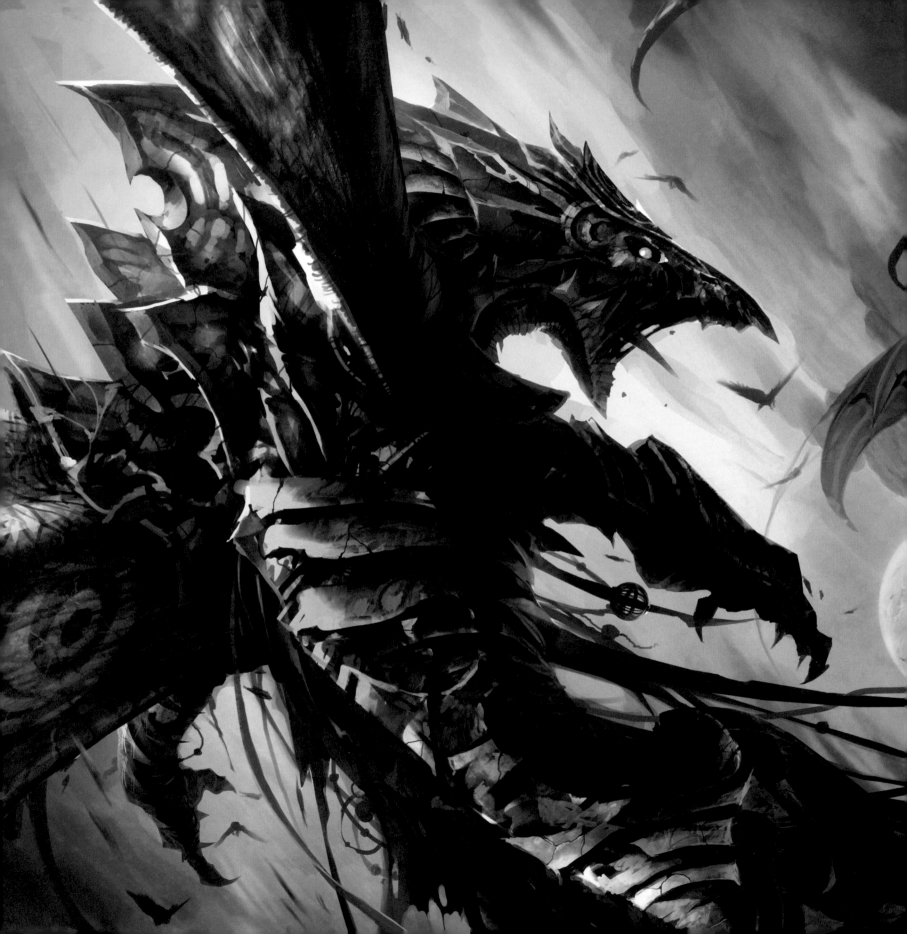

# CHAPTER 3
## BEASTS

◄ **Storm Song**
*Raymond Swanland*
*The Universe of Dragons*
Digital
*www.raymondswanland.com*

*"Dragons are a ubiquitous*
*symbol of our most fantastical*
*fears and our most ancient*
*wisdom. When offered a blank*
*canvas to create a dragon image*
*for the third edition of* The
Universe of Dragons, *I chose*
*to play with that symbolism by*
*expressing the dragon as a lonely*
*and weary master of the weather.*
*Adorned in regal armor and*
*huge carved slabs of jade, the*
*dragon reveals its powerful royal*
*history. Yet, age and weather*
*have removed its shine and the*
*dragon takes its place in the*
*gray areas of history as a force*
*of nature."*

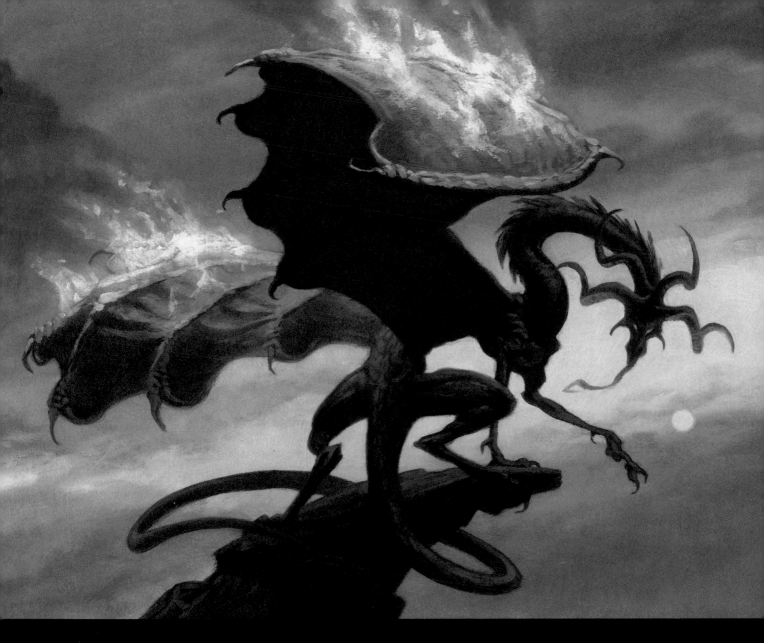

◀ **The Ice Demon**
*Alex Horley*
Magic: The Gathering—Coldsnap
Wizards of the Coast
Acrylic and oils
www.alexhorley.com

"This is a concept design I did for Magic's Coldsnap. It is rare to get total freedom with a design, so when I do I get to really have fun with it. I also don't always get the opportunity to work with cold colors and I was really happy with the final look of thi...

▲ **Flame Wings**
*Daren Bader*
Wizards of the Coast
Digital
www.darenbader.com

"Flame Wings was one of those assignments that every illustrator loves to get (i.e. minimum art direction). I was asked to make a cool dragon of my own design, with the only requirement being to have the wings on fire. I had fun designing various horn configurations, and ended up with snaking shapes to echo the dragon's body."

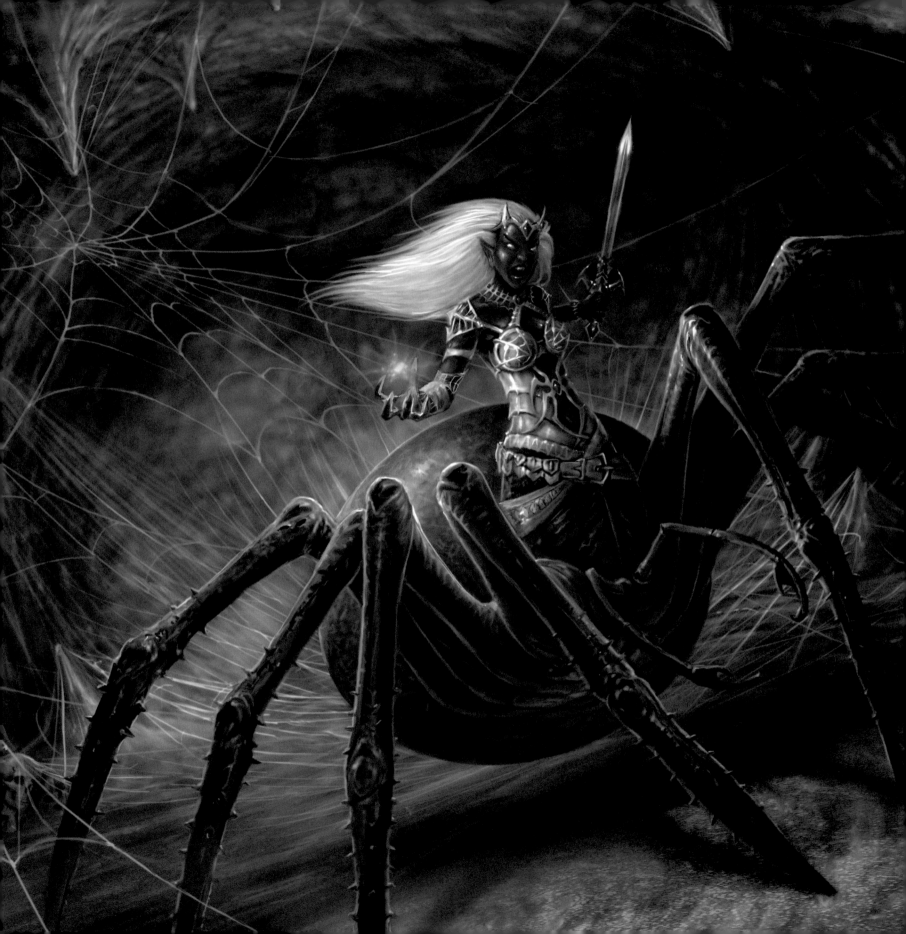

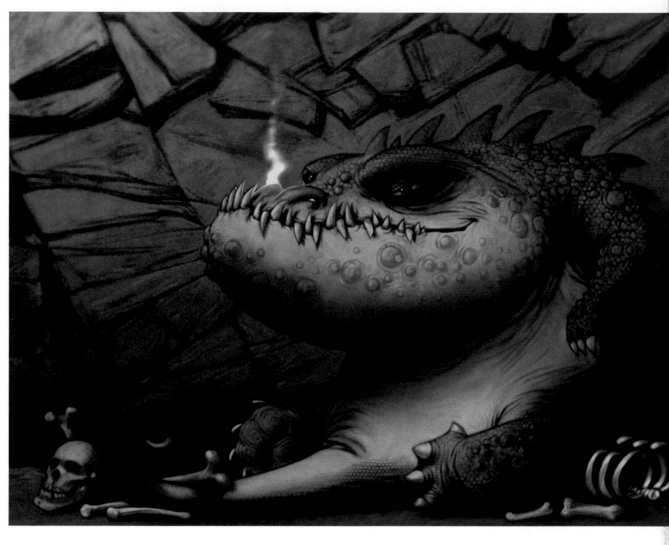

◀ **Drider**
*Anne Stokes*
Wizards of the Coast
Digital
*www.annestokes.com*

"This image was commissioned
for the Monster Manual of
the 4th edition of Dungeons
and Dragons by Wizards of
the Coast. The Drider is a cross
between a dark elf and a giant
spider and as such, made a cool
subject to paint. For the book
it is designed to be a character
portrait, but the cave and skulls
caught in the web also give a
little extra flavor."

▲ **Dragon**
*Don Seegmiller*
Personal work
Digital
*www.seegmillerart.com*

"At one time I started to do a
series of dragons based on dogs.
I hope to continue the series
eventually. This particular
dragon is loosely based on my
daughter's bulldog. The dog sits
in a very un-dog-like position.
The dragon here has just had
a comfortable meal and is
now contemplating a long
nap. A mild case of heart-burn
manifests itself in the small flame
from his nostril as he burps."

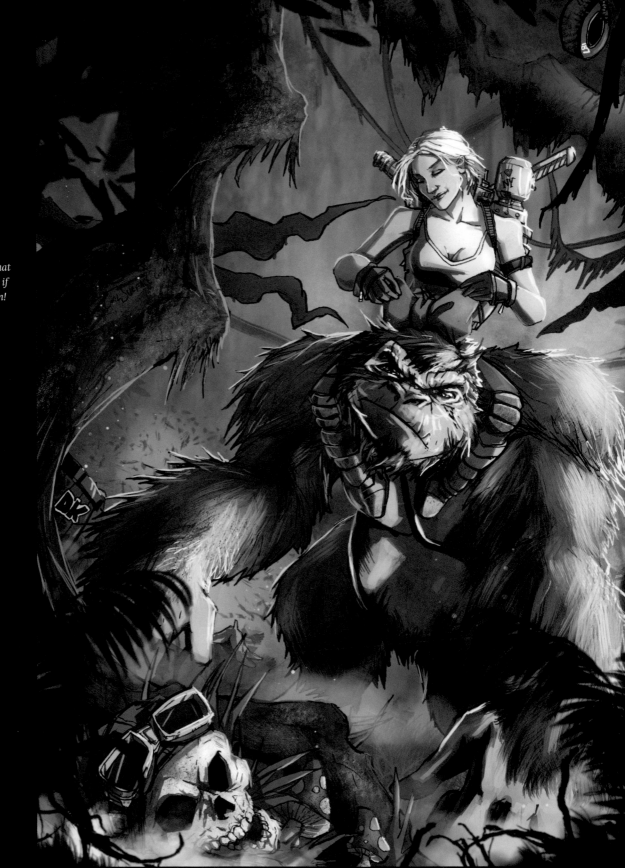

▶ **Walkies**
*David Cousens*
IDG Publishing
Pencil and Adobe Photoshop
*www.coolsurface.com*

*This image was revisited especially for this book. Originally it appeared as part of a tutorial in* Digital Arts *magazine. The image was inspired by true events; Sarah, David's partner, once tied a ribbon into his hair against his wishes, proving that men will suffer any indignity if a woman is attractive to them!*

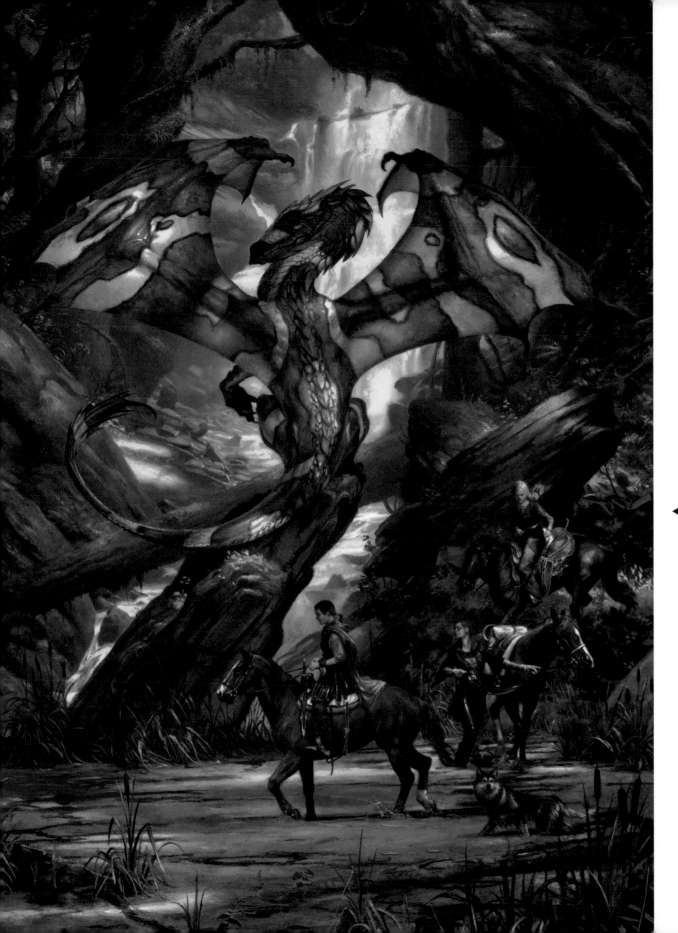

◄ **Adventurers**
*Donato Giancola*
Private commission
Oil on panel
*www.donatoart.com*

*"Adventurers was my first
dragon in quite some years, and
it was a real pleasure to tackle on
a large scale with extraordinary
detail. I've always viewed dragons
as highly intelligent, a nod to
my history of Dungeons and
Dragons role playing. After
visiting the Tetryakov Gallery in
Moscow, I discovered the amazing
works of the Polish orientalist
painter Henri Siemiradzki, a
master of subtlety and dappled
light. With this newfound
inspiration, I combined my love
of storytelling and abstraction
with creating a play of light
across the adventurers, the
dragon, and the duckweed film
on the surface of the pond."*

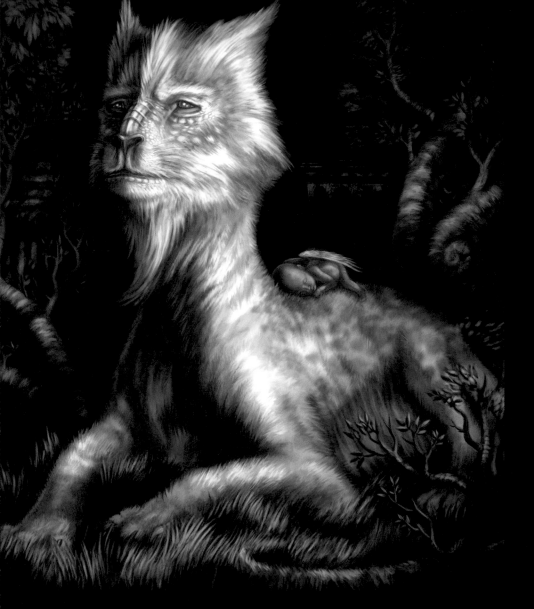

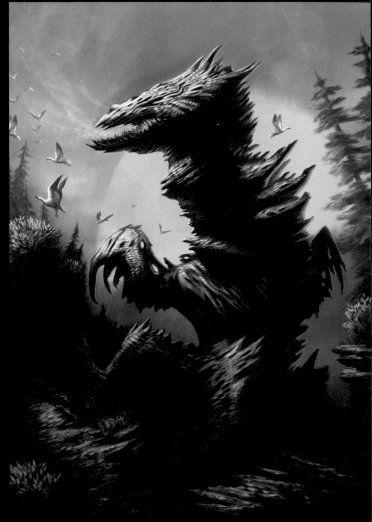

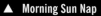 **Morning Sun Nap**
*Mike Corriero*
Personal work
Adobe Photoshop and Corel Painter X
*www.mikecorriero.com*

"A baby angel sleeps in the morning sun, unafraid of any danger
and carefree of the world around him as he takes a nap on the
back of his guardian. The large magical beast watches over his
little companion until he's old enough to care for himself and then
they part ways. A bond is forever linked between the two, even

▲ **Samarium Dragon**
*Mike Corriero*
Personal work
Adobe Photoshop and Corel Painter X
*www.mikecorriero.com*

"An elemental burrowing dragon made up of a rare earth
metal known as Samarium. The dragon is quite abstract and
asymmetrical in form to try and mimic the look and feel of this
element. Samarium has a bright silver lustre but is also rigid
and rough."

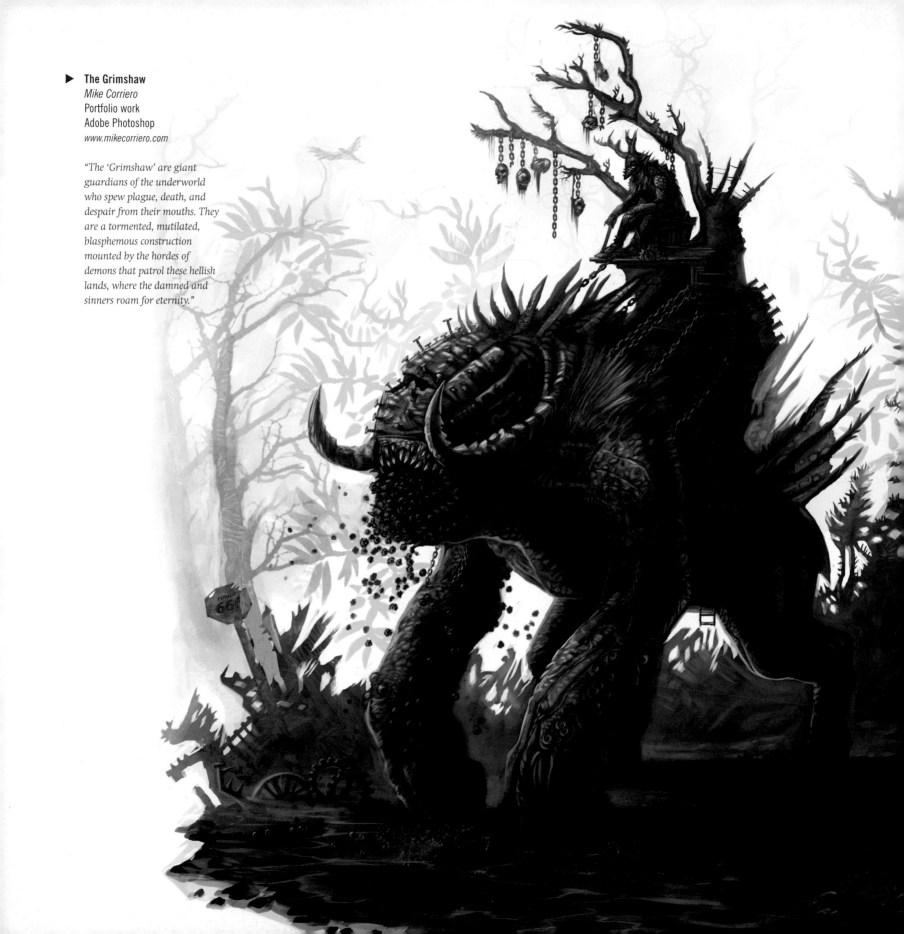

**The Grimshaw**
*Mike Corriero*
Portfolio work
Adobe Photoshop
*www.mikecorriero.com*

*"The 'Grimshaw' are giant
guardians of the underworld
who spew plague, death, and
despair from their mouths. They
are a tormented, mutilated,
blasphemous construction
mounted by the hordes of
demons that patrol these hellish
lands, where the damned and
sinners roam for eternity."*

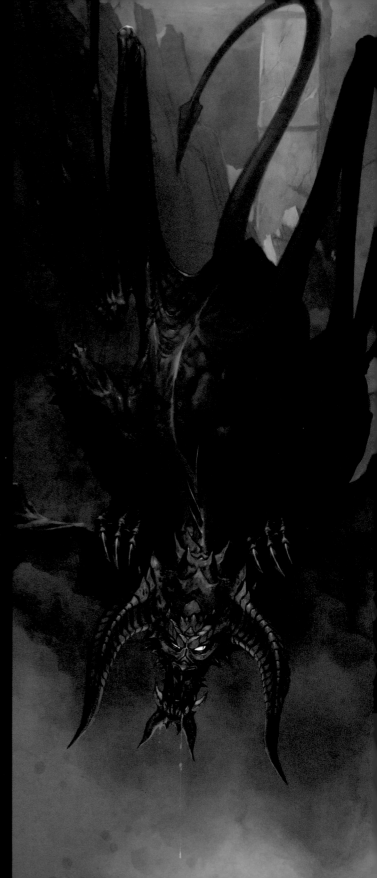

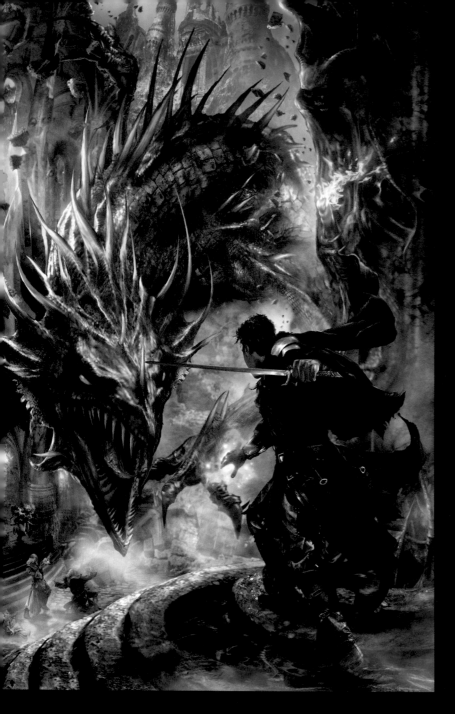

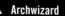 **Archwizard**
*Jon Sullivan*
Solaris Books
Adobe Photoshop
*www.jonsullivanart.com*

*"Christmas comes early when I get a creature or monster to design.
Compositionally it was tricky to pull off. Designing a 'ying and yang'
composition was the only way I could keep all the action tight, giving
the main character (Rod Evlar) a strong forward movement, which
brings the viewer directly into the picture."*

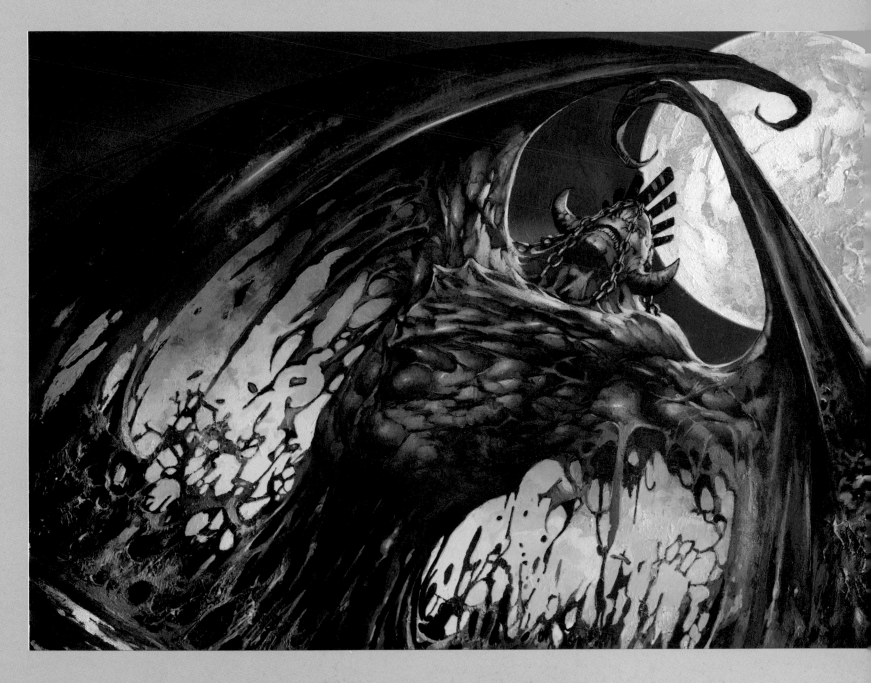

◀ **Rhashaak of Haka'torvhak**
*Francis Tsai*
Wizards of the Coast
Digital
*www.teamgt.com*

"*Rhashaak is a guardian dragon who watches over the city of Haka'torvhak. I created this illustration for the Eberron Campaign Setting game manual for Wizards of the Coast. In this image, the viewer is intrigued by what might lurk beneath the image, in the space, and city, that the dragon is peering into.*"

▲ **Demigod of Revenge**
*Jim Murray*
Wizards of the Coast
Acrylic
*www.jimmurrayart.com*

"*This is a strange piece. There were a few problems getting the sketch approved, mainly because I still don't actually play Magic and so I sometimes miss stuff that's important, or add inappropriate things. That said, once approved this piece went very fast, I think about four or five hours from blank paper to being uploaded to the client's ftp.*"

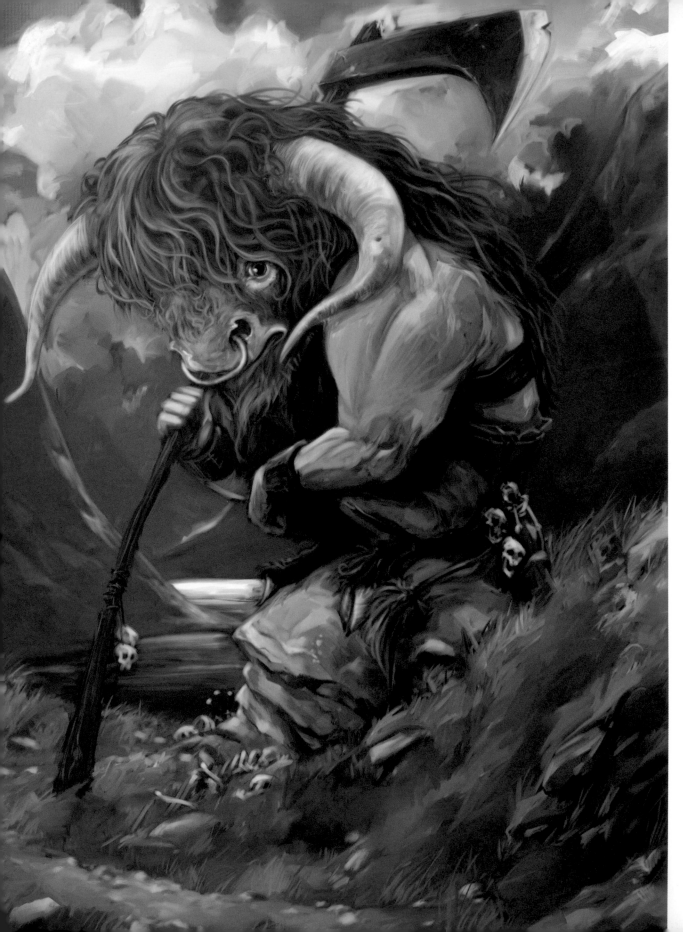

**The Highland Minotaur**
*Jonny Duddle*
Future Publishing
Corel Painter X
www.duddlebug.com

*"This painting was commissioned by* Imagine FX *magazine, for a mini-supplement to coincide with the launch of Corel's Painter X. I received a beta copy of the software prior to launch and was asked to look at all the new Real Bristle brushes. These brushes are meant to mimic the movement and control of bristles on a 'real' paintbrush, so I was aiming for a traditionally painted look. While reviewing my portfolio, a few of my clients have been surprised to discover this is a digital piece, so the Corel Painter software seems to be doing its job!"*

▶ **Fire Rannet**
*Jim Murray*
Wizards of the Coast
Acrylic
www.jimmurrayart.com

*"I usually try to sketch on the train home from work. This piece came directly from a train sketch. Rough as it was, I just projected it straight onto the board and worked it up from there. Hopefully it doesn't lose too much energy that way."*

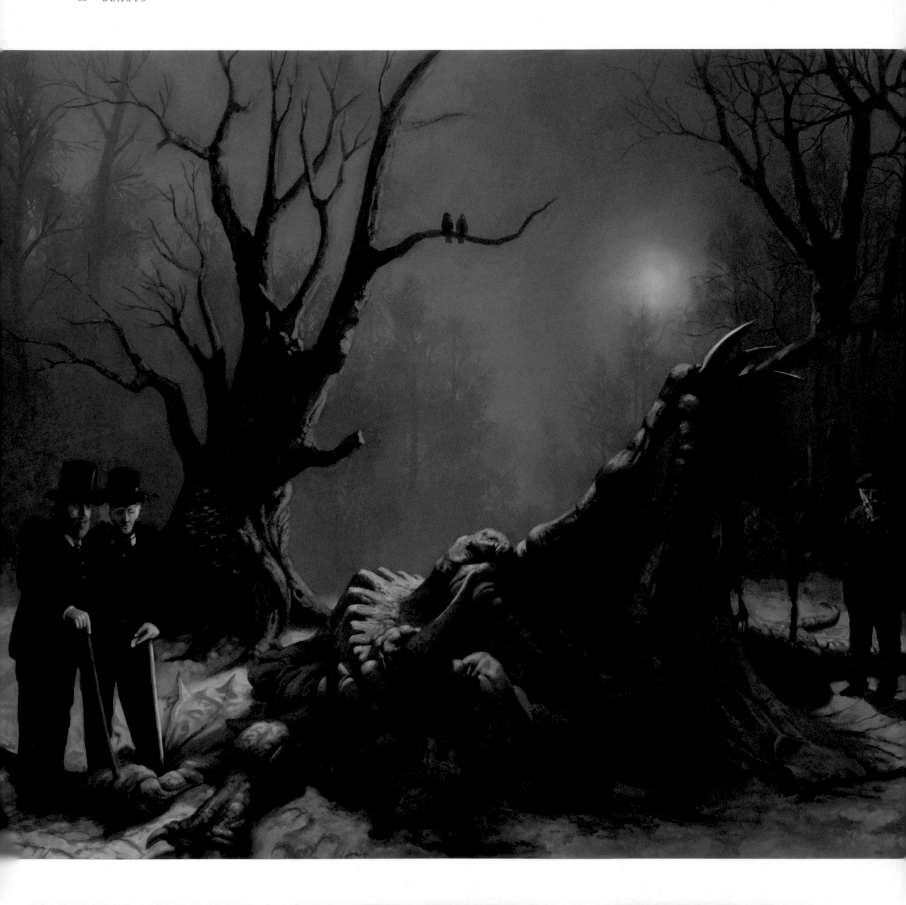

◀ **The Last Dragon**
*Simon Dominic Brewer*
Portfolio work
Digital
*www.painterly.co.uk*

*"One of the first pieces I ever created was of a dead dragon, so lacking any fresh inspiration I recycled the idea and shifted the whole scene into the Victorian era. The Victorians were an odd bunch; while the sight of a woman's ankle would cause no end of fuss, the discovery of a dead dragon provokes mere jowl-pulling and the occasional prod from a gentleman's cane."*

▶ **Death Horse**
*Min Yum*
Personal work
Digital
*www.minart.net*

*Min produced this for a weekly challenge on ConceptArt.org. The subject was "Death's Horse." It is a fine example of how his brush marks layer up to produce depth and atmosphere. The result is a truly creepy and disturbing image!*

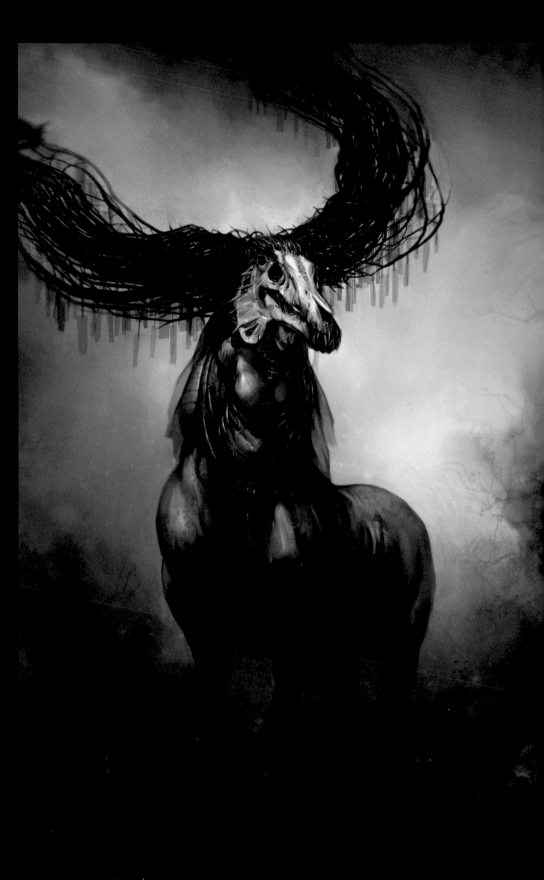

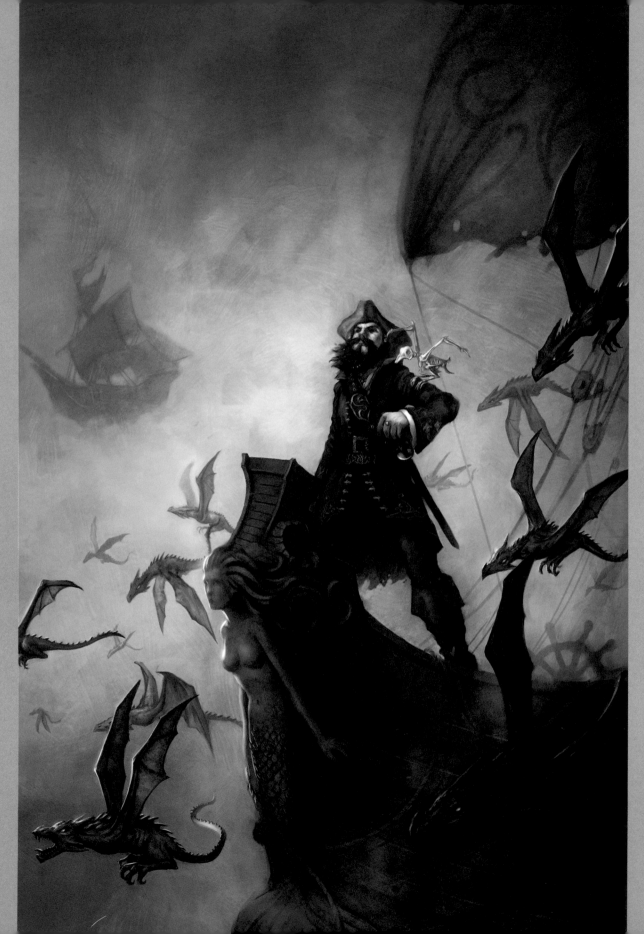

▶ **Fast Ships, Black Sails**
*Scott Altmann*
Book cover
Night Shade Books
Digital
*www.scottaltmann.com*

*"When sent the job details it was brief: 'just make it say pirates.' The book was to be a collection of pirate stories with a fantasy and sci-fi twist, the difficulty was to create an image, for not one story but a collection. I wanted something iconic, and ambiguous enough not to single out a particular story. Using earthy, muted tones, the idea was to keep my colors reserved and punch it up in small, selective spots. The dragons' eyes and the embroidery on the jacket are some of the only areas with high chromatic hues."*

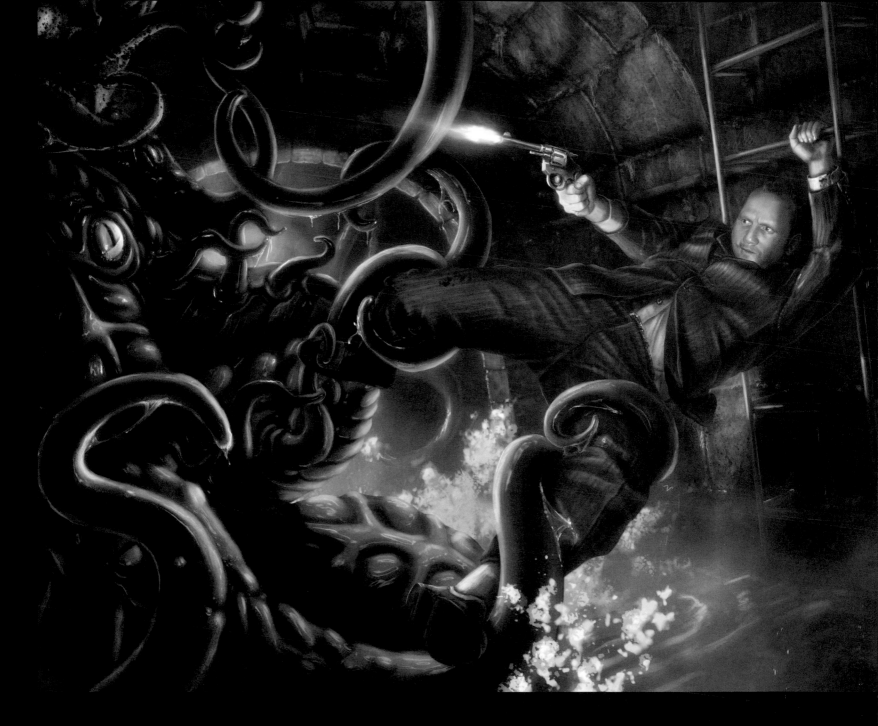

▲ **All Out**
*Henning Ludvigsen*
Fantasy Flight Games
Adobe Photoshop
*www.henningludvigsen.com*

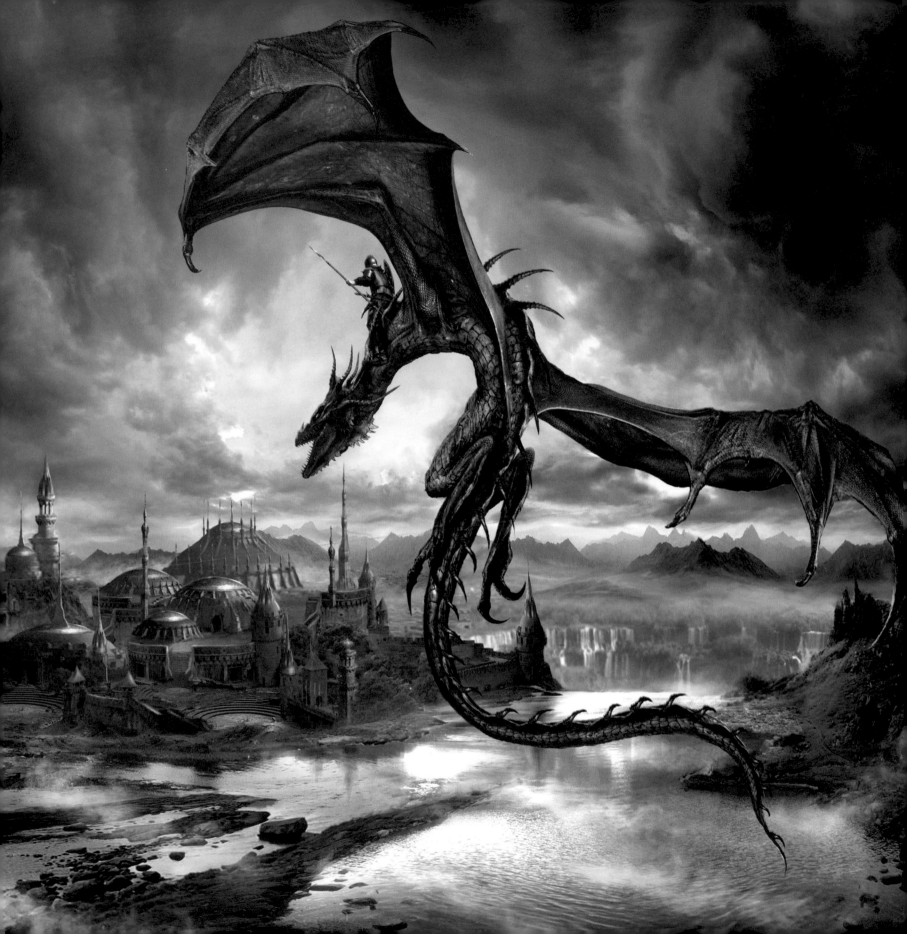

**◀ Solaris Fantasy Anthology**
*Jon Sullivan*
Book cover
Adobe Photoshop
*www.jonsullivanart.com*

"Sometimes when designing
a picture you end up with an
unexpected overall movement
that works well. The dragon's
flight and the circular movement
of clouds (which frame the
picture) end up keeping the
viewer's eye active. This cover
was for the Solaris Fantasy
anthology. I particularly liked
designing the hidden pathways,
secret corners, and passages in
the city."

**▶ Dawn Watch**
*Janny Wurts*
Personal work
Oil on Masonite
*www.paravia.com/jannywurts*

Janny explains this image was
created as a separate work,
purely for the artist's enjoyment.
It has since appeared as a
greeting card, a t-shirt for
DragonCon, a module cover
for Mayfair Games, and as a
calendar image in Janny Wurts'
Myth and Magic 2010, *from
Tide-mark Press.*

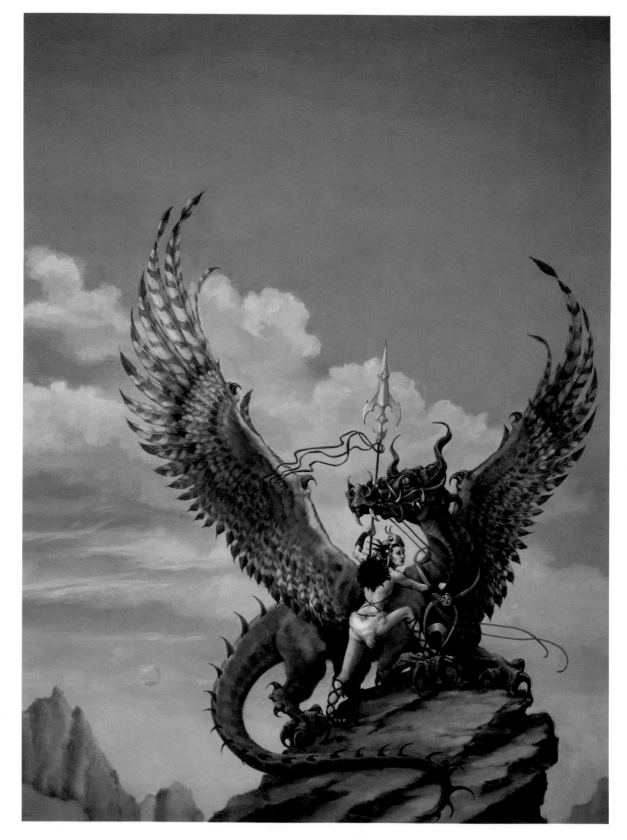

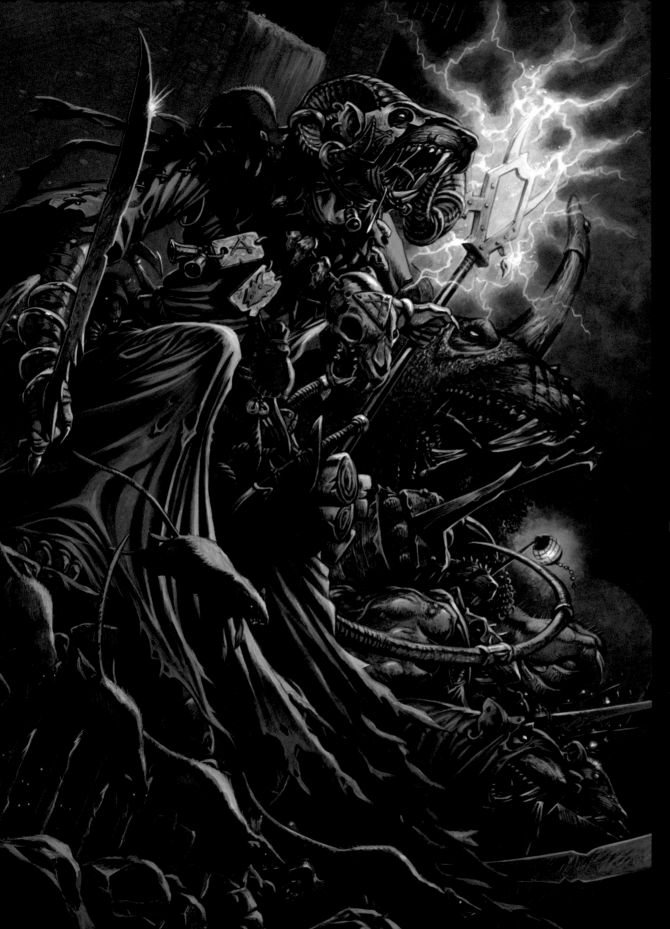

**◄ Thanquol**
*Ralph Horsley*
Book cover,
*Thanquol and Boneripper*
Games Workshop
Acrylic
*www.ralphhorsley.co.uk*

"*The Skaven seer, Thanquol,
urges the ratmen on using his
warp-stone powered magic, with
his huge rat-ogre bodyguard,
Boneripper, providing extra
impetus. Created as a novel cover
for Games Workshop's Black
Library, it was important to
convey a lot of action and drama.
The strong green magical
lighting and low viewpoint
help emphasize tension while
strengthening the sense of power
Thanquol has. The leaping
rats and flowing cloak create a
heightened sense of movement.*"

**▶ Shadow Flayer**
*Ralph Horsley*
Box cover,
*Dungeons and Dragons*
Wizards of the Coast
Acrylic
*www.ralphhorsley.com*

"*The Shadow Flayer is an evil
predator whose tentacles pierce
the skulls of his victims to draw
out their essence. The artwork
was made for packaging and
wraps around a tetrapak-style
box. This meant that the focal
point of the artwork needed to
be kept central and punchy.
An archway helps emphasize
his darker silhouette and frames
the Flayer. This is combined
with the contrasting colored
torchlight to draw attention
to him. Meanwhile, the skulls
and crystals hint of a narrative
beyond the immediate moment.*"

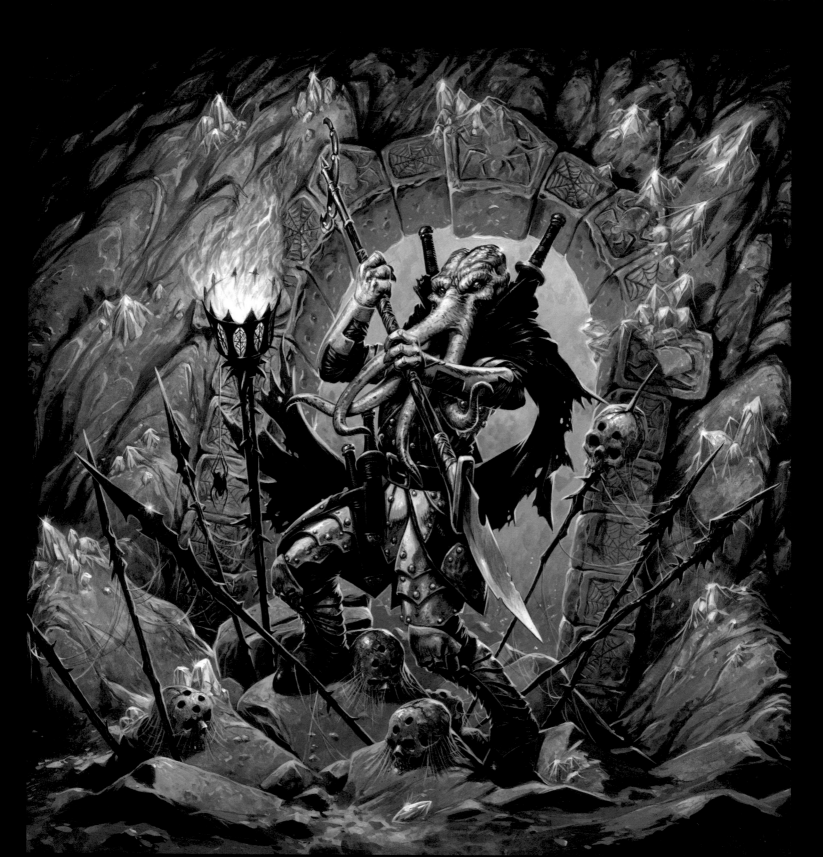

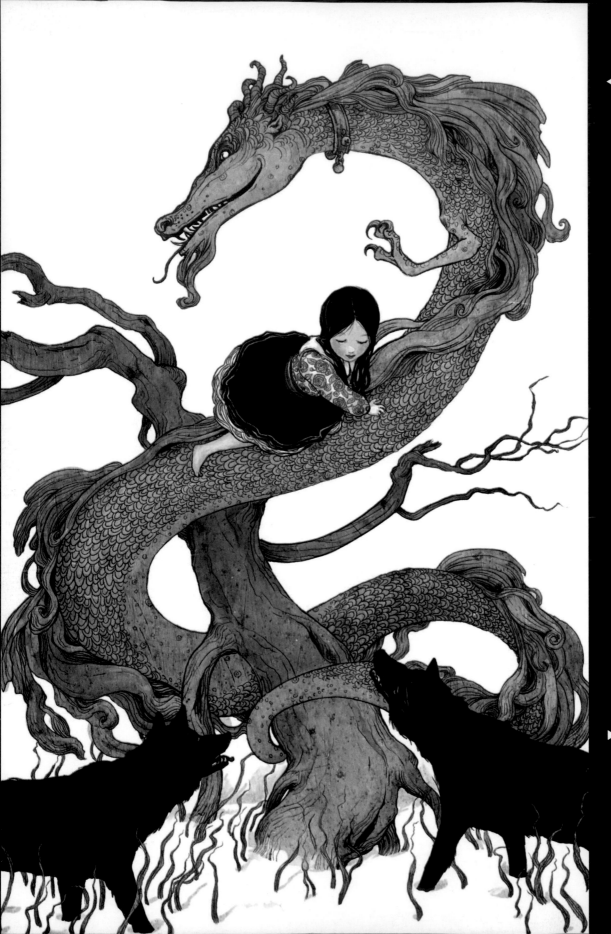

◀ **Unfair Advantage**
*Erin Kelso*
Competition entry
Adobe Photoshop
*www.conceptart.*
*org/?artist=bluefooted*

*In her entry for the penultimate round of the Last Man Standing art competition on ConceptArt. org, Erin is hinting at the beginning of a story; the start of a journey, just part of a fairytale for a young girl and her dragon.*

▶ **Stroller-Baby**
*Sean Andrew Murray*
Personal work
Digital
*www.seanandrewmurray.com*

*"Infant versions of hideous creatures is a fascinating concept, with lots of great material. This piece was just a burst of pure fun and nonsense, nothing more."*

◄ **Wandering Monsters**
*Michael Dashow*
Competition entry
Adobe Photoshop and 3DS Max
*www.michaeldashow.com*

*"Created for a competition on
CG Society themed 'Strange
Behavior,' this painting features
Tolkien-esque elves enjoying a
role-playing game, where they
play workers in a human office.
But to me, the strange behavior
is how others are quick to shun
them just for enjoying their
pastimes and being themselves.
I used 3DS Max to help work the
perspective and the forms in the
background buildings, railing,
and table detail, and painted
over that and my pencil drawing
using Photoshop."*

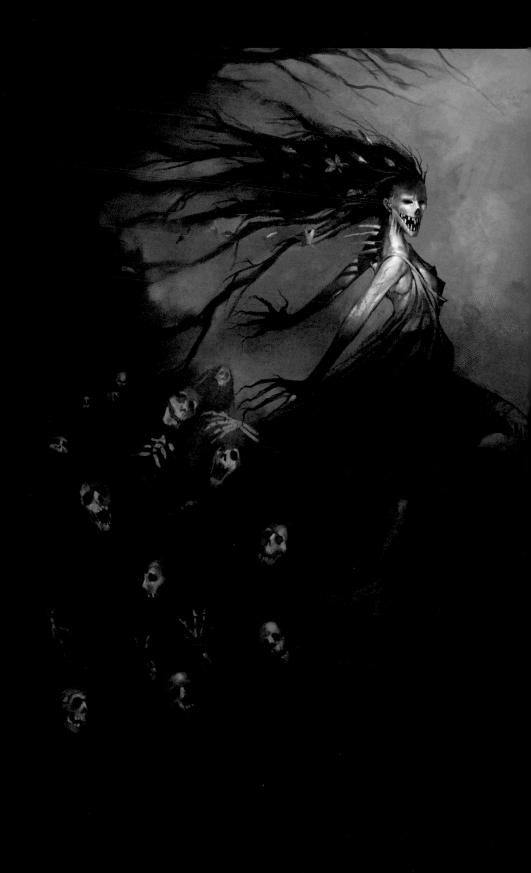

◀ **The Hunt**
*Aly Fell*
Personal work
Adobe Photoshop
*www.darkrising.co.uk*

*"Another experiment really.
When ConceptArt.org ran
their almost annual Last Man
Standing competition, this
was one of the images I never
actually submitted. My entry
was something else altogether.
Here the subject was 'Outbreak.'
I don't quite know what I was
thinking, but the two of them
are sisters. The story is kind
of the viewers' prerogative
really; suffice it to say there is
a real enmity between them,
and like everything, not all
is black and white."*

▶ **Soul Catcher**
*Aly Fell*
Personal work
Adobe Photoshop
*www.darkrising.co.uk*

*"Characters of the Week on
ConceptArt.org have been an
enormous source of inspiration
and this was something a little
spookier for me. A stealer of
souls, she trails the lost and
tormented behind her like a
wedding train. I wanted an
image very set in a fall world,
as though she is as much a
part of the slow decay of that
time of year as the leaves and
lengthening shadows."*

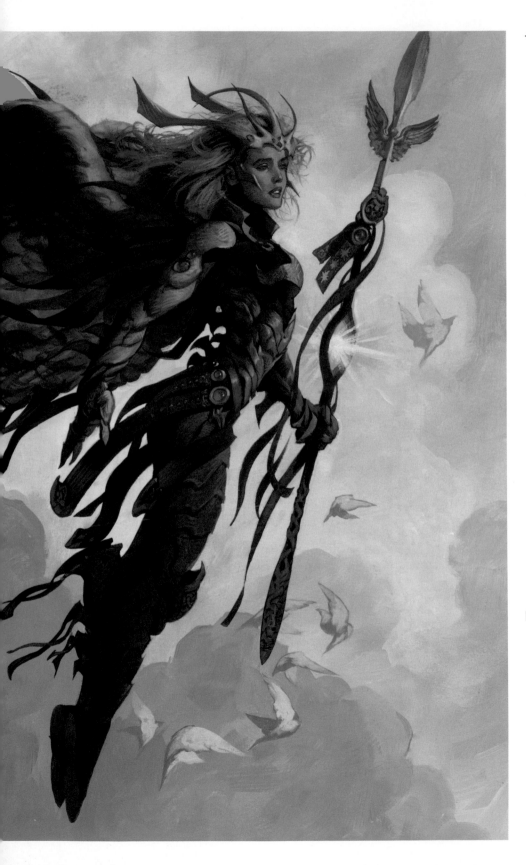

◀ **High Angel of Freedom**
*Christopher Moeller*
*Angel Quest*
Acrylic
*http://mysite.verizon.net/moellerc*

*"Rachael, the High Angel of Freedom's mission is to lead people to keep our freedoms strong. This illustration was for* Angel Quest, *a unique series of cards encouraging collectors to do good in the world. 'Will you complete all 100 acts of kindness?'"*

▶ **Sower of Temptation**
*Christopher Moeller*
Wizards of the Coast
Acrylic
*http://mysite.verzion.net/moellerc*

*"One glamer leads him far from home. The next washes away his memory that home was ever anywhere but at her side."* Sower of Temptation *is another of Christopher's* Magic *card illustrations. The faeries in this world are mischevious pranksters, as the* Sower of Temptation *displays.*

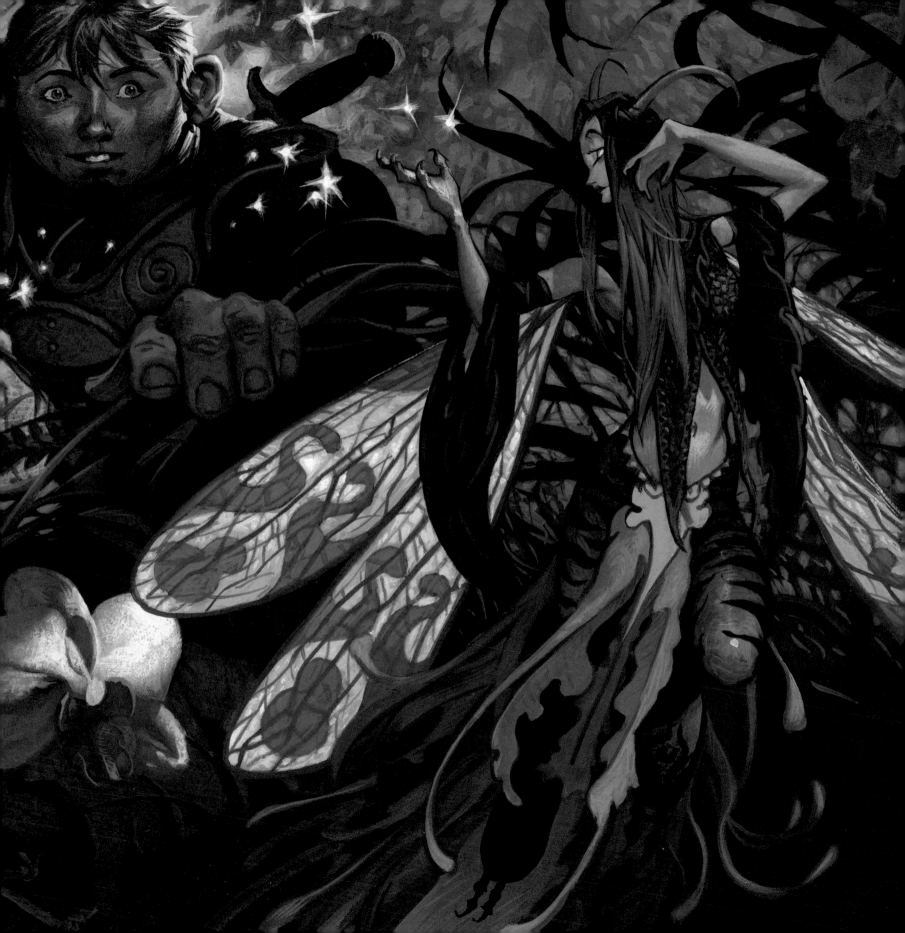

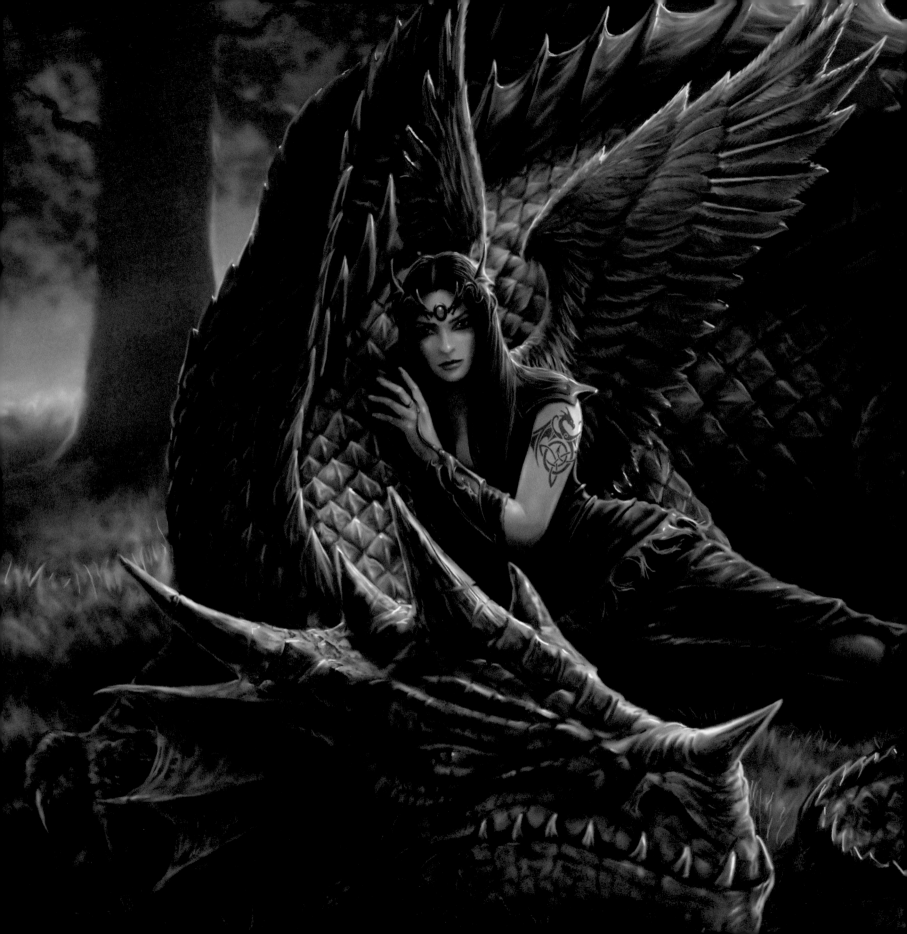

◄ **Winged Companions**
*Anne Stokes*
Personal work
Digital
*www.annestokes.com*

*"Angels and dragons are both
iconic fantasy subjects and
are shown together here in a
sunlit glade. I tried to create an
atmosphere of summer and a
glimpse of a relaxed moment."*

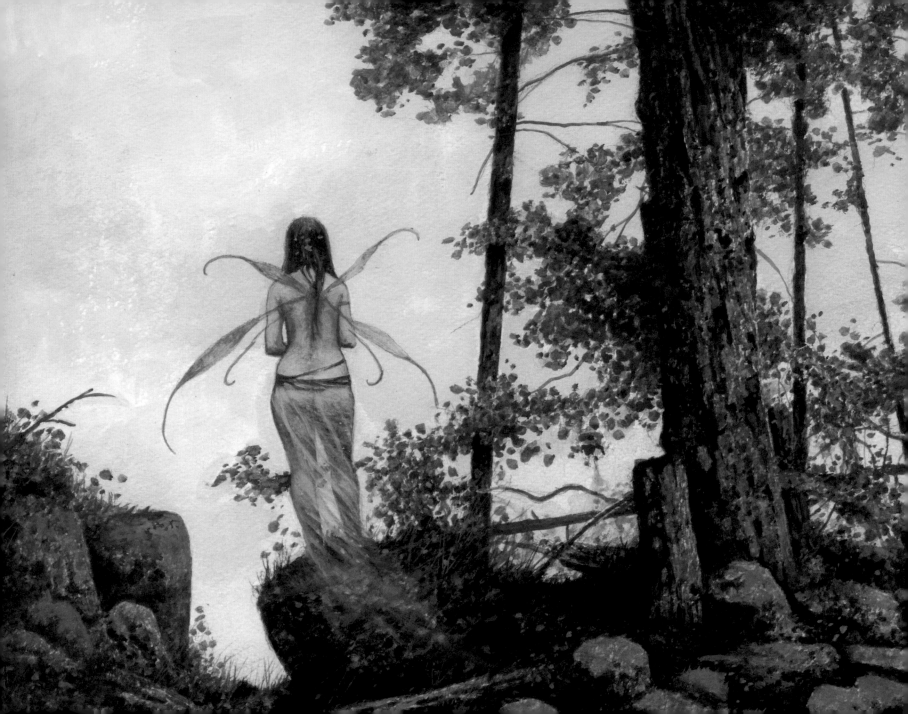

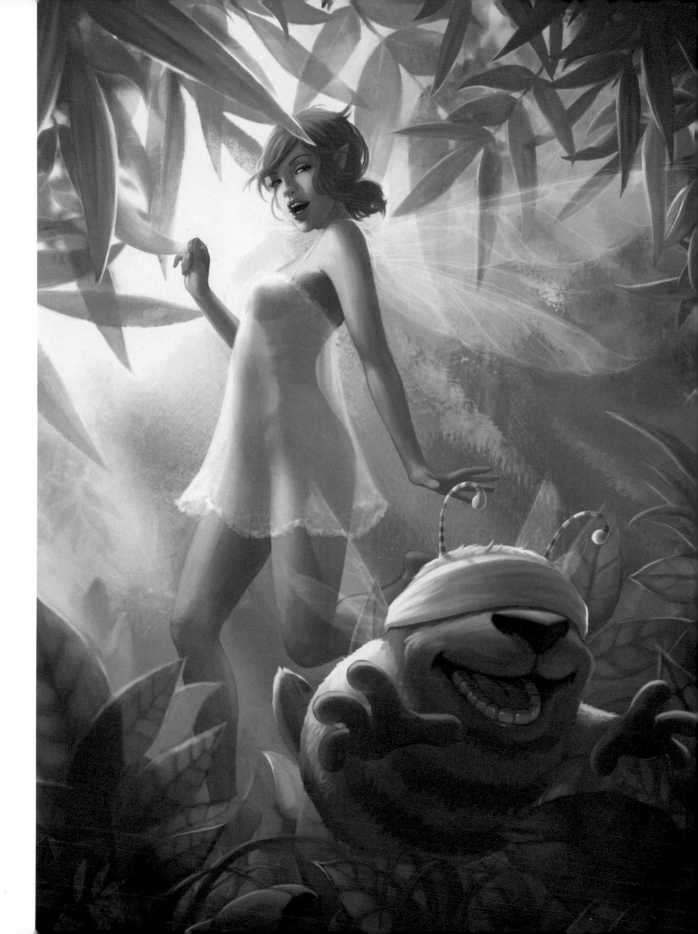

**◄ Wood Wink**
*Larry MacDougall*
Personal work
Watercolor and gouache
*www.mythwood.blogspot.com*

*"The Wood Wink is standing on the edge of an escarpment, looking off into the distance. I see her as like a firefly, just kind of blinking on for a second and then vanishing, and winking on again a short distance away. Hence the name. Painted in watercolor, then tweaked and tightened with gouache, the color is played down to enhance the mood and satisfy my desire to pay homage to two of my favorite illustrators — Arthur Rackham and John Bauer."*

**► Blindman's Bluff**
*Daniela Uhlig*
Personal work
Adobe Photoshop
*www.du-artwork.de*

*Daniela tells us she wanted "to create a window into another funny world." Bags of expression and personality in both the fairy and the bumblebee make this piece great fun, in an image that is both sexy and innocent. There's a real mischievousness in the fairy's attempts to tiptoe quietly behind her blindfolded friend.*

▲ **Bosk Banneret**
*Ralph Horsley*
*Magic: The Gathering*
Wizards of the Coast
Acrylic
*www.ralphorsley.co.uk*

"The treefolk shaman rarely moves from his meditative position in the glade, but his avian friends keep him well informed of the whole world. Painted for the card game Magic, this image needed to read well when shown at small size. To achieve this I went for a strong, simple composition, with the key elements of the image — the bird on the branch/hand — standing out against the lightly colored backdrop."

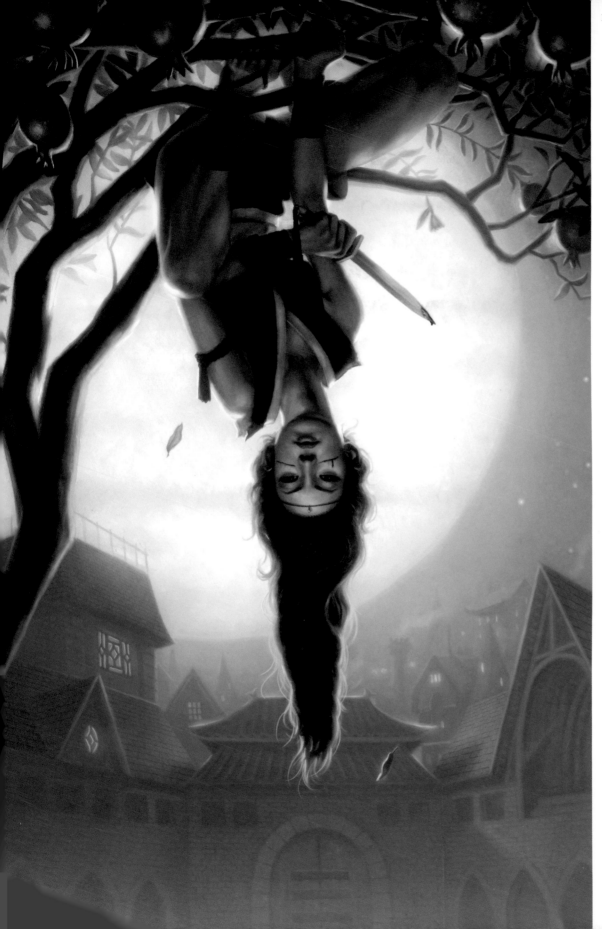

◄ **Green**
*Dan Dos Santos*
Tor Books
Oil on board
*www.dandossantos.com*

*Apart from being an effective
cover, this image is great fun too.
The playfulness of the inverted
composition is both a story
element and also creates curiosity
in the viewer. Color-wise, reds and
greens in such a muted palette
are very strong visually, being
complimentary colors.*

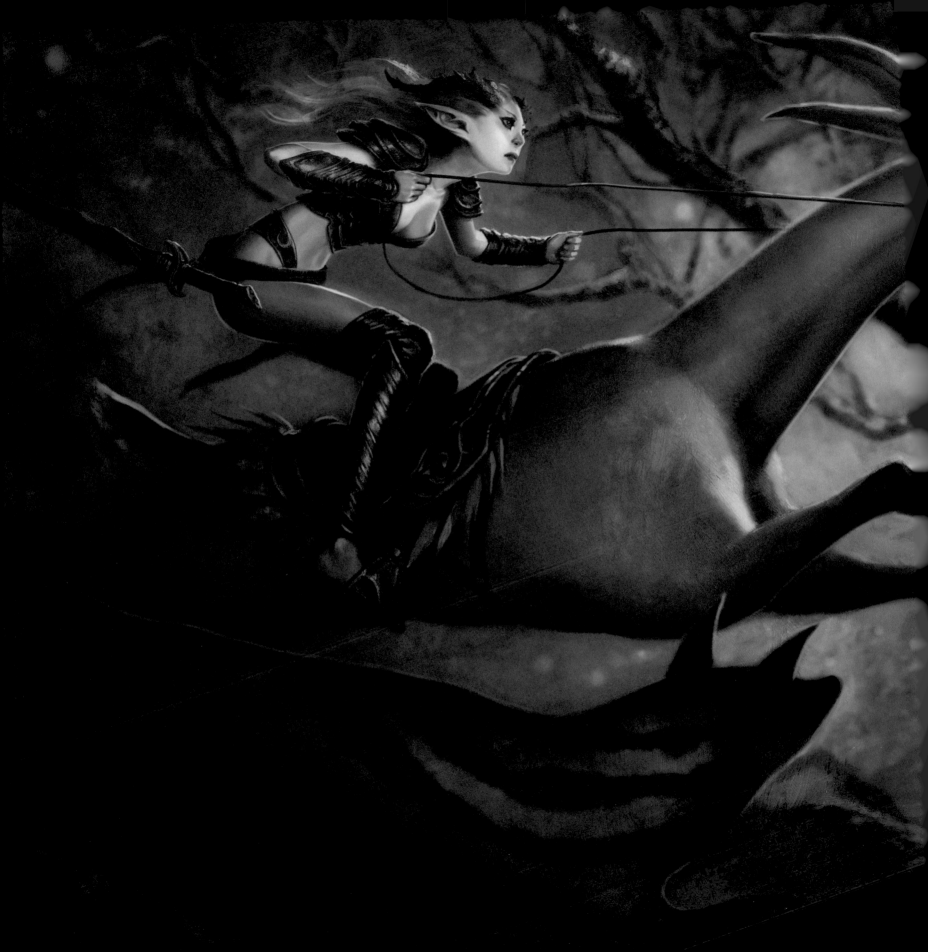

◄ **Wilt Leaf Liege**
*Jason Chan*
Wizards of the Coast
Acrylic and Adobe Photoshop
*www.jasonchanart.com*

*In this painting, Jason manages
to create an almost photographic
effect in the soft edges and depth
of field, while maintaining the
fantasy and stylization that
permeates his work. To create
this effect he relies on both
traditional and digital media.
"It's half acrylic on board and
half Photoshop," he says.*

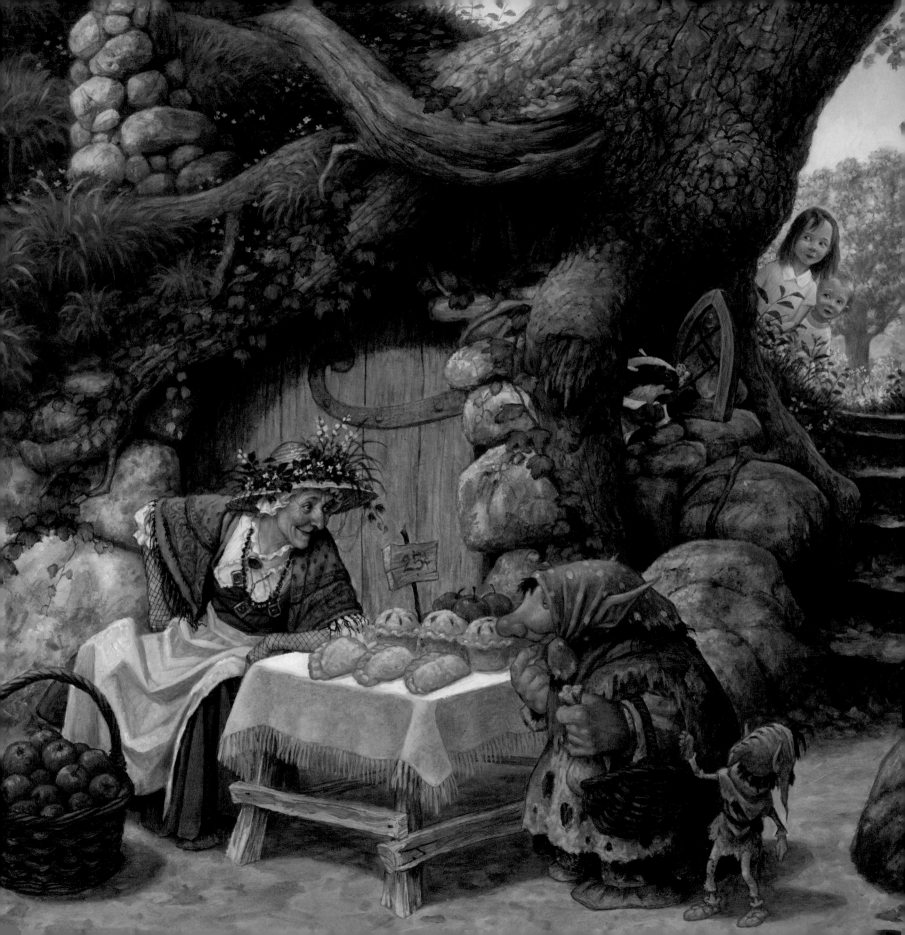

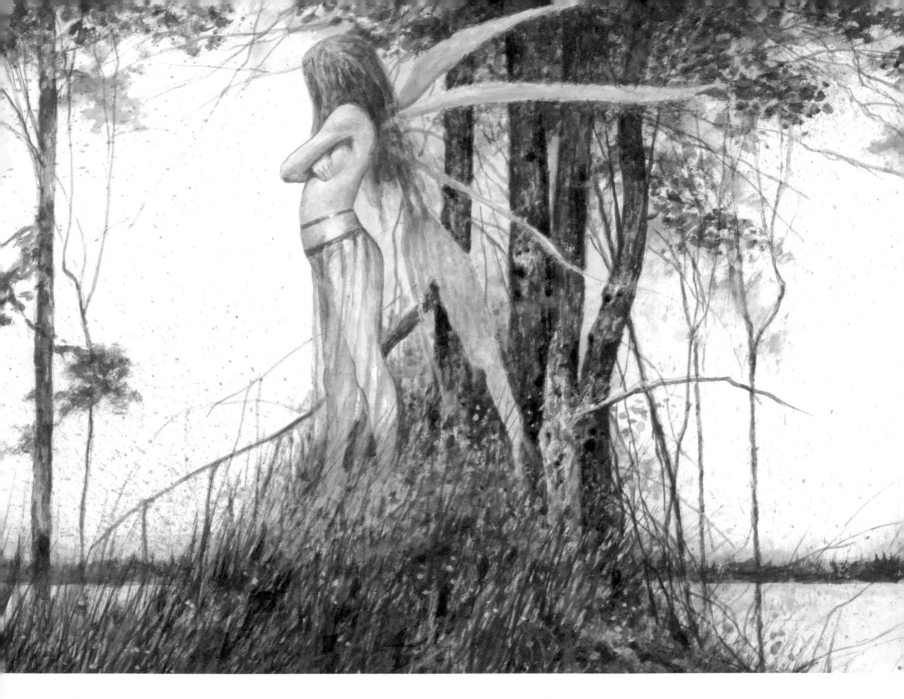

◄ **Under a Hill**
*Scott and Pat Gustafson*
The Greenwich Workshop Press
Oil on panel
*www.scottgustafson.com*

*The texture work in this entertaining image from* Favourite
Nursery Rhymes from Mother Goose, *is typical of Scott's
attention to detail.*

▲ **Rainy River**
*Larry MacDougall*
Personal work
Watercolor
*www.mythwood.blogspot.com*

*"This piece is a simple, understated watercolor in the style I prefer to
use when working for myself. It is quiet, monochromatic, and moody,
and I was completely stunned to find out it had won a Spectrum award.
It seemed so unlikely. But there you go, you can never tell what is going
to happen with a piece of art when you put it out 'there.' I've named it
Rainy River after a town in North Ontario. I haven't been there but
I love the name, it sounds so peaceful and melancholy."*

► **Summer**
*Tom Fleming*
Personal work
Pencil on Bristol
*www.flemart.com*

*"This is the fourth image
in my* Four Seasons *series
and has been nominated
for a Chesley Award."*

► **Faun**
*Julian Totino Tedesco*
Personal work
Digital
*www.totinotedesco.blospot.com*

*Produced for the joint blog,
1xSemana.blogspot.com,
where Julian and his friends
submit their interpretations
of a theme mutually agreed
upon. This was Julian's
version of the classic faun, or
"place spirit." This beautiful
variation is complimented by
the composition, which breaks
the image up into three, and
the simple muted color scheme.*

# CHAPTER 5
## LANDSCAPES

◀ **Distant Shores**
*Andreas Rocha*
Personal work
Digital
*www.andreasrocha.com*

*"This matte painting is my homage to the Arrabida Natural Park here in Portugal. The relationship between the high cliffs and the expansion of the sea is really something breathtaking. Most of the photos used here were taken there, although the final result looks quite different from the actual place."*

▶ **Acid River**
*Andreas Rocha*
Personal work
Digital
*www.andreasrocha.com*

*"Here, I was playing with rocky textures and atmospheric effects. The tiny figure in the foregound is a traveler on his way to the dwelling on top of the cliff. He gives both scale and a backstory to the image. He's thinking whether he should take a bath."*

◄ **Dark Castle**
*David Hong*
Personal work
Adobe Photoshop and ArtRage
*www.davidsketch.blogspot.com*

*"I started this one with ArtRage, which has some very good 'traditional' brush effects. I went back and forth between ArtRage and Adobe Photoshop to finish the painting."*

◀◀ **Worlds Collide**
*Ogy Bonev*
Personal work
3DS Max and Adobe Photoshop
*www.northflame.com*

*"A mechanical harvester unit caught in a deadly battle with one of the guardians of the realm. The idea here was to represent the first (and deadly) encounter between two opposing species: a mechanical self-reproducible race which invades different habitats to harvest all the resources and Ent-like forest creatures protecting their land."*

▲ **The East**
*Andy Hepworth*
White Wolf CCP North America
Corel Painter
*www.andyhepworth.com*

*"It's great to get the chance to do something a little bit different, so
having a widescreen format to play with was really fun, instead of the
usual portrait proportions. It was also nice to get the chance to work
on something huge in terms of pixels, and this was one of the first
outings for my new iMac, which didn't fail me I am pleased to say!"*

◀ **The Dragon Kytes of Baron V**
*Simon Dominic Brewer*
Portfolio work
Digital
www.painterly.co.uk

"Freedom of movement was what
I strove for here, which, when
combined with mad aliens and
madder riders, adds up to the sort
of extraterrestrial high jinx that
I believe occurs on other planets.
It makes a change from painting
battles and wars, although it
could be that these guys are
actually celebrating their latest
victory. We can only speculate."

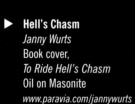

▶ **Hell's Chasm**
*Janny Wurts*
Book cover,
*To Ride Hell's Chasm*
Oil on Masonite
www.paravia.com/jannywurts

The multi-talented Janny
completed this as the cover to her
novel To Ride Hell's Chasm,
appearing on the US version of
the book published by Meisha
Merlin, and by Harper Collins in
the UK. A story of high fantasy
and demonic evil, Janny creates
convincing worlds in both her
writing and her painting.

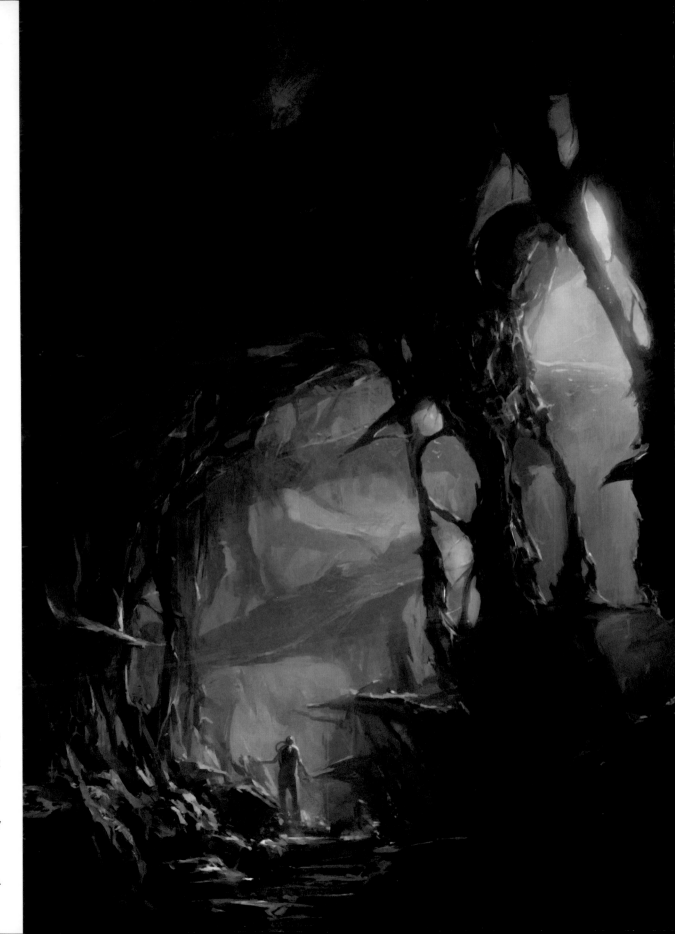

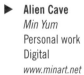 **Beacon**
*Andreas Rocha*
Personal work
Digital
*www.andreasrocha.com*

*"This was inspired by the
Croatian city of Dubrovnik.
The middle age feeling is just
so present you are almost
taken back in time. Initially
this was an attempt at matte
painting without the use of
any photographic elements,
but it ended up looking more
painterly than I wished."*

▶ **Alien Cave**
*Min Yum*
Personal work
Digital
*www.minart.net*

*Light seems to be something Min
has fun with, and no more so
than in this beautifully rendered
image. Fading-off objects and
environment to create depth is
used with great effect here, and
the viewer's focus is immediately
drawn to the lone figure by the
clever use of shadow, and light
and dark. The transparent
membranes are eye-catching too.*

◄ **Sanctuary**
*Min Yum*
Personal work
Digital
*www.minart.net*

*An astounding and hypnotizing environment from an artist at home with both characters and the worlds that they inhabit. The richness of the greens and the surreal touches are almost tangible. Min manages to keep the simple composition uncluttered despite having so much detail within it.*

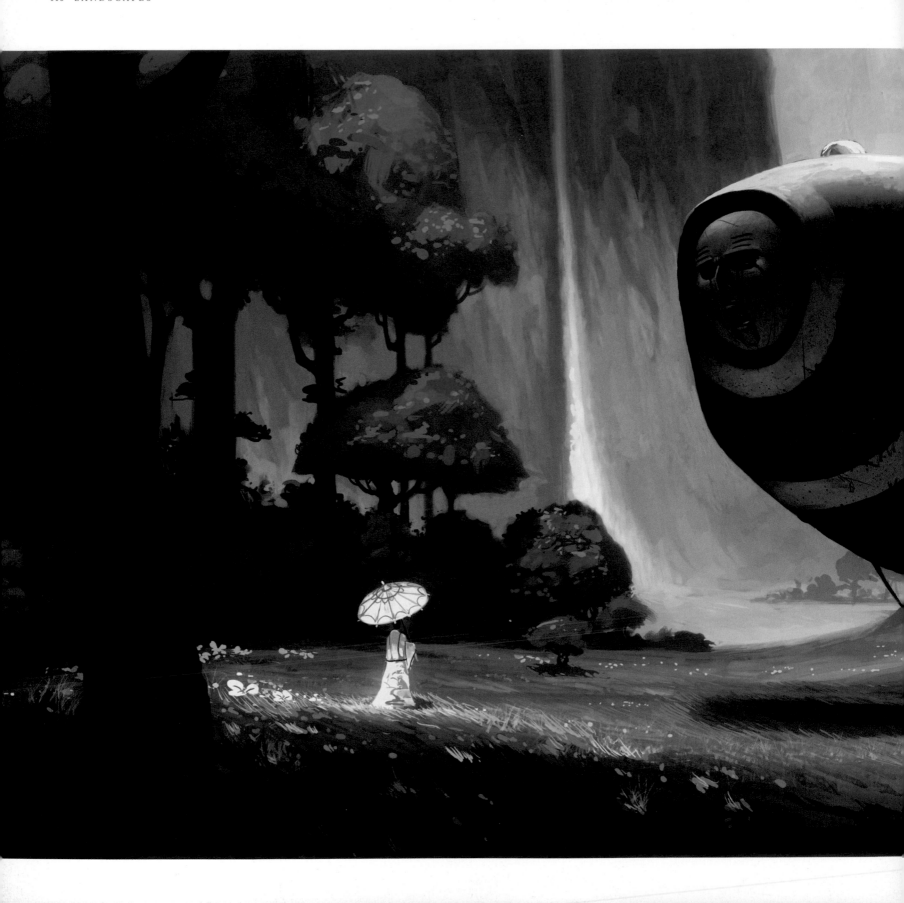

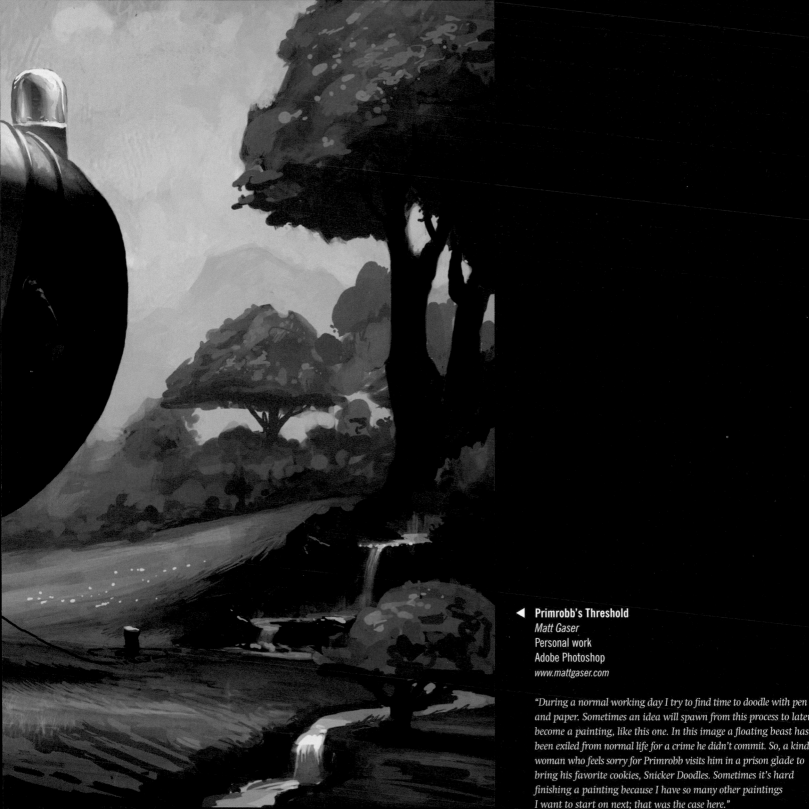

**◀ Primrobb's Threshold**
*Matt Gaser*
Personal work
Adobe Photoshop
*www.mattgaser.com*

*"During a normal working day I try to find time to doodle with pen
and paper. Sometimes an idea will spawn from this process to later
become a painting, like this one. In this image a floating beast has
been exiled from normal life for a crime he didn't commit. So, a kind
woman who feels sorry for Primrobb visits him in a prison glade to
bring his favorite cookies, Snicker Doodles. Sometimes it's hard
finishing a painting because I have so many other paintings
I want to start on next; that was the case here."*

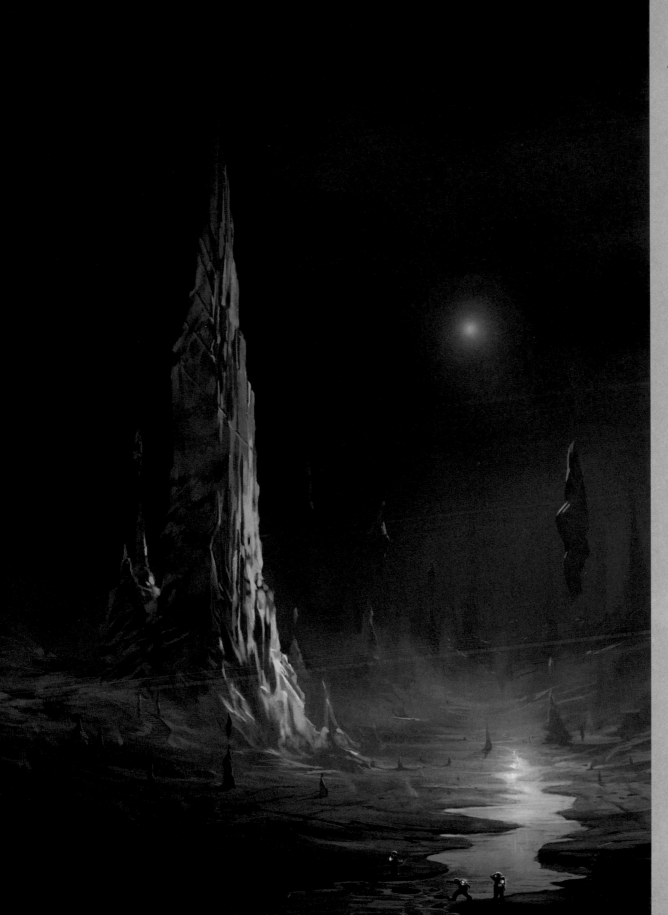

**Expedition**
*Emrah Elmasli*
Personal work
Digital
*www.partycule.com*

"This is a personal, sci-fi
environment concept. Three
astronauts are exploring
an alien planet," explains
Emrah. This piece harks back
to the vivid colours of '60s and
'70s sci-fi art, brought up to date
with the tight rendering and
control of digital art techniques.
Emrah has great control of
color and his images always
pack a punch.

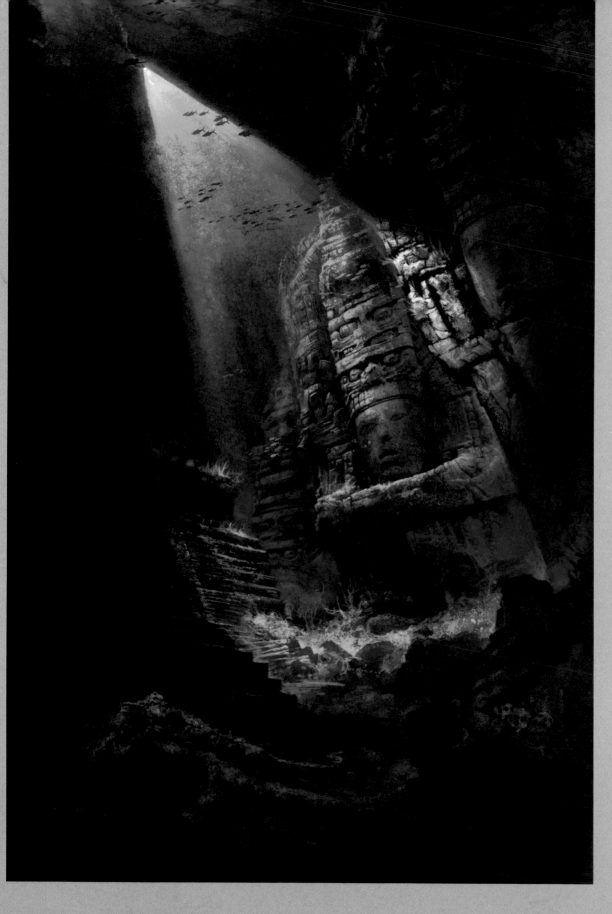

◀ **Dive Deep**
*Jeff Haynie*
Personal work
Digital
*www.jeffhaynie.com*

"I've always been fascinated with underwater lighting. The idea of exploring for sunken treasure is very exciting. The underwater environment with dancing water highlights on the bottom surface is so magical and full of energy. This concept painting started as an idea of a sunken Atlantis except with Mayan/Aztec architectural influences. The scene depicts the actual moment of discovery of a great find. But it's not without hidden dangers; it seems others have tried to explore before without success. The texture was created with a rock texture brush made from rock photo samples. It gives the surface a more painterly feel."

◀ **Troll Hunters**
*Chris Beatrice*
Titled Mill Entertainment
Corel Painter
*www.chrisbeatrice.com*

*"This is the title screen for the
game Hinterland. The image
uses two different lighting
schemes, underscoring the
contrast between the safe and
comforting village versus the
dark and scary forest that the
adventurers are heading into.
This meant a really compressed
value range to work with in
each section, and it was a bit
of a balancing act to get
them to work together."*

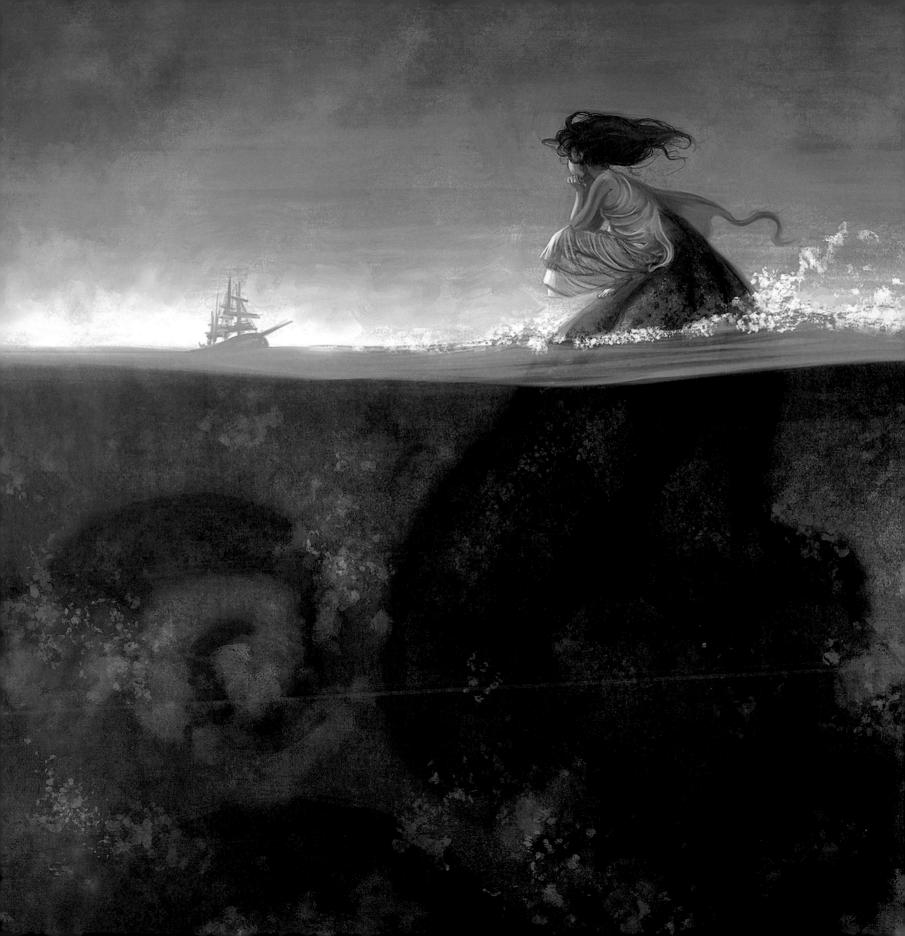

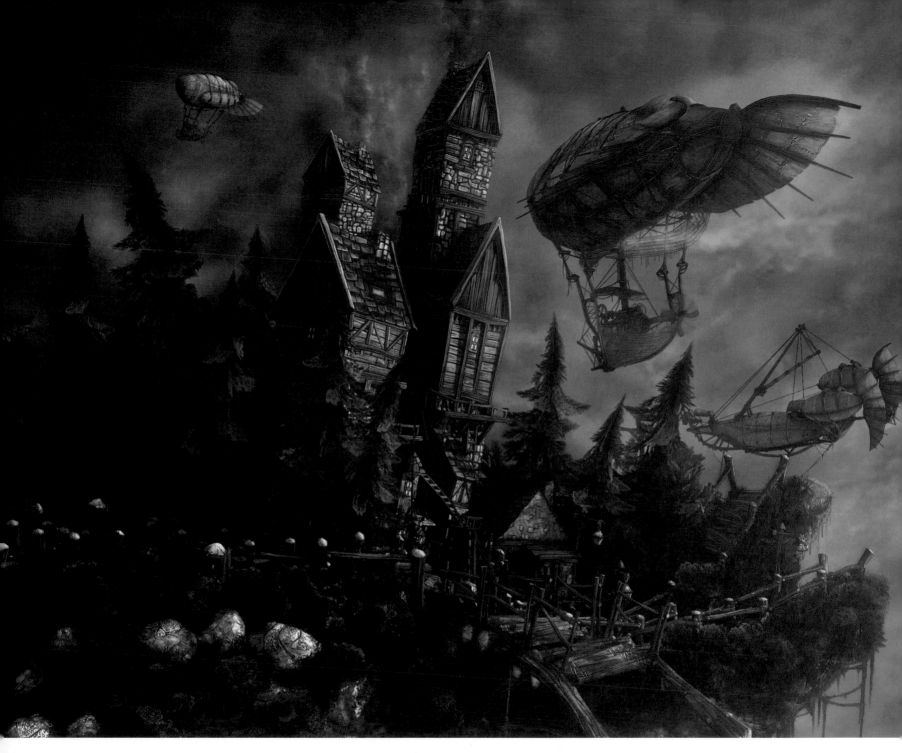

◄ **Marine Monster**
*Julian Totino Tedesco*
Personal work
Digital
*www.totinotedesco.blogspot.com*

*"I like this piece. I liked the idea of the hazard underneath
the innocence; of what is beautiful. The melancholy hidden
in that small body of the girl who waits for its prey."*

▲ **The Outpost**
*Ogy Bonev*
Personal work
3DS Max and Adobe Photoshop
*www.northflame.com*

*"A small isolated outpost, situated on a solitary mountain peak.
This image is part of a small series of fantasy-like environment
stills, most of them incorporating some steampunk elements."*

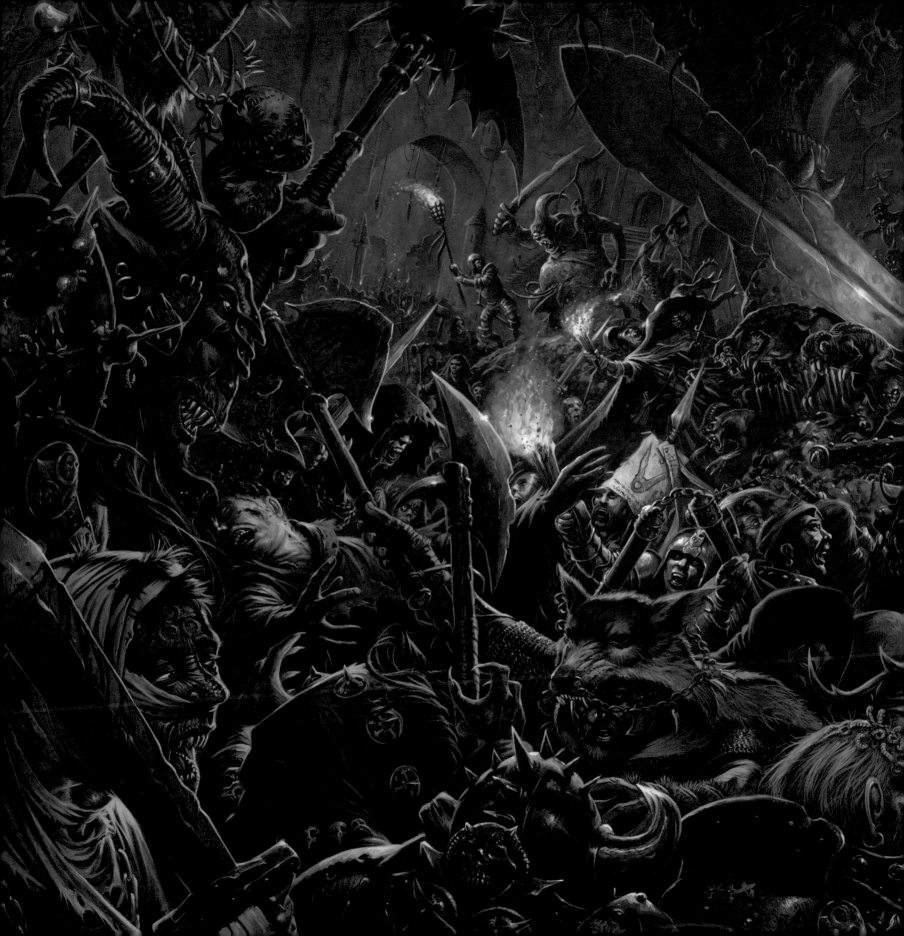

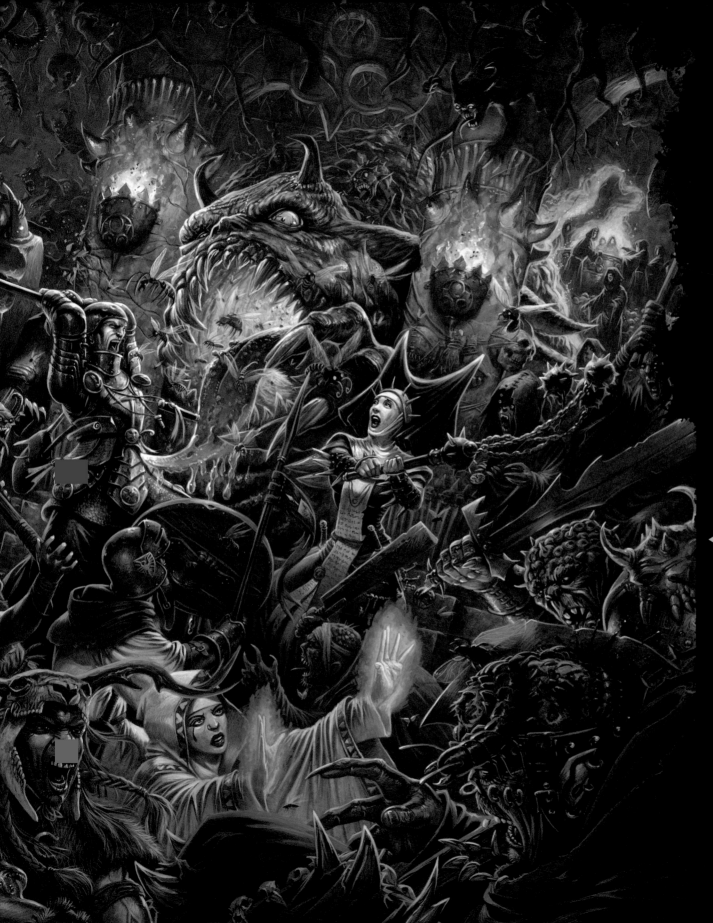

# CHAPTER 6
## BATTLES AND FIGHTS

◀ **Tome of Salvation**
*Ralph Horsley*
Book cover,
*Warhammer Fantasy Foreplay*
Games Workshop
Acrylic
*www.ralphhorsley.co.uk*

*"The forces of the Empire sweep
into an infested Chaos temple as
the cultists near the completion of
the Daemon summoning ritual.
The painting is a wraparound
book cover, which means that
both halves of the image need to
work in their own right as well
as together. To help with this I
created different focal points,
using torchlight and differing
colored magical effects. The main
point of action, the fight against
the gaping Daemon, has the most
contrast with a strong green light
against the predominant red."*

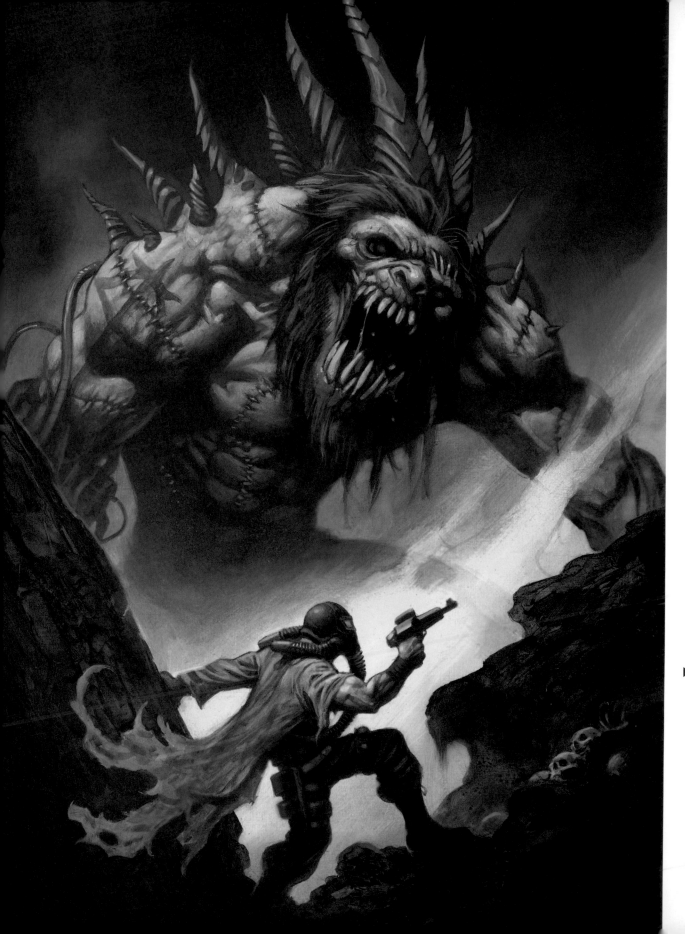

◀ **Biogiant**
*Alex Horley*
*Mutant Chronicles*
Acrylic and oils
www.alexhorley.com

*"Every year I create a special
piece for the Mutant Chronicles
Italian Club, a group of hardcore
fans who produce their own
fanzine for conventions. I always
enjoy this because there are so
many amazing characters to
choose from and I have total
freedom to pick whichever
I want, as well as to create
the scene of my choice."*

▶ **Shield Removal**
*Alex Horley*
Upper Deck Entertainment/
Blizzard Entertainment
Acrylic and oils
www.alexhorley.com

*"The nickname for this piece
is 'The Conan Orc.' I was really
inspired by Frazetta's Conan
for the composition of this one.
I wanted to capture the flavor
of the main character standing
on a ground littered with bodies
of his defeated enemies."*

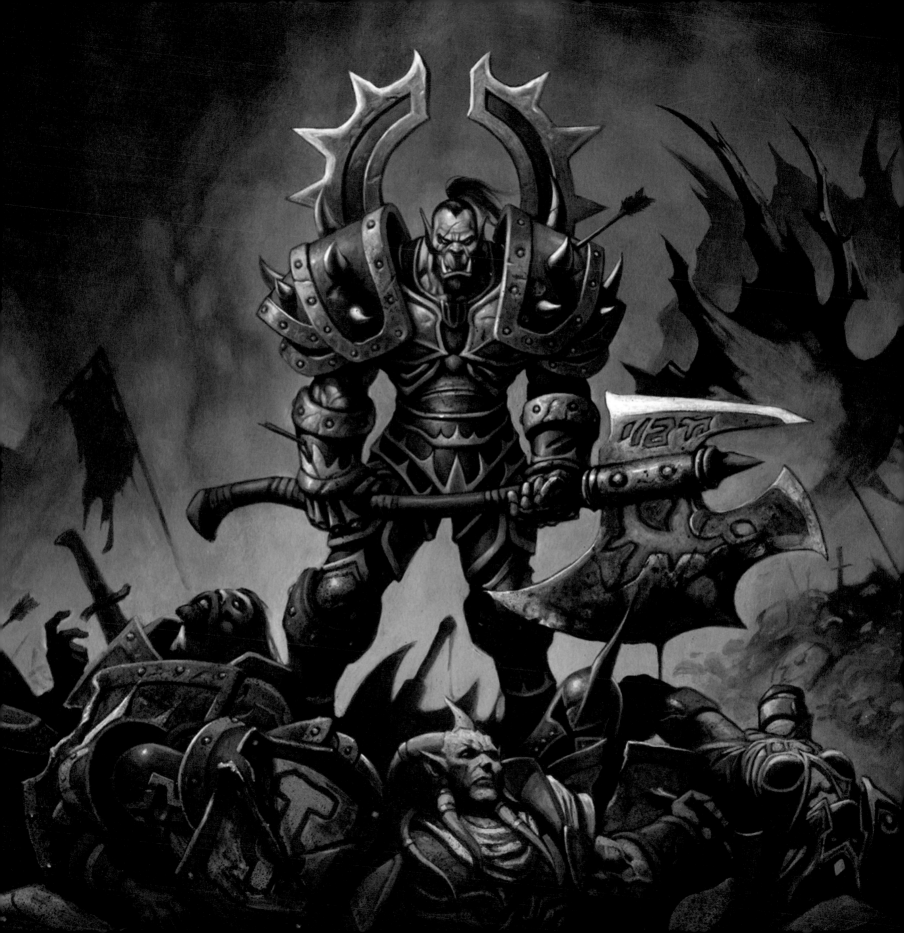

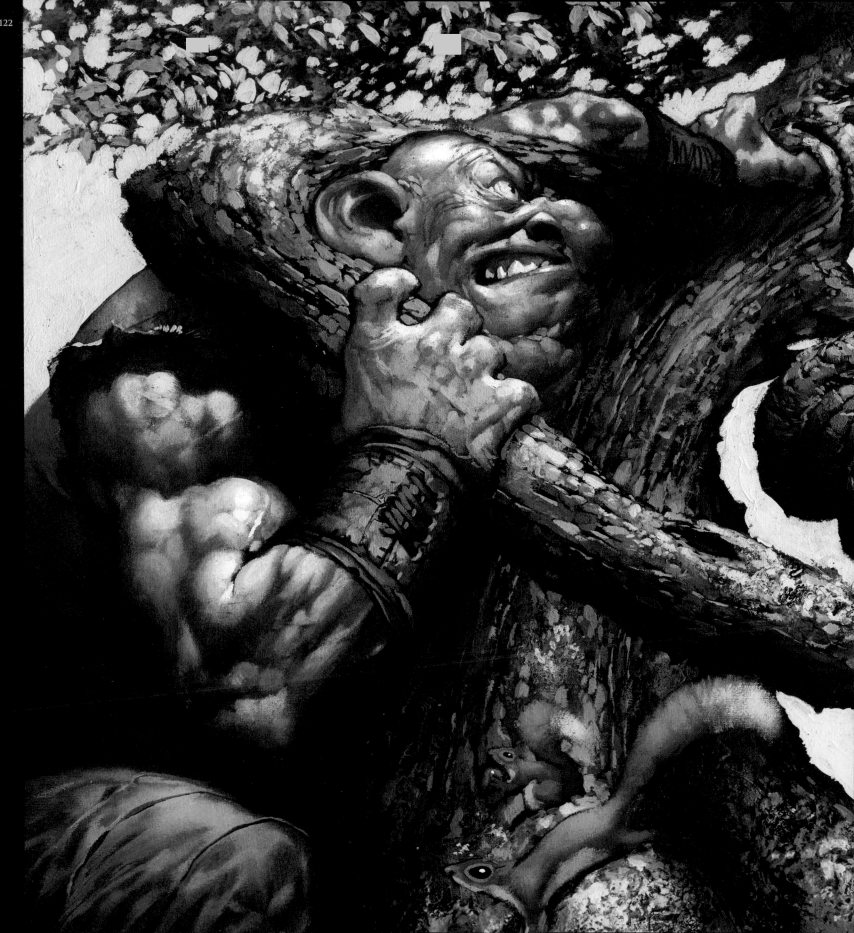

◀ **Oaken Brawler**
*Jim Murray*
*Magic: The Gathering*
Wizards of the Coast
Acrylic
*www.jimmurrayart.com*

*"This was my favorite card I did*
*for the* Lorwyn *set for Magic.*
*It was an interesting challenge to*
*come up with a wrestling match*
*between an ogre and a tree;*
*I think I went through at least*
*50 thumbnails before I settled on*
*this composition. It's always a*
*laugh to paint ogres though."*

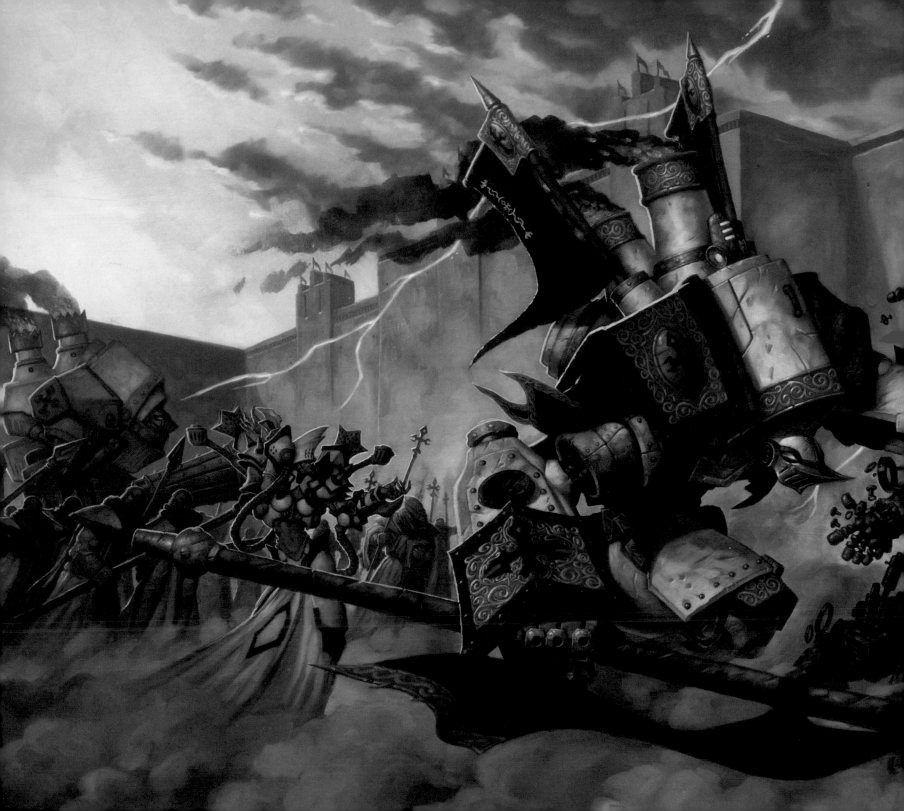

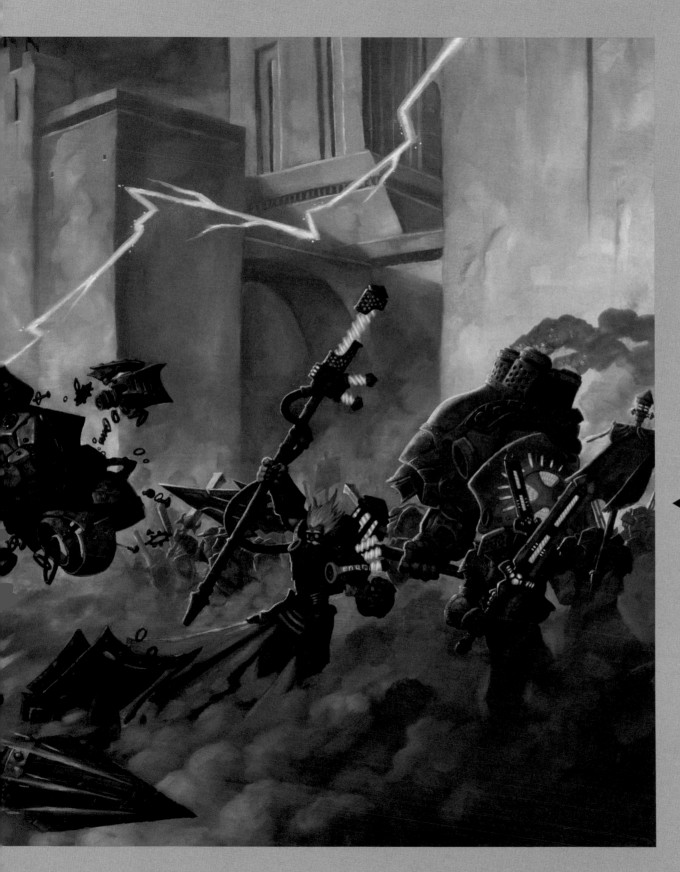

◄ **Metal on Metal**
*Matt Wilson*
Book cover,
*Warmachine: Escalation*
Privateer Press
Oil on board
*www.mattwilsonart.com*

"*Nearly four feet wide, this
painting was more an exercise
in attention-span endurance
than anything else. Painting
on a larger scale allows you to
experience the feeling of painting
in ways that you can't realize
on a smaller scale, or working
digitally. Moving mass quantities
of paint from side to side is lovely.
Unfortunately for me, I seem to
have no more ability to loosen up
on the larger stuff than I do the
smaller, so the end result is that
the larger painting just takes
exponentially longer!*"

▶ **Metamorphosis**
*Matt Wilson*
Book cover,
*Hordes: Metamorphosis*
Privateer Press
Oil on board
*www.mattwilsonart.com*

*"As of the point that I submitted
this painting, it was my most
recent work and also marks
my commitment to stop doing
complex, multi-figure battle
scenes. I've done a lot of these
crazy compositions over the
past few years, and while
they're a lot of fun to cook up,
they can be pretty taxing on
time. I'm looking forward to
concentrating on some simple
compositions in the future, with
just one or two figures — this
crazy stuff is for artists with
more time!"*

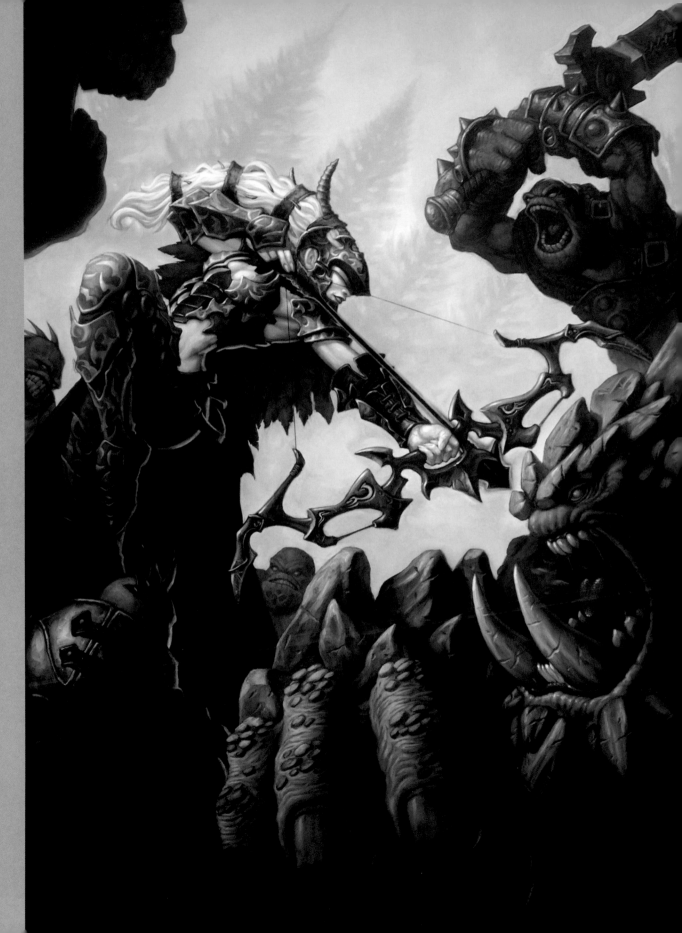

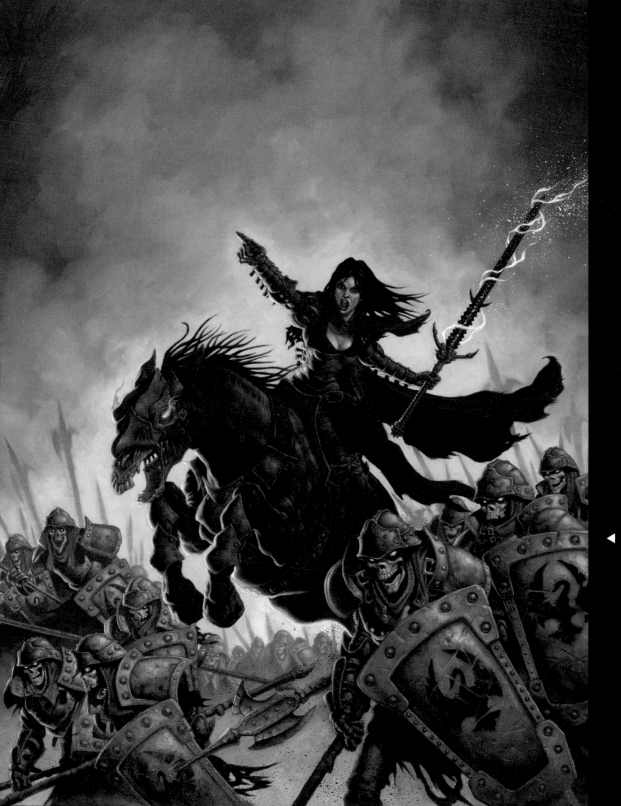

◀ **Witchfire 3**
*Matt Wilson*
Book cover, *Witchfire 3:*
*Legion of Lost Souls*
(RPG Adventure)
Privateer Press
Oil on board
*www.mattwilsonart.com*

*"You can't tell by looking, but
the character and army featured
in this painting are actually the
good guys. Sure, the girl (Alexia)
is a little off her keel, but it has
more to do with the sword that
she's carrying — it makes her
crazy and it also raises up that
undead army. But it's all for the
greater good!"*

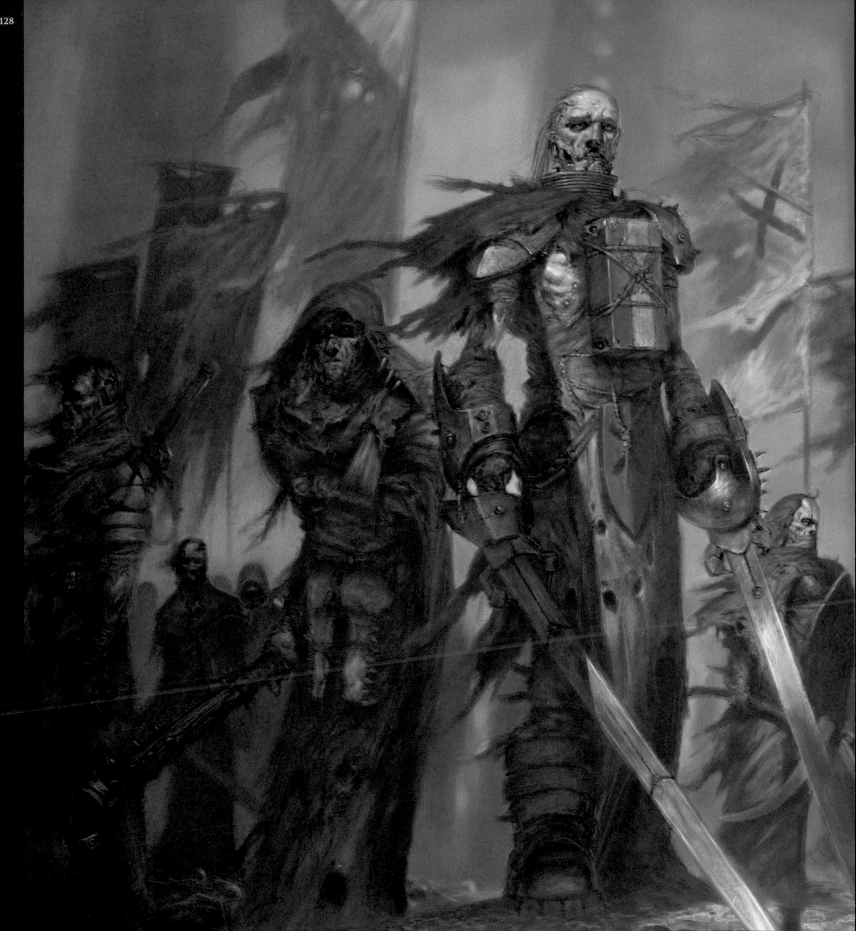

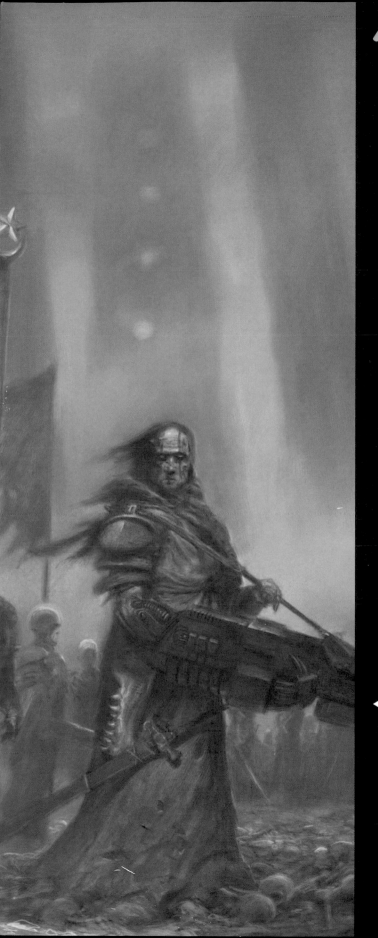

◀ **Leper Uprising**
*Adrian Smith*
Personal work
Corel Painter
*www.adriansmith.co.uk*

"I've always had a leaning
toward the darker side of
fantasy. The thought behind this
piece was a leper colony which
had had enough of being ignored
and ill-treated and decided to
rise up against their oppressors."

► **Farm Attack**
*Chris Beatrice*
Titled Mill Entertainment
Corel Painter
*www.chrisbeatrice.com*

*"This is a concept image for a game called* Hinterland, *where you build a small medieval, fantasy village in a hostile region on the edge of the kingdom. The emphasis is on the mundane elements typically overlooked in grand fantasy — livestock; farmers fighting to defend their homes with their simple tools; and an ogre, whose only goal is to make off with some tasty morsels and a keg of ale!"*

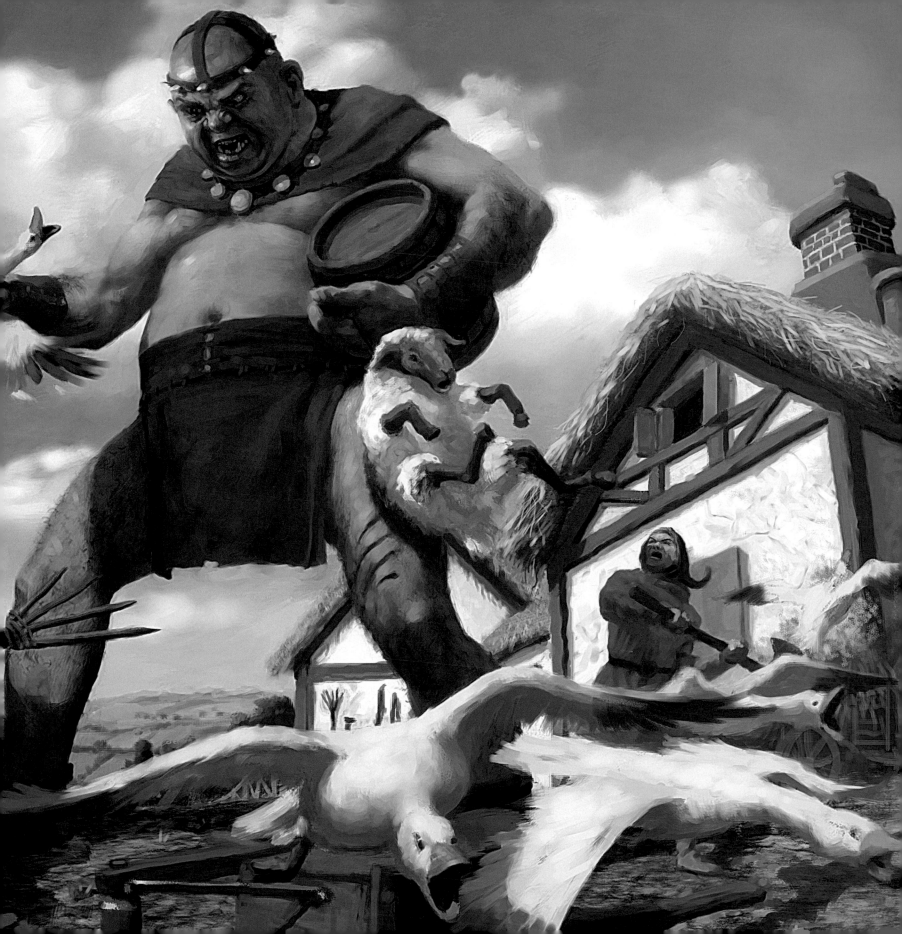

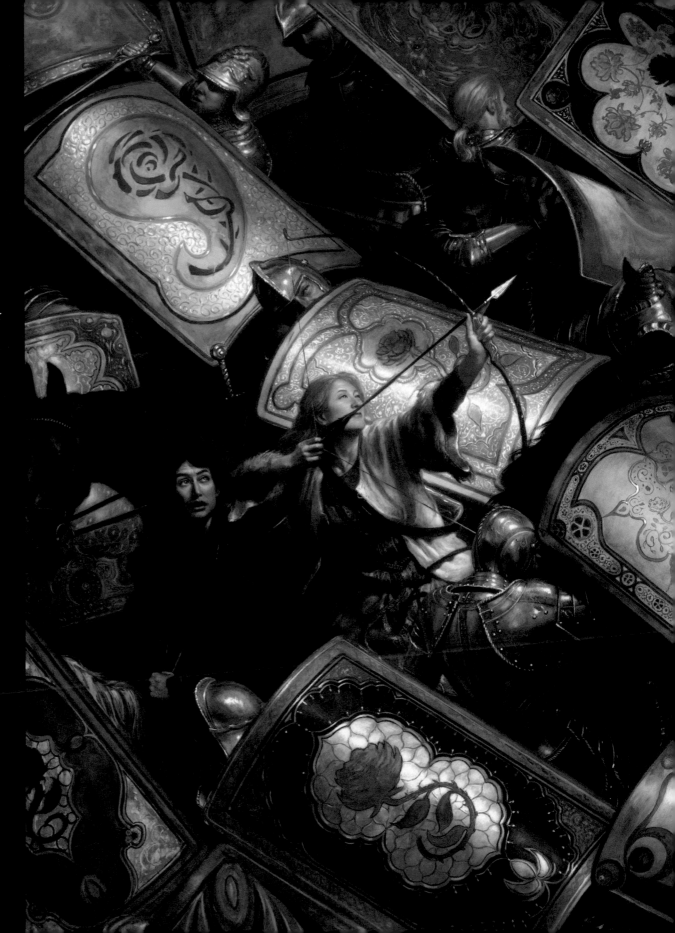

► **Archer of the Roses**
*Donato Giancola*
Book cover,
*The Archer and the Rose*
Oil on panel
*www.donatoart.com*

"Although the third book in the trilogy of the War of the Rose novels by Kathleen Bryan, this was originally created for the first novel cover. This series' covers received a great deal of praise, thus I was obligated to produce a very special painting for the final book. The shield's rectilinear forms create a barrier recalling the Roman phalanx and provide a wonderful contrast for the archer to rise from the midst of. Unadorned shields seemed an easy time saving solution, but in a quest to push my skills further Persian manuscript illuminations became the inspiration for the decorations. The decision was highly labor intensive, but worth every hour in the end!"

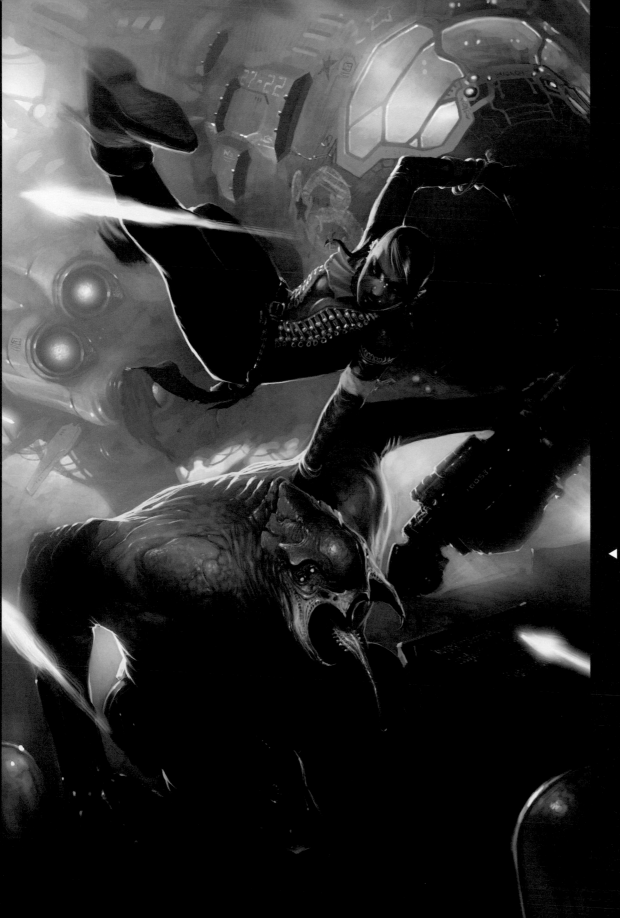

◄ **Smugglers!**
*Trevor Claxton*
Personal work
Digital
*www.trevorclaxton.com*

*"This picture was a good chance to do some sci-fi art for a change. It was originally for a character design contest on an art forum, but I have since continued to work on it for this book. Creating this kind of work is just about the only thing in this world that truly brings me happiness. The idea of being able to (hopefully) take any concept rattling around in this vacuous melon on my shoulders and be able to create and share it is a dream come true. Being able to make a living doing it is just a very fortunate side effect."*

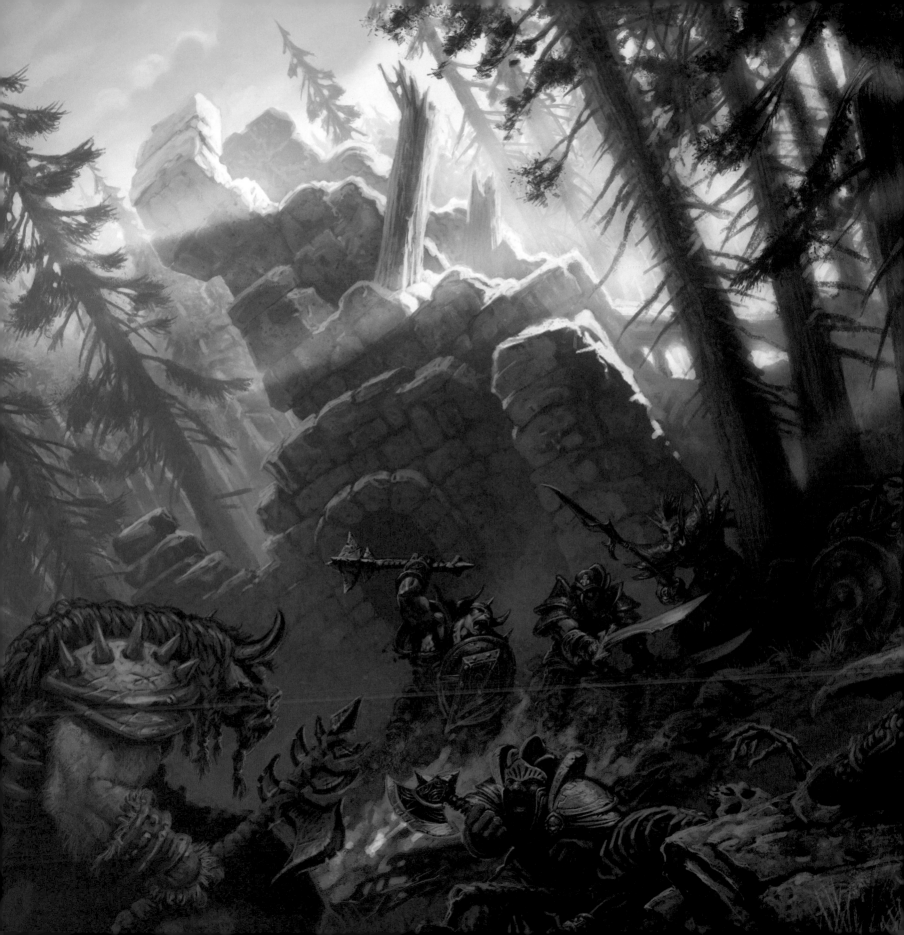

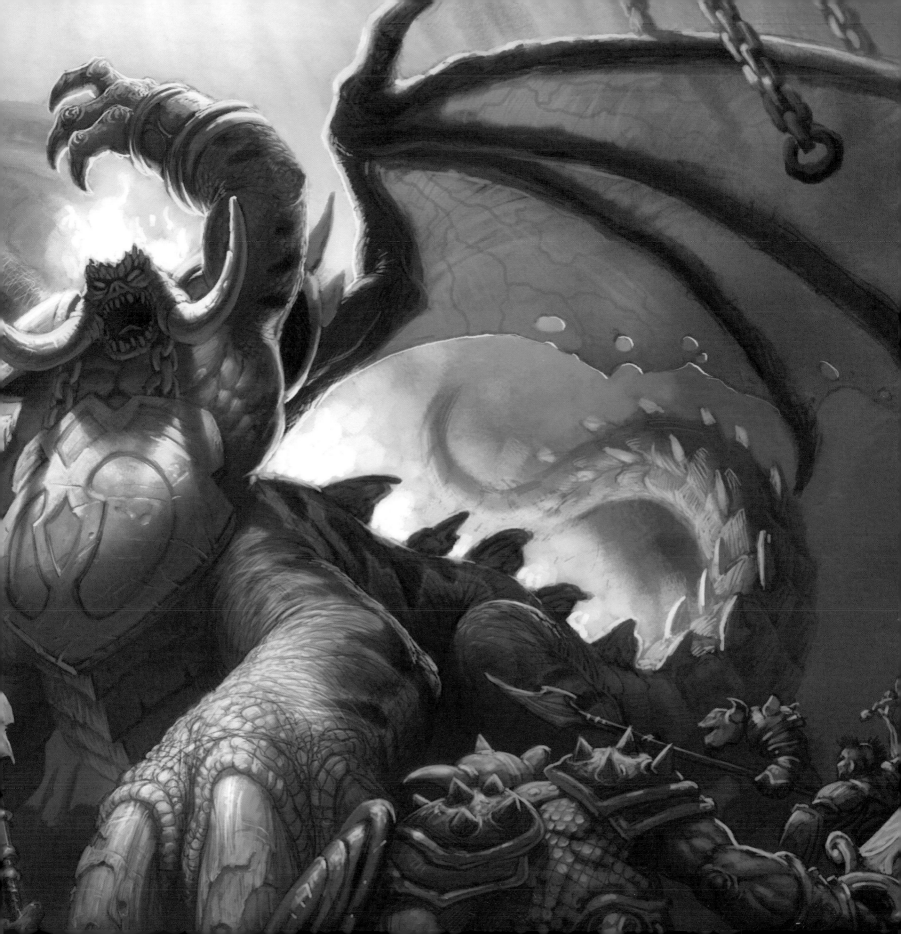

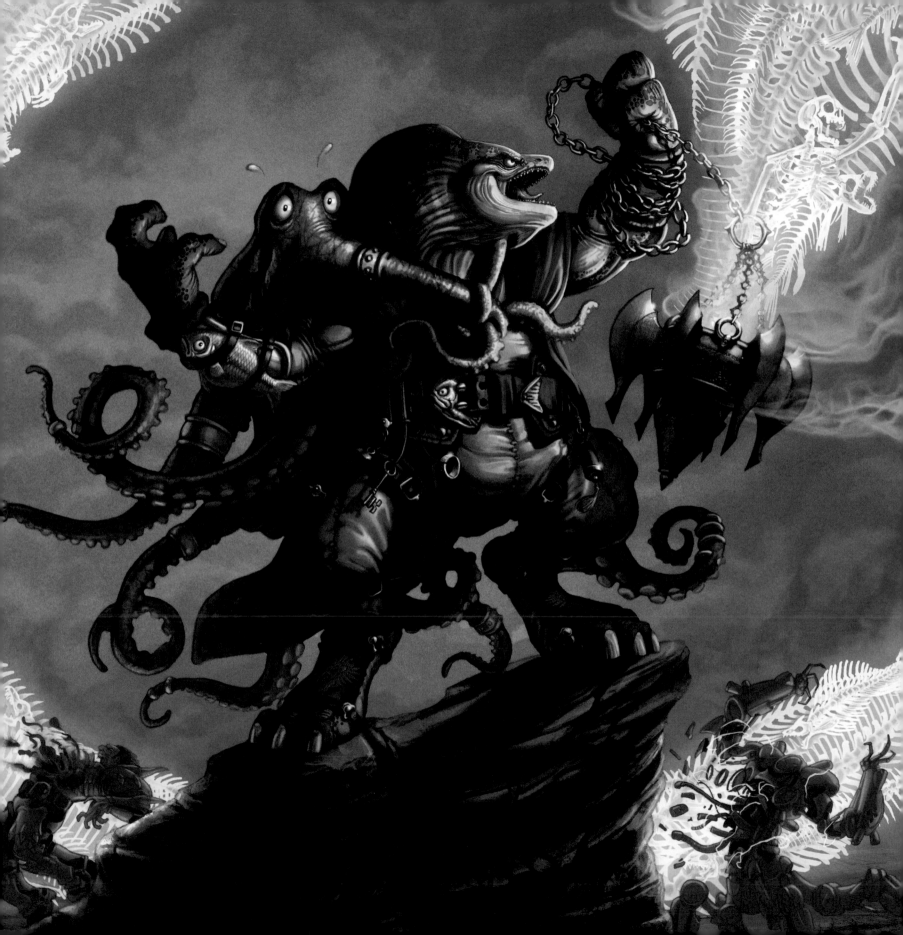

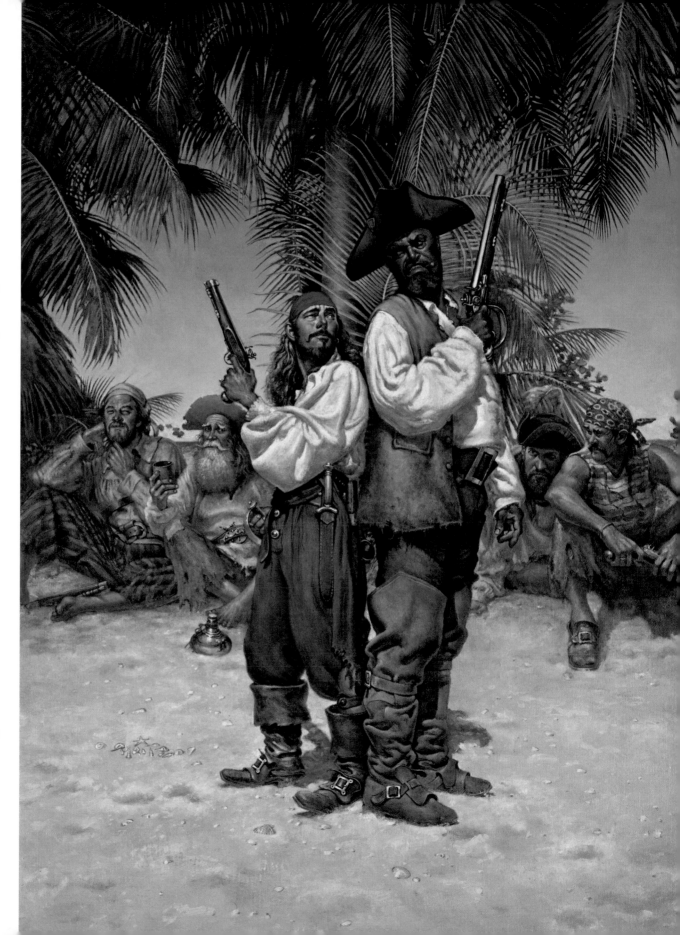

**◄ Sesslyth and Ezekiel**
*Michael Dashow*
Competition entry
Pencil and Adobe Photoshop
www.michaeldashow.com

"Sesslyth is a powerful Eel-bear
mage who uses his Pschecept to
summon the souls of creatures
who have perished in the sea.
He pals around with his friend
Ezekiel, the octopus who is seen
here hanging on for dear life.
With this, as with my other
paintings, I work in pencil, refine
the sketch in Adobe Photoshop,
trace the finished line art on
vellum, scan back into Photoshop,
and do all of the coloring there.
This piece was created for the
Dominance War III game
character competition."

**► Six Paces Turn and Fire**
*Don Maitz*
Personal work
Oil on canvas
www.paravia.com/donmaitz

"No European society during
the early 1700s was more
democratic than that of the
Sea Rovers. Each crew member
had a vote, and their status
was confirmed by ability, not
privilege of birth, religious
affiliations, or social standing.
Pirates were equal opportunity
self-employers! African slaves
were incorporated as large crews
required to simultaneously sail
and fight. As many as a third
of a crew might be captured
Africans intended to be sold into
slavery. As it was customary
to reward bravery within their
ranks, this scene might well
have occurred as crew members
worked out their squabbles and
animosity by duelling ashore."

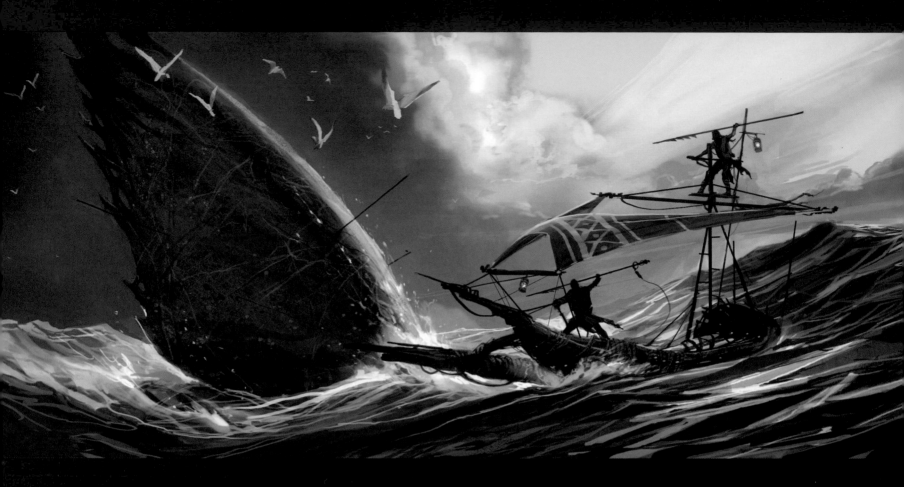

▲ **Big Fin**
*Stuart Jennett*
Personal work
Adobe Photoshop
*www.stuartjennett.com*

*"Two sailors bent on revenge
face the mighty god of the sea,"
is how Stuart describes this piece.
As usual, he's packed the action
into his painting with a flurry
of Photoshop strokes. With the
widescreen format, this seascape
takes on a cinematic feel that
draws the viewer in.*

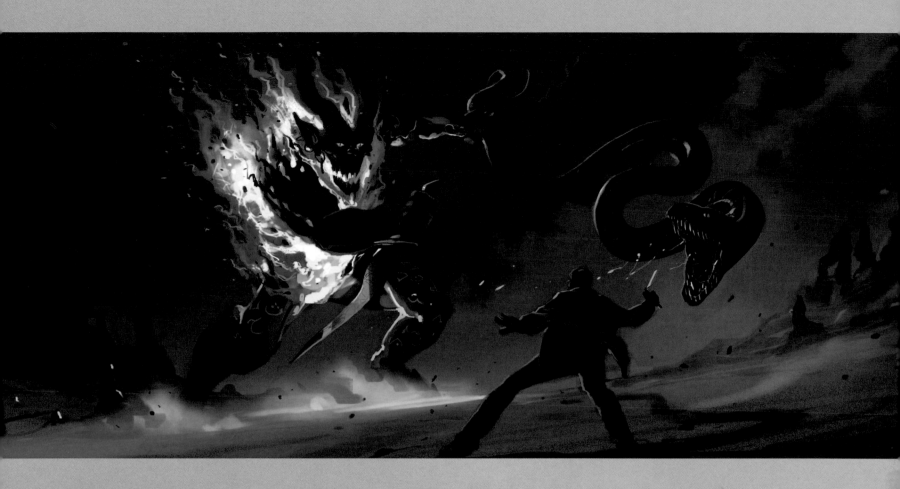

▲ **Jinn Battle**
*Stuart Jennett*
Movie pitch artwork
Adobe Photoshop
*www.stuartjennett.com*

Stuart started his career in
comics and spent a few years
working in-house for some major
UK companies, before going
freelance and providing concept
art for games and film. His
digital work often draws from
comics, games, and film, and
is almost always full of drama,
color, and movement. "Here, the
Jinn, a smokeless demon, faces
the hero of the story within his
own evil realm."

◀ **Battle Looming**
*David Hong*
Personal work
Adobe Photoshop
*www.davidsketch.blogspot.com*

*David creates beautiful
atmospheric work in Photoshop
and explains: "I have tried to
capture the brooding intensity
before the battle. I started several
compositions before I picked one
to finish."*

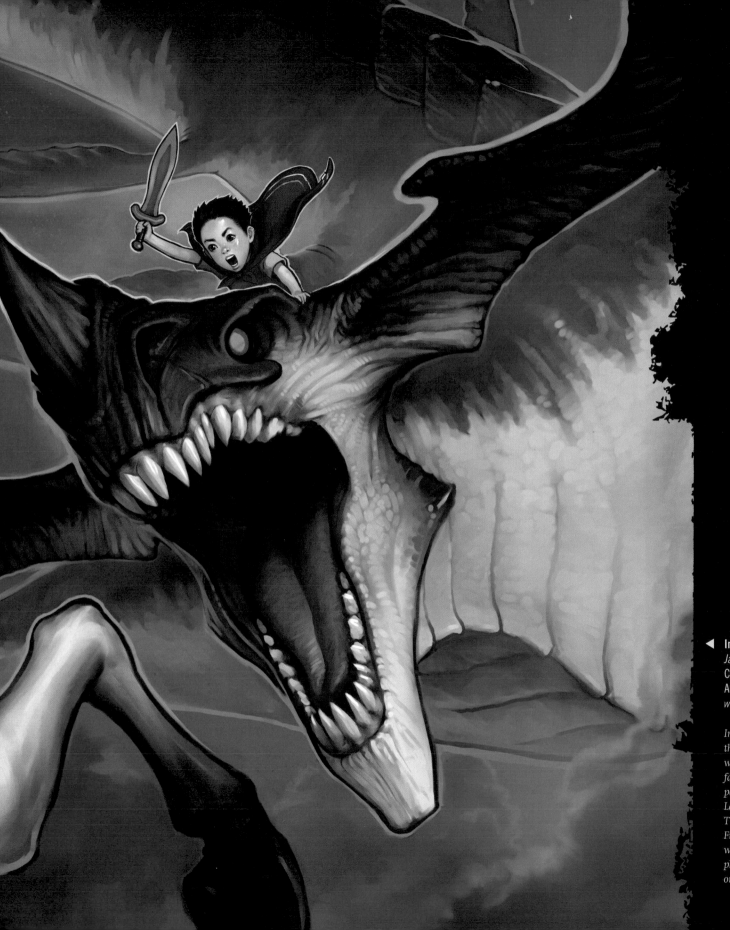

◄ **Imagine**
*Jason Chan*
Competition entry
Adobe Photoshop
*www.jasonchanart.com*

*In this piece Jason taps into the mind of every small child who dreams of flying aboard fantastical creatures; "This was painted for ConceptArt.org's Last Man Standing contest. The theme was 'Imaginary Friend.' I was inspired by the way my siblings and I used to play as kids, relying heavily on our imaginations."*

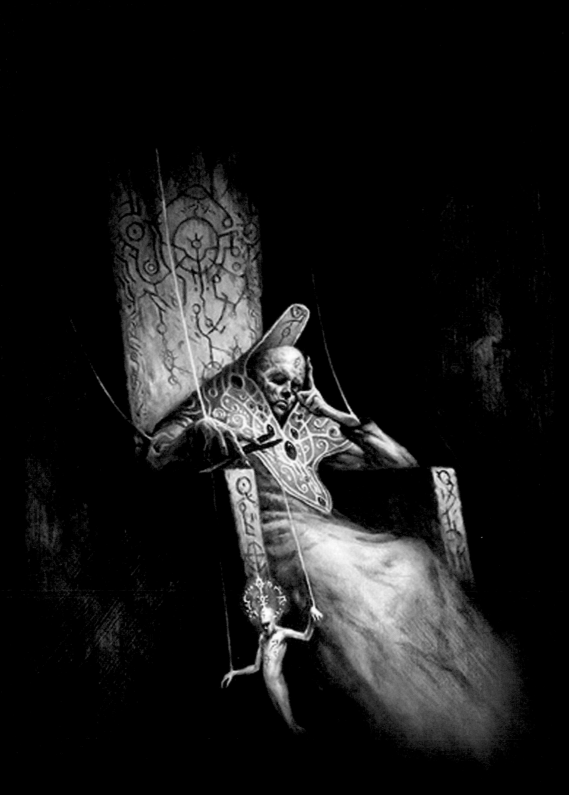

◀ **The Seer of the Throne**
*Michael Ryan*
White Wolf
Oil on Masonite
*www.michaelryanart.com*

"The Seer of the Throne *is
part of a series published by
White Wolf. A dark manipulator
is controlling the downtrodden
masses, and yet he himself
is just a puppet.*"

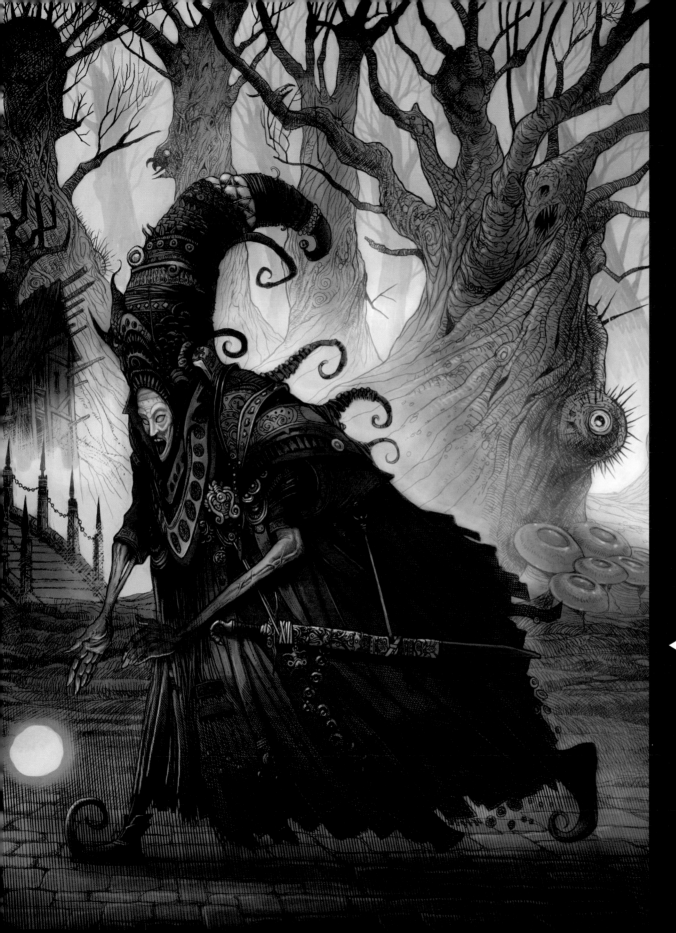

◄ **Globechaser**
*Sean Andrew Murray*
Personal work
Pen and digital
*www.seanandrewmurray.com*

*"I started this piece a couple of years before I finished it. It was one of those things that I started, lost interest in, then returned to over a year later while combing through some of my old images looking for inspiration. This is the first piece where I attempted to recreate my line-hatching technique from back when I used nib-pens and rapidographs."*

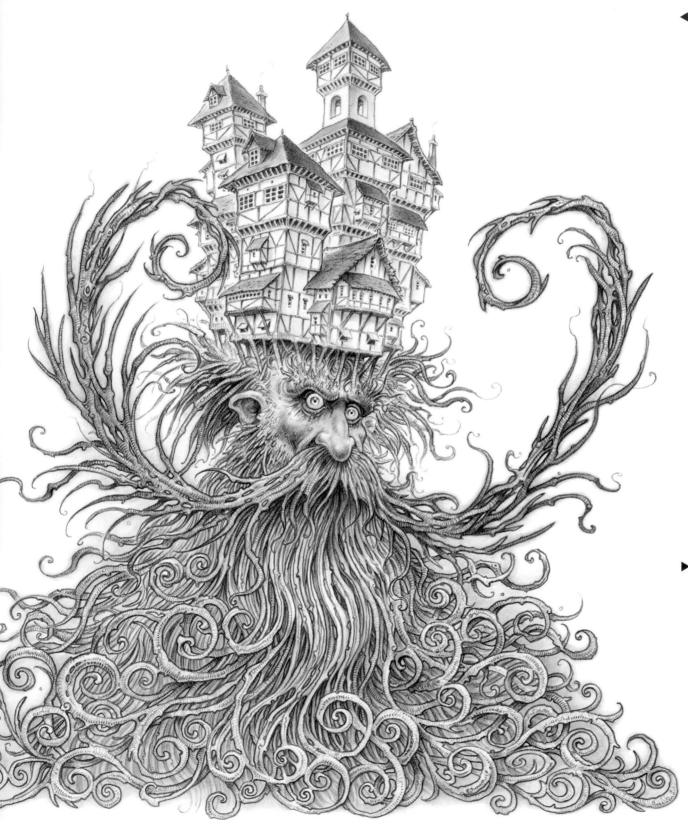

◀ **Humphli Pumphli**
*Douglas Carrel*
Personal work
Pencil
*http://community.imaginefx.com/
fxpose/hethabyrs_portfolio*

*"This crusty old carbuncle is one
of the Thulian Giants (native to
the ancient world of Cyrimbal)
who live in perfect symbiosis
with the relatively tiny 'Picky
Pocky People.' Typically, within
weeks of a Thulian's birth, the
Picky Pockies will be found
amongst the giant child's hair
follicles, busily working on what
will become an ever-growing
aggregation of dwellings. The
child's parents welcome the
arrival of the tiny builders,
knowing that the benefits will
outweigh any inconvenience.
Let's face it, to have your
every bodily orifice cleaned
and maintained, in return for
protection and assistance…
that would be an excellent
arrangement, wouldn't it?"*

▶ **The Tough Guide to Fantasy Land**
*Douglas Carrel*
Book cover for *The Tough Guide
to Fantasy Land*
Victor Gollancz
Pencil
*http://community.imaginefx.com/
fxpose/hethabyrs_portfolio*

*"One of a number of covers
produced for Gollancz, each one
allowing me a fairly free rein
to be as inventive — and pretty
much as silly — as I wanted to be,
in producing images that would
hopefully grab eyeballs and convey
the light-hearted fantasy style of
each title. Great fun to do."*

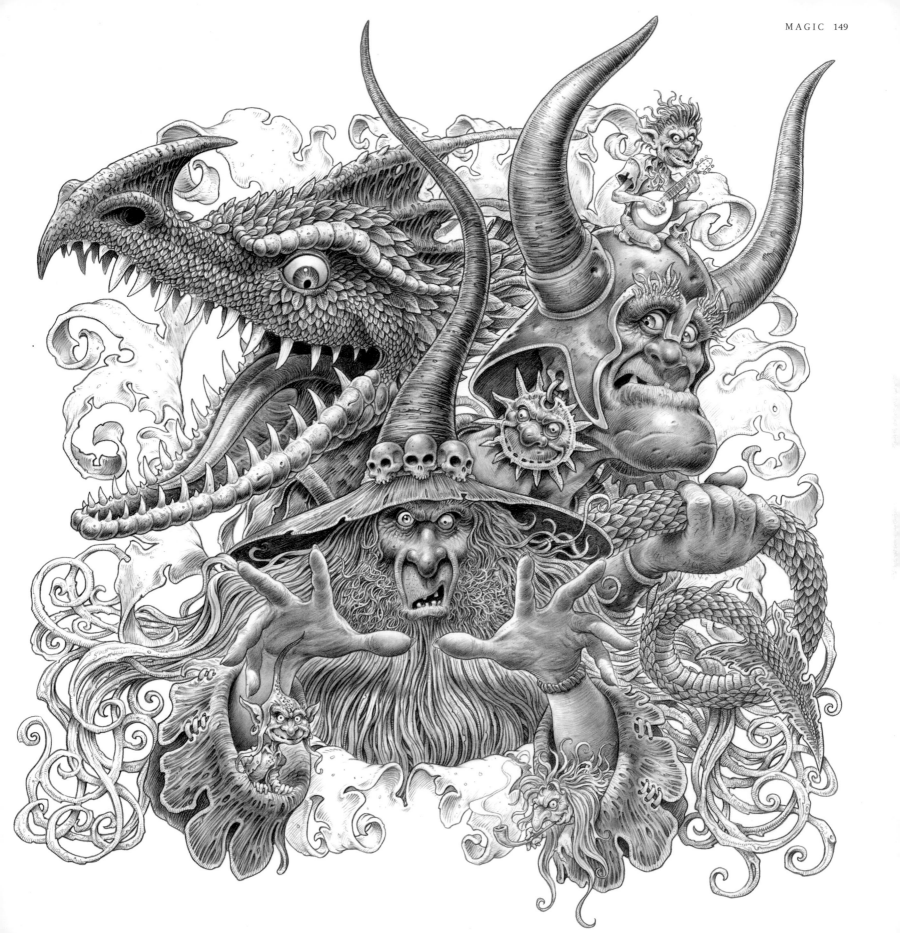

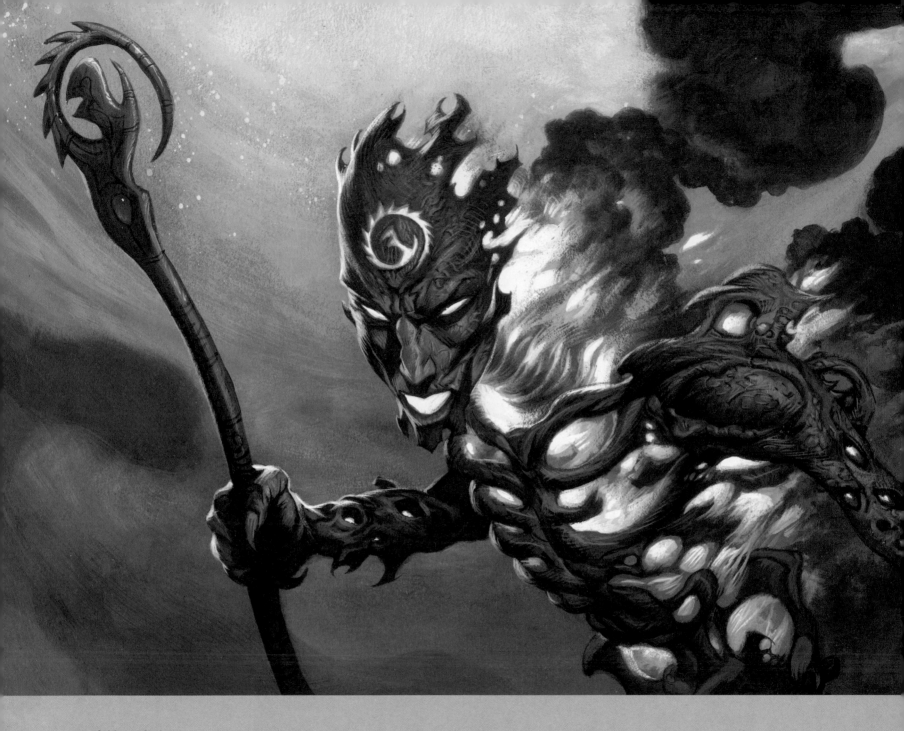

▲ **Cultbrand Cinder**
*Christopher Moeller*
*Magic: The Gathering*
Wizards of the Coast
Acrylic
*http://mysite.verizon.net/moellerc*

*"Your seared flesh will be the first step in your journey to dark
enlightenment."* Cultbrand Cinder is one of over 100 illustrations
Christopher has done for Magic: The Gathering. This character is an
Elemental, a race of warriors whose fiery souls are being extinguished.

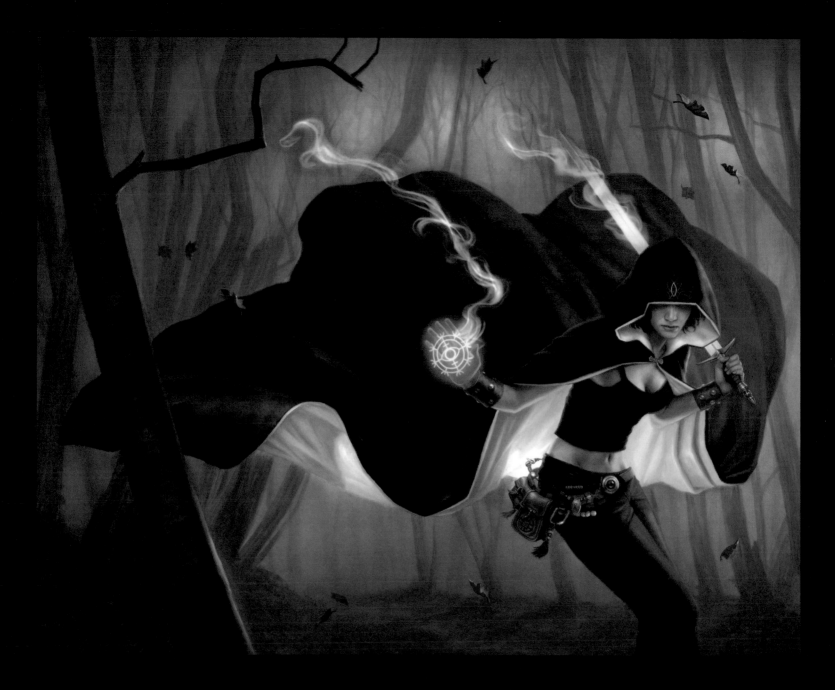

▲ **Dead Reign**
*Dan Dos Santos*
Book cover
Bantam Books
Oil on board
*www.dandossantos.com*

*The hidden face of the protagonist creates mystery in an already mysterious environment. As this is a cover, Dan would be working to instructions, but at the back of every artists' mind is also the desire to make the image stand up on its own; This is an example of how.*

▶ **Wizard's Approach**
*Don Maitz*
Personal work
Oil on Masonite
*www.paravia.com/donmaitz*

*Don presented this personal piece in his 2008 Wizards! Calendar. The image illuminates the stylish arrival of a seriously magical dude! Don says he finds painting wizards an exciting prospect. Since their abilities are only limited by one's imagination, their presentation provides limitless possibilities. Don spent time photographing the castle at Disneyworld, and invigorated the photos with additional research. He also benefits from having a theatrical retailer at a warehouse nearby, where he can rent costumes!*

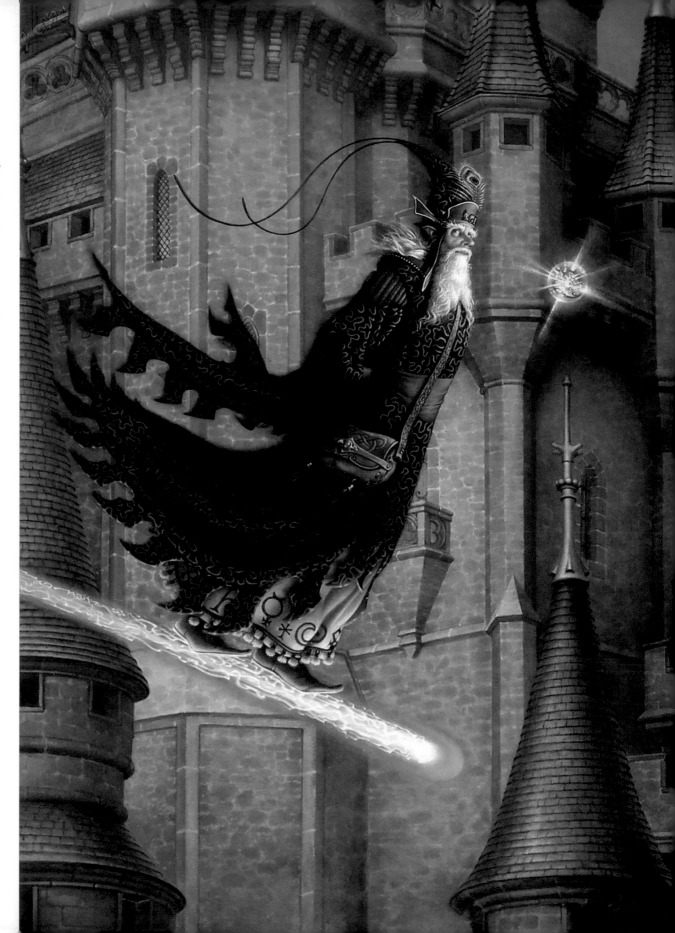

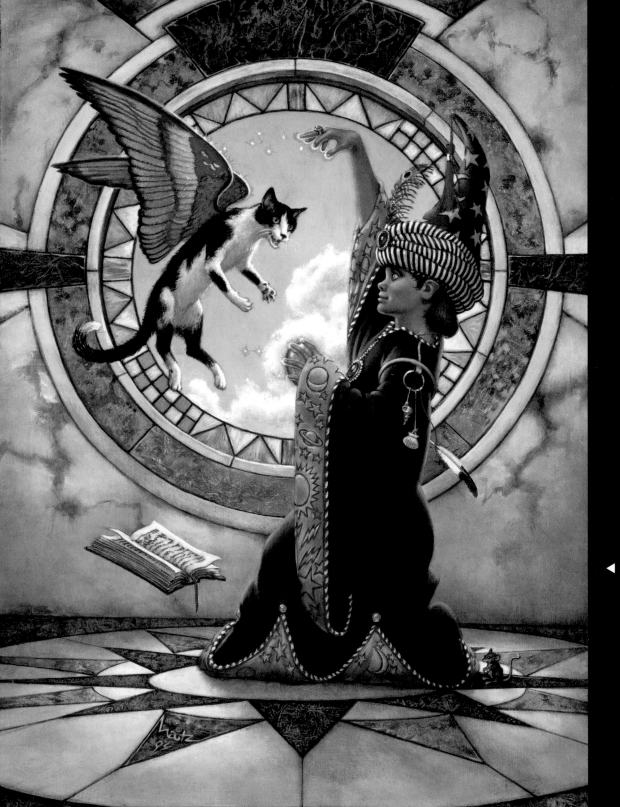

**Abracatabra**
*Don Maitz*
Personal work
Oil on Masonite
*www.paravia.com/maitz*

*A personal work featuring Don's favorite cat. First published as an art trading card for FPG. A wanna-be magician dabbles with the contents of an arcane book of spells he found, which describe using the power of a magically endowed crystal. The resulting conjury suprises the castle's cat and dismays the castle's mouse!*

▲ **The Alchemist Room**
*Ogy Bonev*
Personal work
3DS Max and Adobe Photoshop
*www.northflame.com*

"A bunch of soft, bright beams from the late afternoon winter
sun is playfully sneaking through the grated window of the old
alchemic lab, graciously eliciting its velvet warmth to all those
thick books and manuscripts, full of ancient knowledge and
forbidden secrets."

▶ **Evil Witch**
Sven Geruschakt
Portfolio work
3DS Max, Mental Ray, and Mudbox
*www.svenger.de*

"An old sketch for Disney's Snow White motivated me to create this. I was
compelled to recreate what Snow White had to face: a deceitful temptation
by a scary, evil witch. I do love creepy characters and this was a great
opportunity to sculpt my own version of a witch. My goal was to provoke
emotions from the viewer, something like fear, disgust, or fascination."

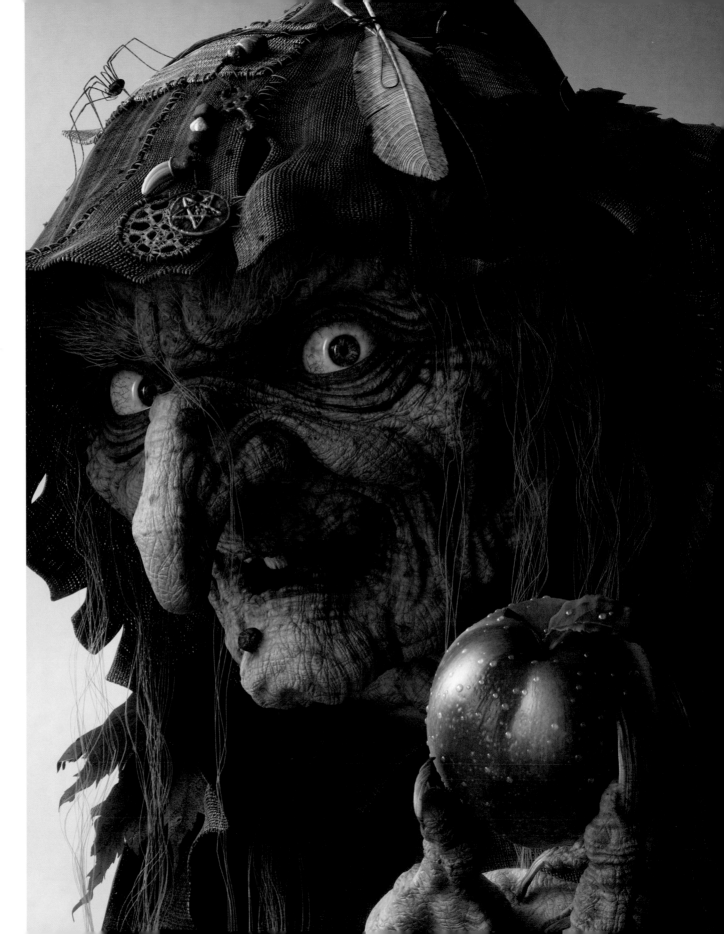

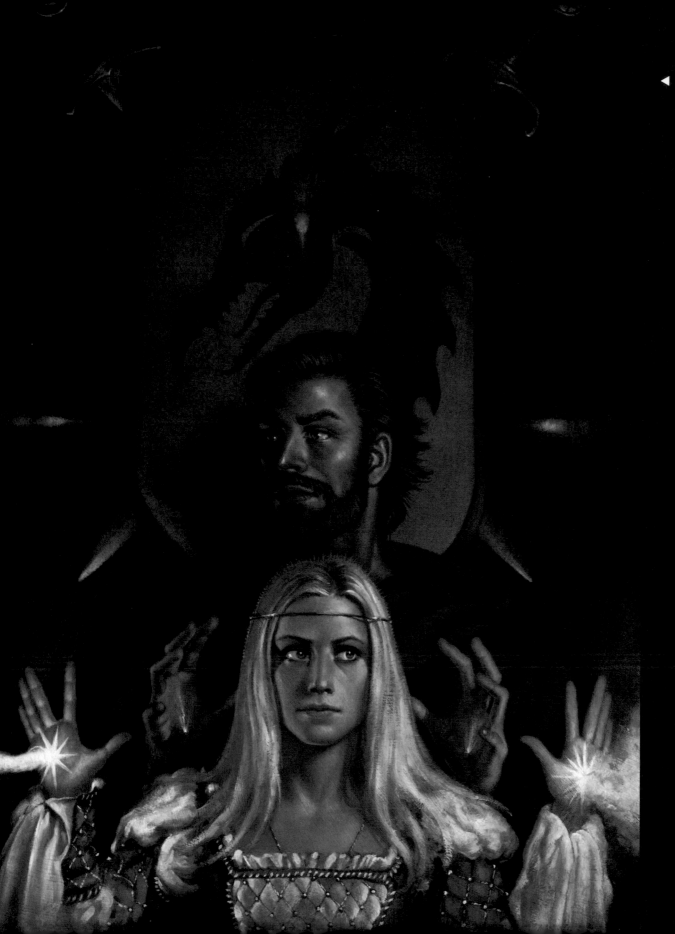

◀ **Savage Empire I**
*Don Maitz*
Book cover
Benbella Books
*www.paravia.com/donmaitz*

*A book cover from Don: a queen and her consort each have different magical powers. One has telepathic abilities, and the other controls destructive forces. When combined, their powers provide short and long range weapons to defeat the enemies threatening their kingdom.*

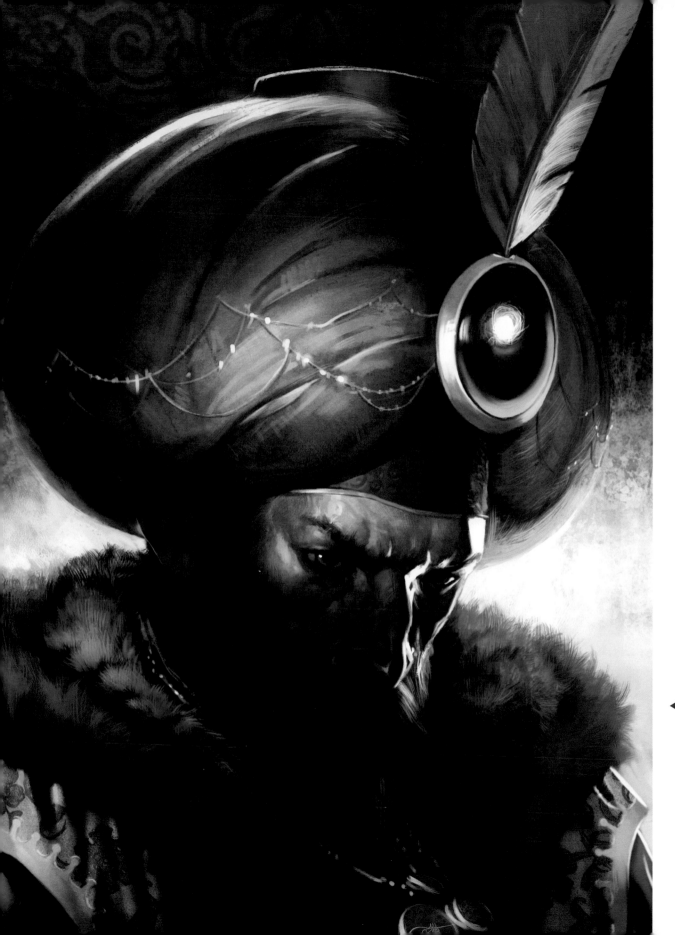

◄ **Fatih**
*Emrah Elmasli*
Personal work
Digital
*www.partycule.com*

*"This is a personal piece of
mine. It's a fictional portrait
of Fatih the Conqueror, the
Ottoman Sultan who conquered
Constantinople in 1453. I don't
think he looked like this in real life
but this is how I imagine him."*

▼ **The Apprentice**
*Jon Sullivan*
Personal work
Adobe Photoshop
*www.jonsullivanart.com*

*"This is the companion piece to another picture called* The Prophet.
*Both the holographic spheres play a large part of the story in each
picture. Here, the Apprentice hides away in a distant secret part of
the castle, immersing himself in the book of spells. In this painting
he reads about the binding power the Sphere has over its subject."*

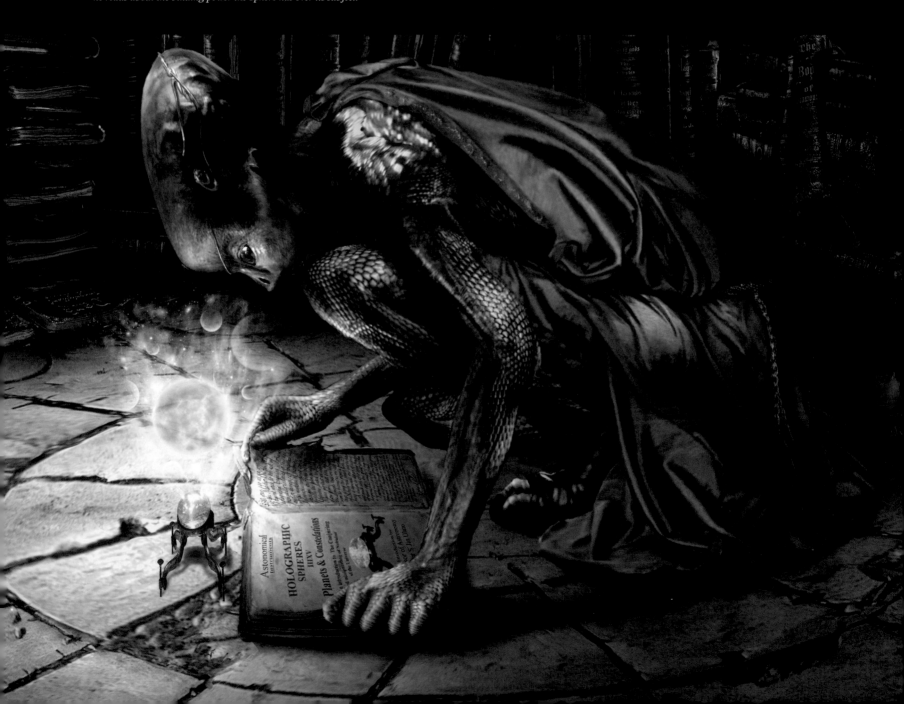

▼ **Written in Bone**
*Raymond Swanland*
Commission for Psycroptic
Digital
*www.raymondswanland.com*

*"The death metal band Psycroptic approached me with a simple, if
rather dark, concept for the cover of their next album, Ob(servant):
'What would a god that wanted to commit suicide look like?' My
thoughts drifted to the pagan gods from our ancient history that have
long since lost their worshippers and faded into oblivion — a powerful
god from the origins of civilization, fossilized, and forgotten."*

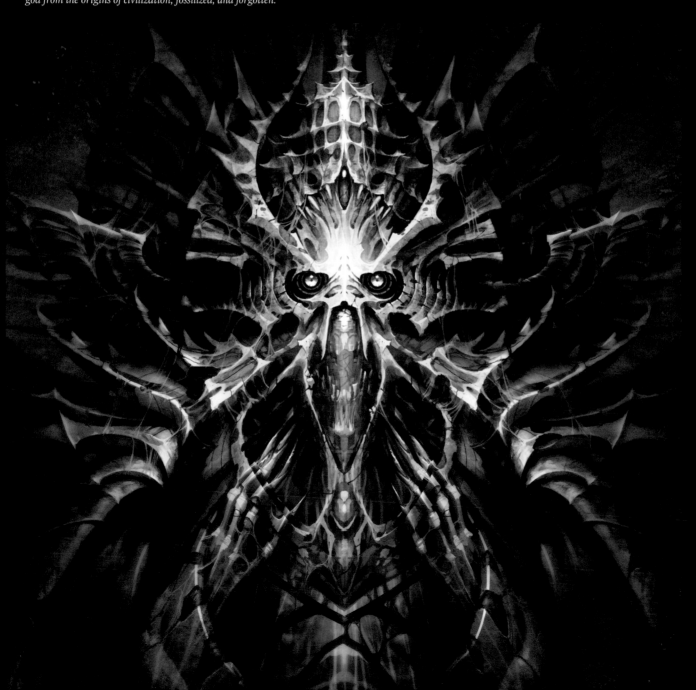

▶ **The Colossus**
*Lee Moyer*
Personal work
Digital
*www.leemoyer.com*

"The Colossus *was painted for pleasure and has not been published before. He began as a quick sketch that became more elaborate as it went on. I think he's really a nice enough chap, but like a good dog with a bad owner he can only do what he's told. If the poor group under assault manage to best the sorceress, I hope they'll forgive the Colossus and give him some nicer tasks to accomplish."*

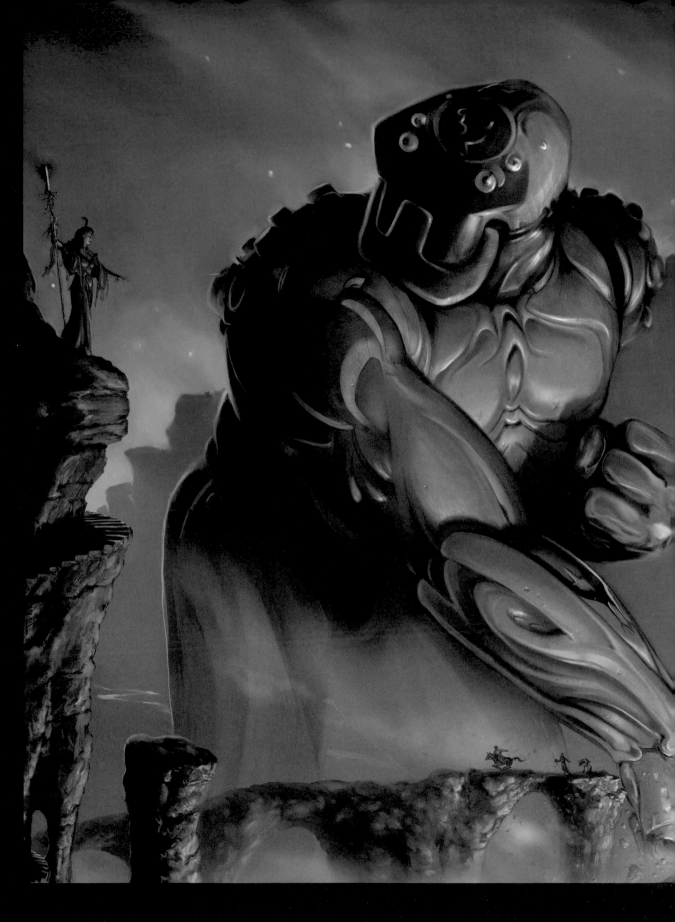

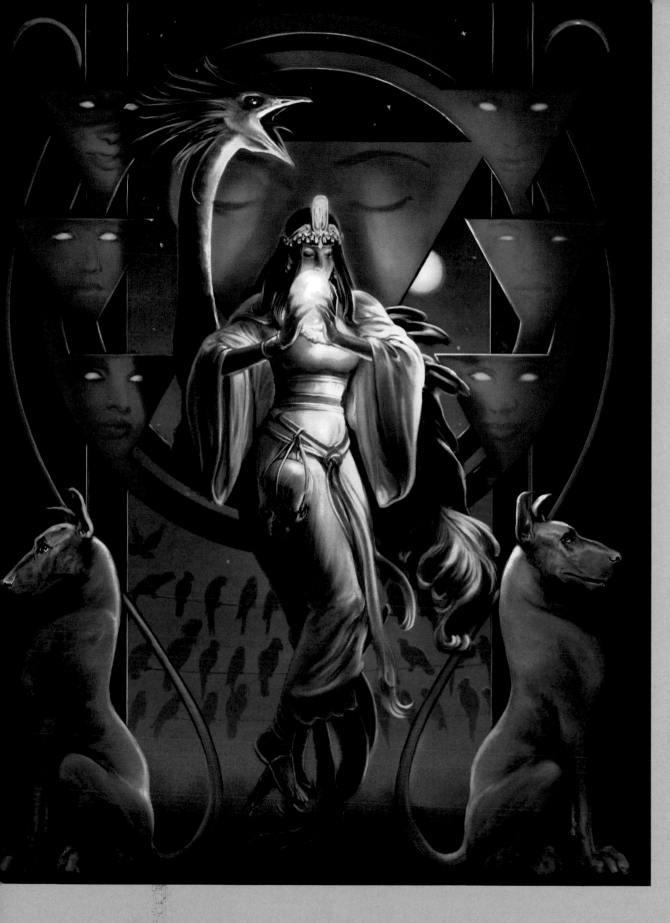

◀ **The Dictionary of the Khazars**
*Lee Moyer*
Private commission
Digital
*www.leemoyer.com*

"The Dictionary of the Khazars *is a meta-textual Serbian novel by Milorad Pavić, first published in 1984. It features three interlocking and overlapping versions of the same events written from the differing perspectives of Islam, Judaism, and Christianity. This painting was commissioned by Scott McDaniel as a portrait of the Princess Ateh. Because the accounts of the Princess differ so widely, it was probably the most challenging piece I've ever painted."*

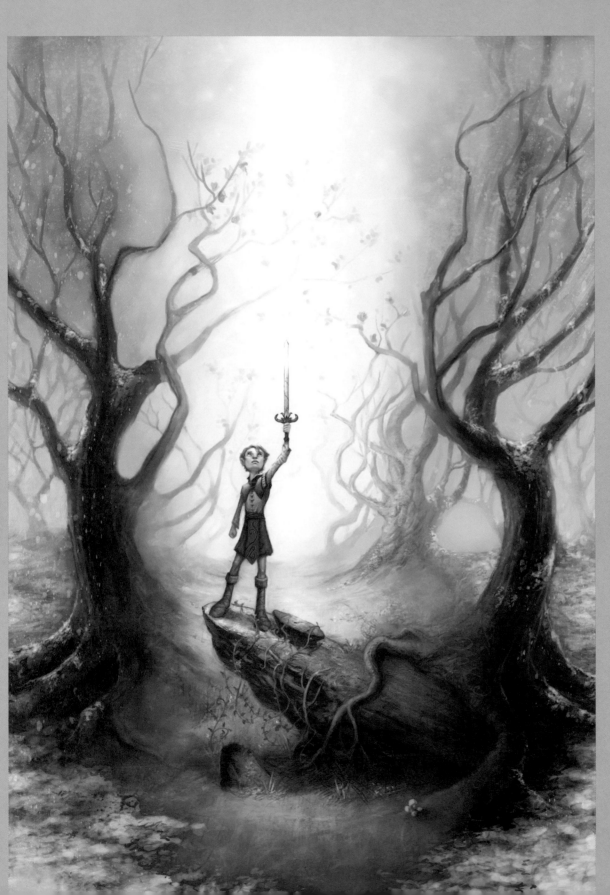

◀ **Arthur and the Sword**
*Scott Altmann*
Book cover
Digital
*www.scottaltmann.com*

"This particular version of the story was meant for 9–12 year olds, and focused on the young years of Arthur. I was asked to keep a saturated palette, and gear the art toward younger readers. My favorite imagery in the story was the scene where Arthur first lays eyes on the sword. The entire forest is set in snow, except for directly around the sword. I thought this was really beautiful imagery and wanted to add these elements to the cover. I pushed the colors and used a palette very unlike my other work. I don't think I would ever combine such intense blues with yellows and greens, but I do feel it works in some way."

▶ **Some New Fangled Nonsense**
*Nick Harris*
Future Publishing
ArtRage
*www.nickillus.co.uk*

"I was commissioned for a piece in Imagine FX about how powerful painting software has become more available to the masses—aimed at new students of digital art. It looked at freeware and budget software and so I chose ArtRage to create the piece. The brief described an alternative life-drawing studio, where a blend of fantasy creatures went to perfect their craft. One student was to have some clever, new technology that nobody else in class had seen before. I had to bear in mind the gutter of the spread, which was about one quarter in from the right. The composition and characters were up to me."

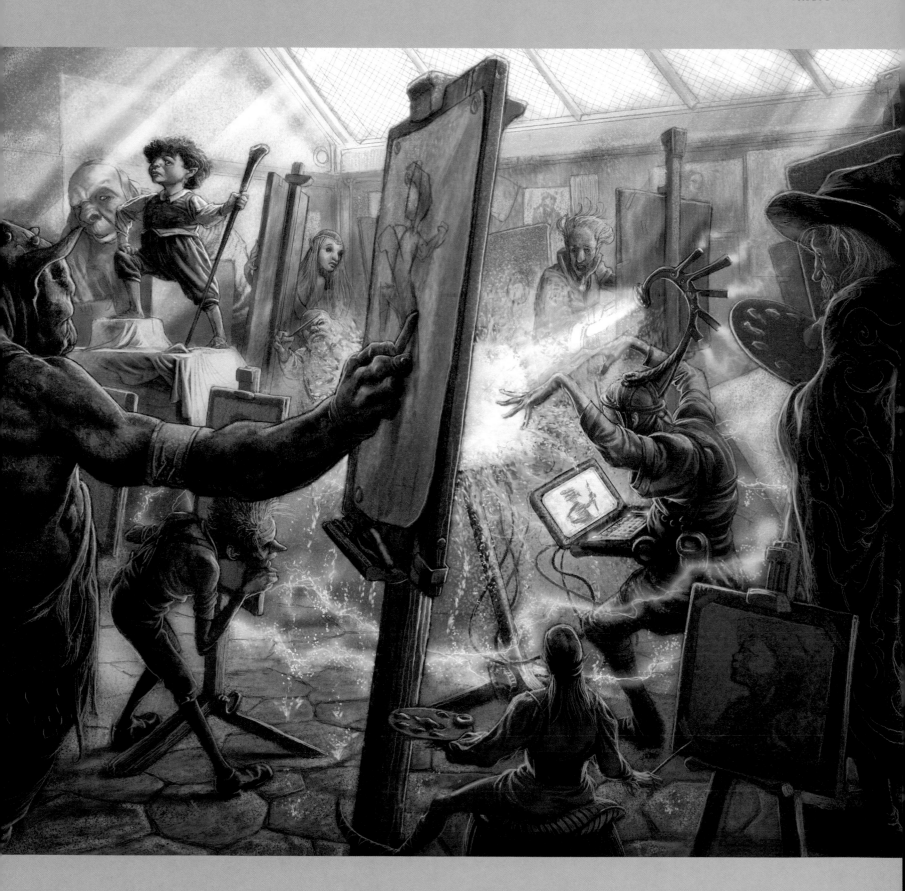

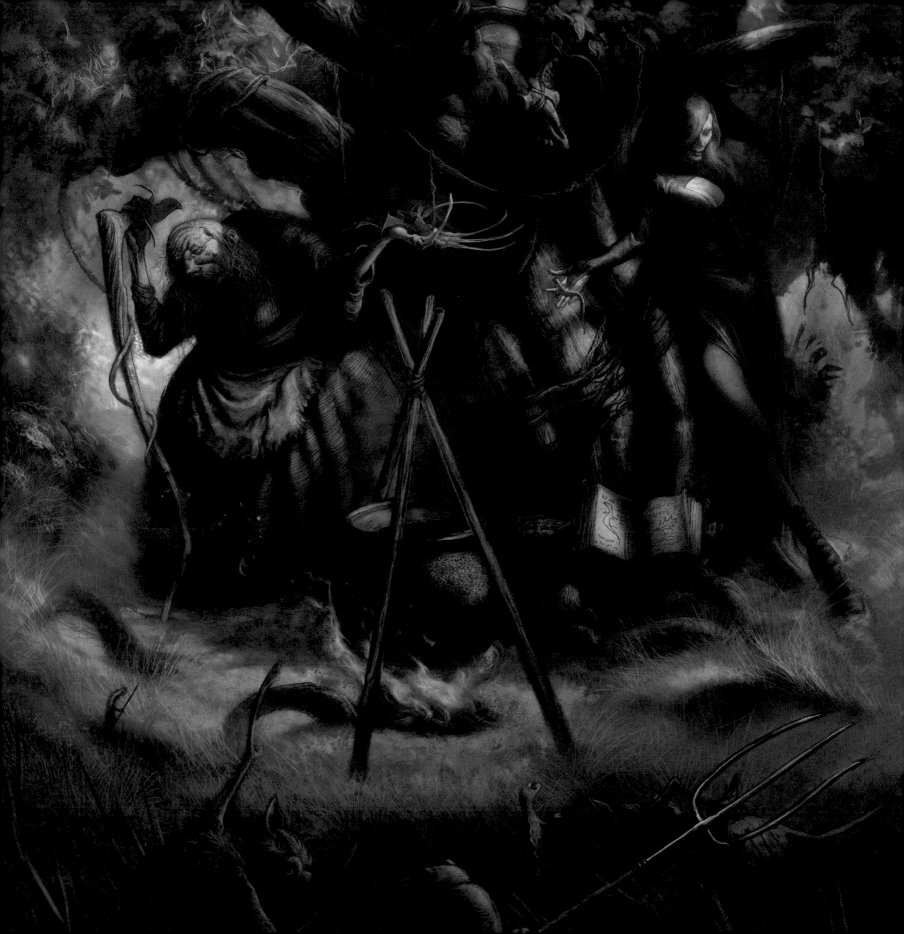

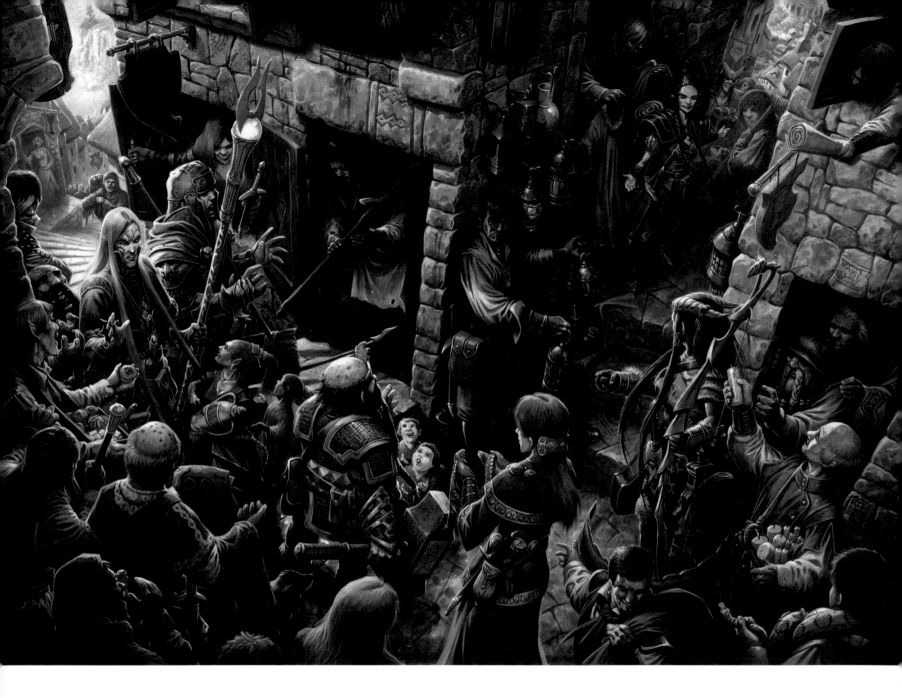

◀ **Revolting Ingredients**
*Nick Harris*
Online challenge
ArtRage
*www.nickillus.co.uk*

*Created for Pixelbrush's halloween challenge, entitled Witches, Cats, and Magics, Nick explains: "This gave me licence to go all Grimm Fairy Tale, which is always fun. The idea came from the classic witch standby recipe that includes ear of bat and eye of newt. I began wondering how these creatures' friends and relatives might feel about this abuse."*

▲ **Fellcrest**
*Ralph Horsley*
*Dungeons and Dragons—Dungeon Master's Guide*
Acrylic
*www.ralphhorsley.co.uk*

*"A group of adventurers arrive in a small town, where their obvious wealth attracts the attention of every citizen in an attempt to extract some coin out of them. This painting is a double-page (chapter opener) spread for the latest edition of D&D. It was a hugely enjoyable challenge to show all the different denizens, and to portray the range of goods they have to offer. I hope that the viewer will be rewarded with a new detail each time they return to the image."*

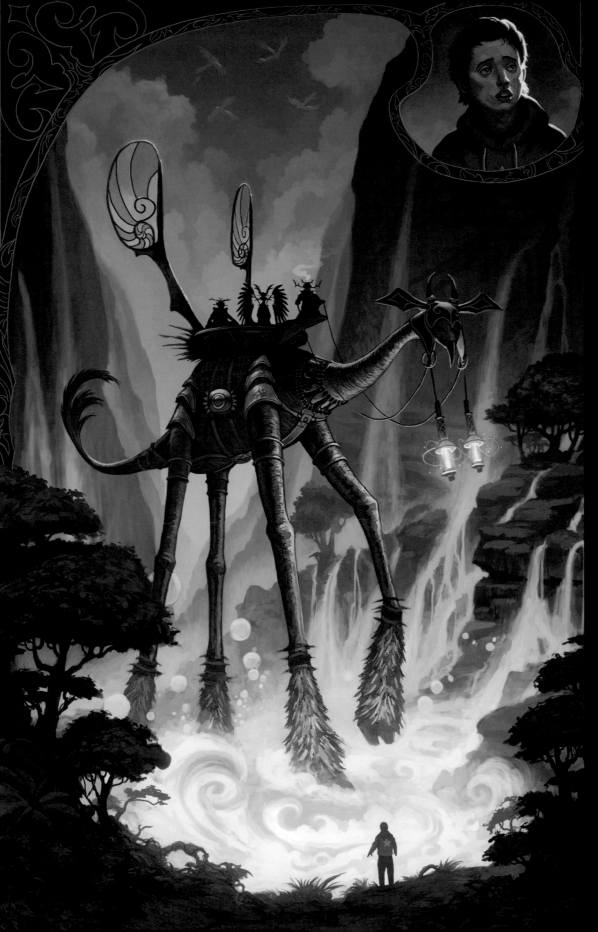

◀ **Griffin Meets the Elders**
*Matt Gaser*
Personal work
Adobe Photoshop
*www.mattgaser.com*

*"I've been working with my mother on a fantasy novel titled* In the Between, *and we're now trying to find a publisher. She wrote the story and I'm illustrating the book. In this image I decided to pick a key moment in the story showcasing the epic scale of the world, while maintaining narrative. Fantasy is a big theme of mine throughout my art; having the chance to work with my mom has been a dream come true!"*

▶ **The Sovereign Miraie**
*Matt Gaser*
Personal work
Adobe Photoshop
*www.mattgaser.com*

*"This was another piece done for my mother's novel,* In The Between. *We decided early on in the process we would focus on several character designs including a few illustrations for showing to publishers. This was a character study of Miraie, a Wisdom Elder who guides the main character through the story. It was a lot of fun to design a character from a written description made by my mother."*

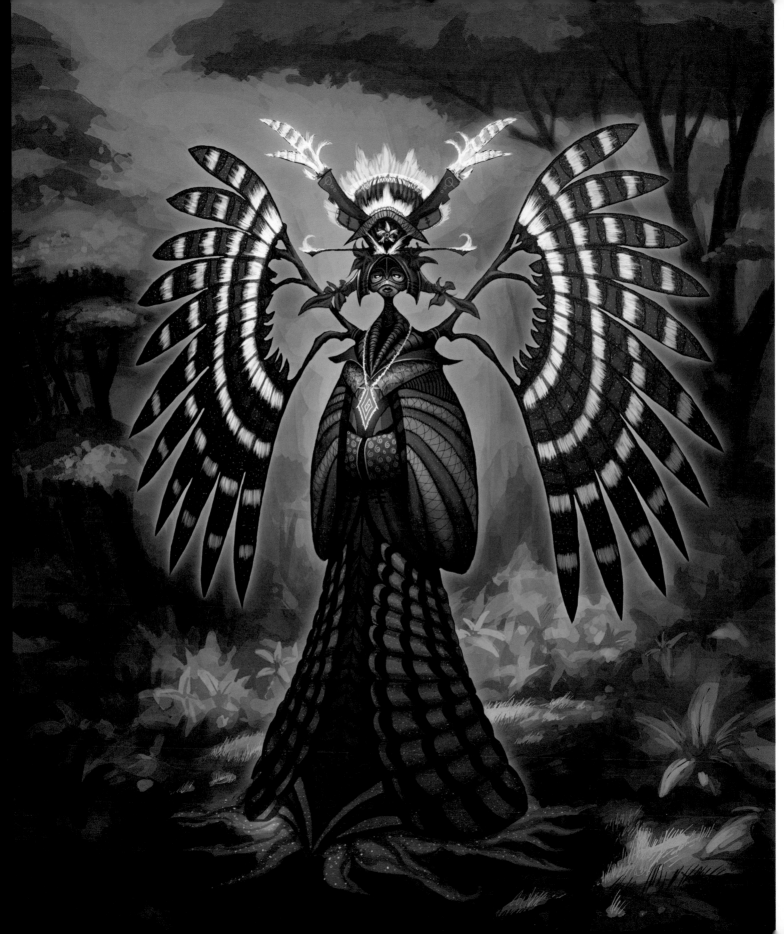

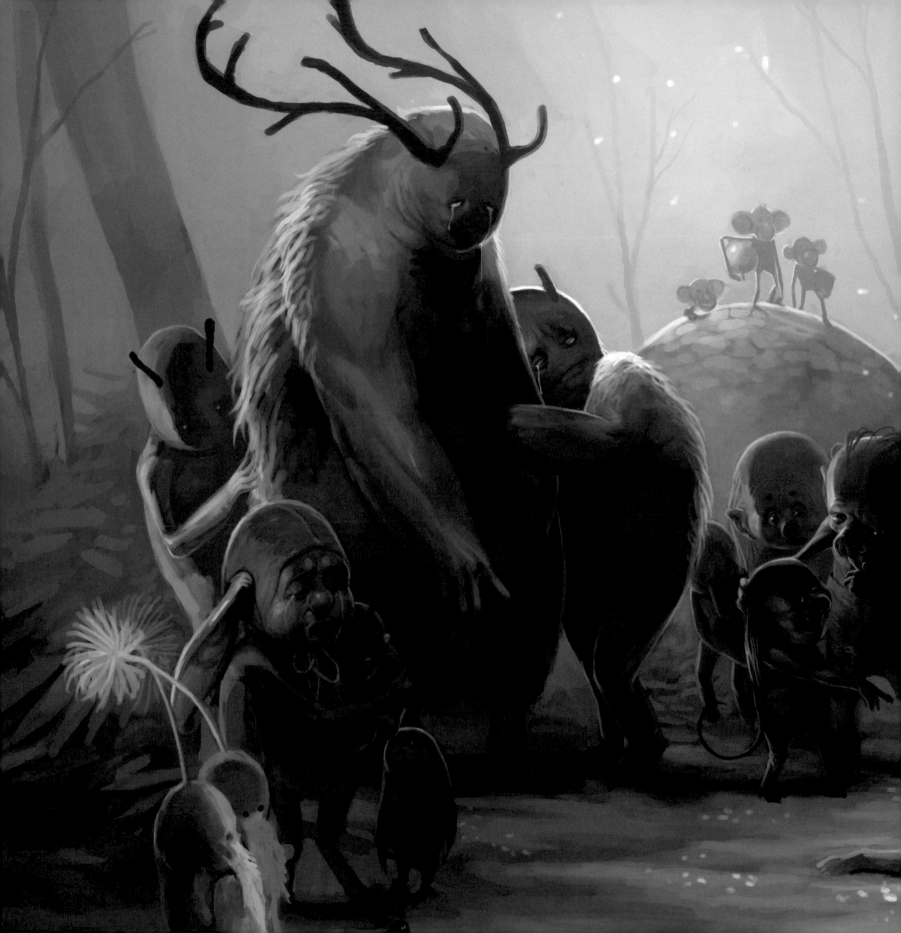

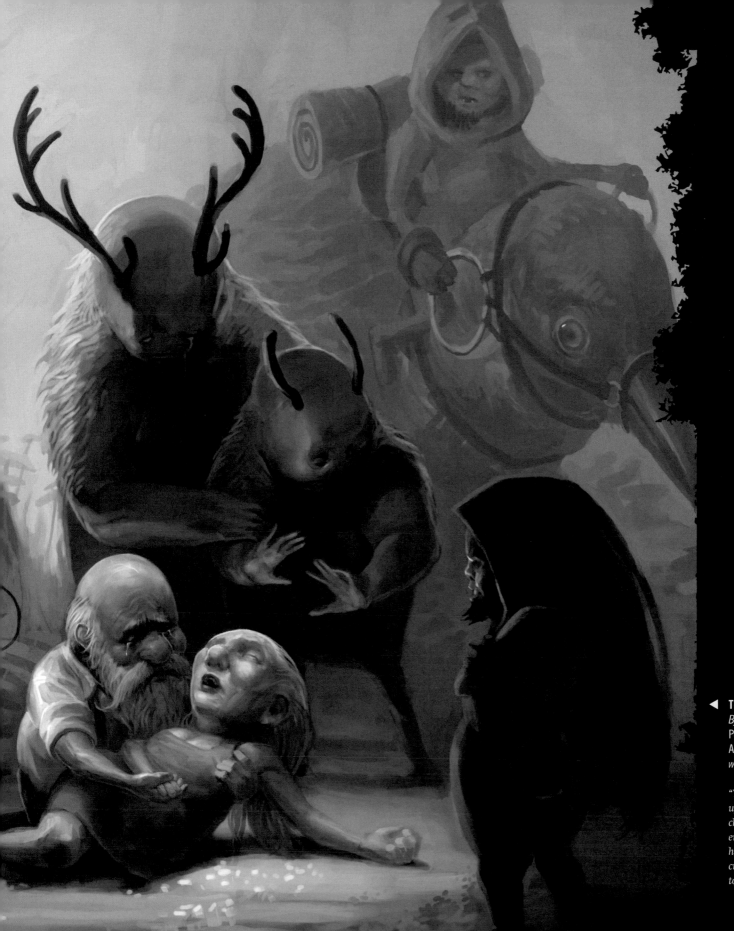

◄ **The Bitter End**
*Bjorn Hurri*
Portfolio work
Adobe Photoshop
*www.bjornhurri.com*

"This is a scene from my upcoming book where the main character's wife meets her bitter end, slain by the evil witch's henchmen. This painting was created in Photoshop from start to finish."

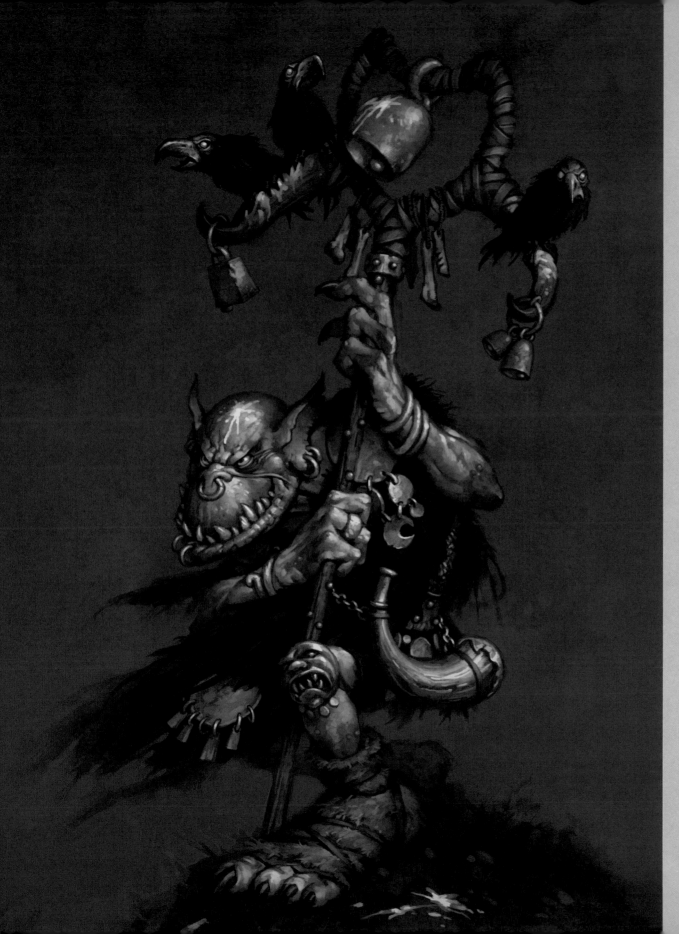

◄ **Crow Caller**
*Matt Dixon*
Personal work
Adobe Photoshop
*www.mattdixon.co.uk*

*"The fantasy genre gives artists many opportunities to exaggerate: pushing the limits of a goblin's toothy grin and contorted pose, as I've tried to do here, must surely be one of the more pleasurable. Run a close second by the joy of spattering his scalp with birdlime."*

► **Pot Belly**
*Matt Dixon*
Personal work
Adobe Photoshop
*www.mattdixon.co.uk*

*"Orcs are one of the few fantasy races who look strong enough to actually function beneath layers of heavy metal and spikes, which is a great excuse to go to town on their armor design. This guy is named after his belly plate, designed to protect his most protrudent (and therefore most vulnerable) asset."*

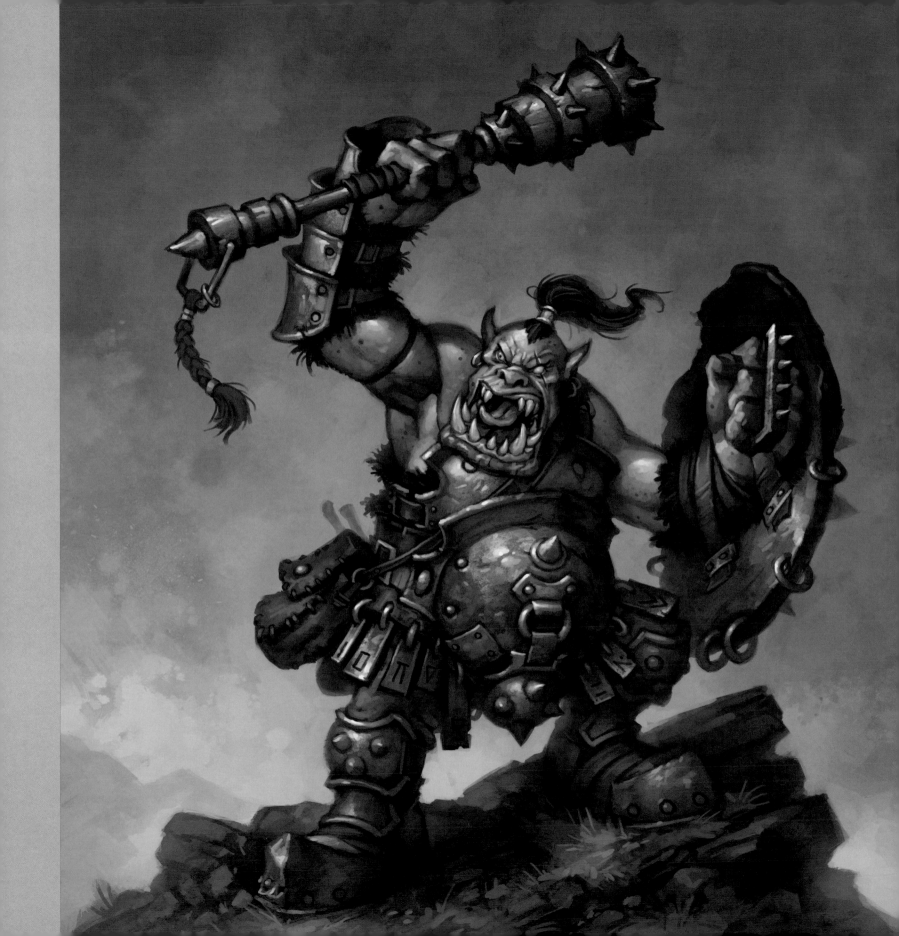

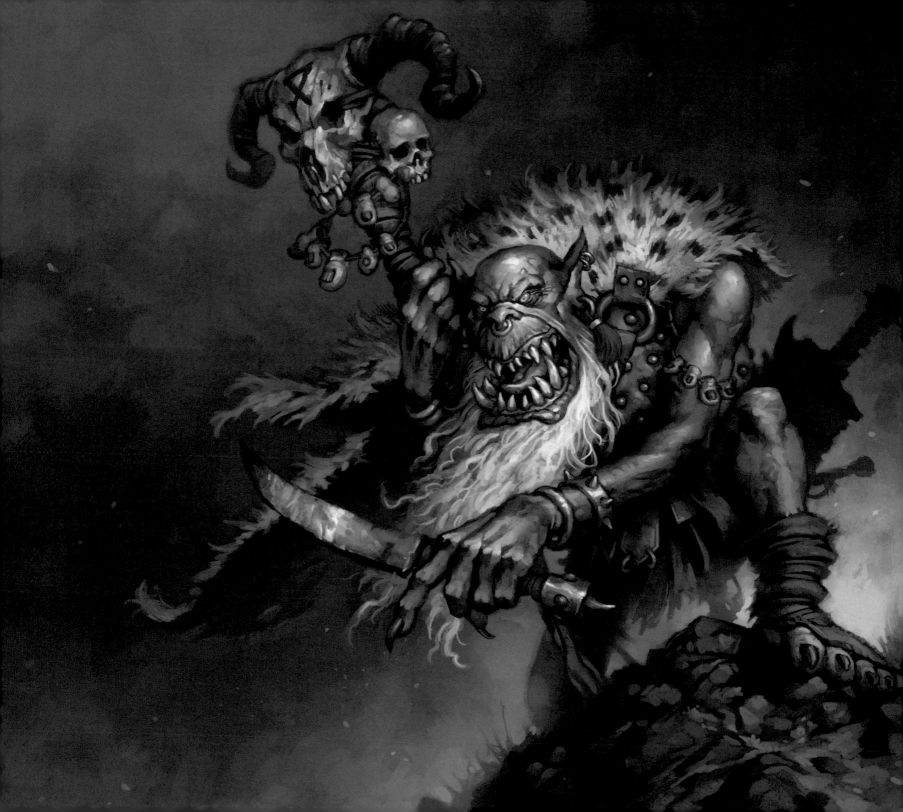

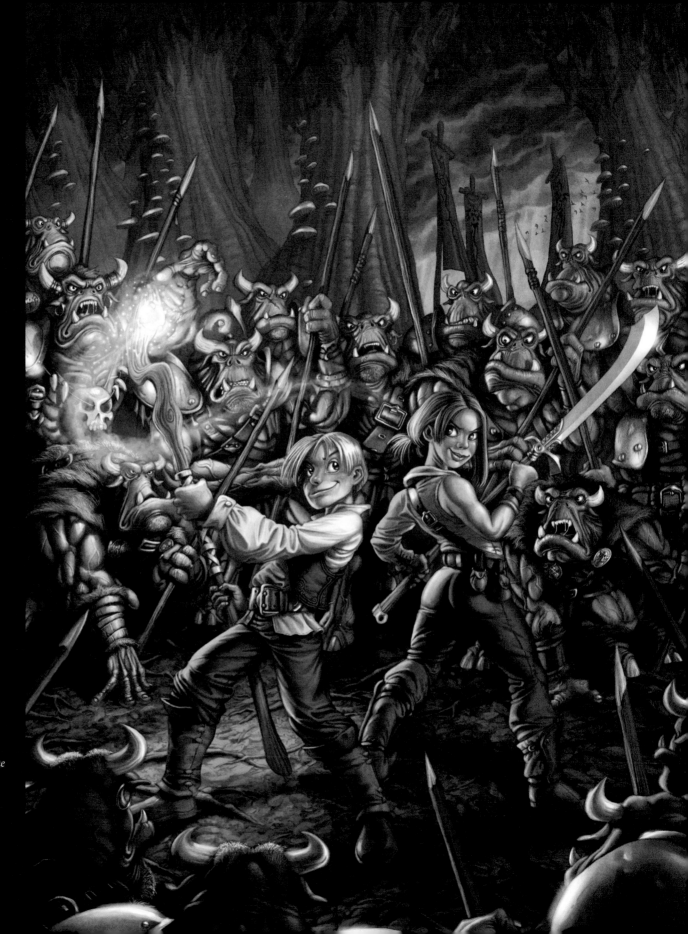

**Black Orc**
*Matt Dixon*
Personal work
Adobe Photoshop
*www.mattdixon.co.uk*

"Hopefully this fellow's
expression leaves little doubt
that he's an unsavory character.
For those who aren't sure,
a collection of severed toes is
included to help reinforce the
impression."

**Troll Crossing**
*Michael Dashow*
Future Publishing
Adobe Photoshop
*www.michaeldashow.com*

"This piece was created for an
article in Imagine FX magazine
on color composition. I tried
out several completely different
palettes for this piece before
arriving at this triadic scheme
using secondary colors. I like
using green for magic, because
it's a color of light that's not
usually found in nature."

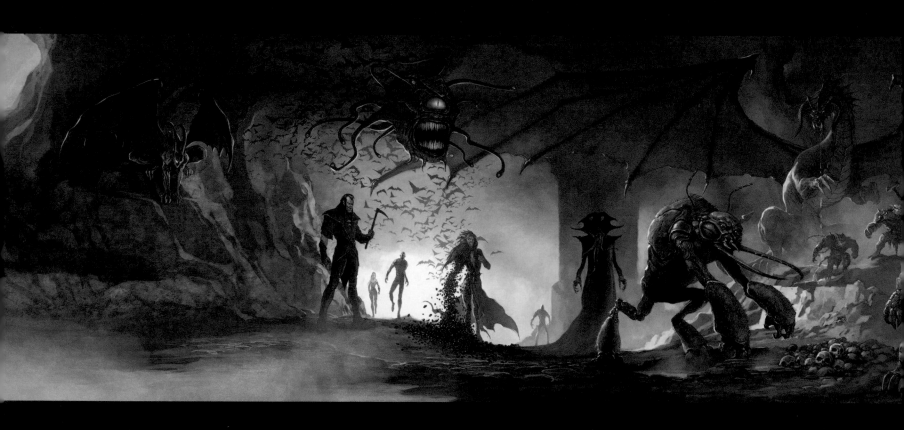

▲ **DMScreen**
*Francis Tsai*
Wizards of the Coast
Digital
*www.teamgt.com*

*"This illustration was created for the exterior of the 4th Edition Dungeon Masters Screen from Wizards of the Coast. The intent was to portray a variety of creatures and races from the newest iteration of the Dungeons and Dragons world."*

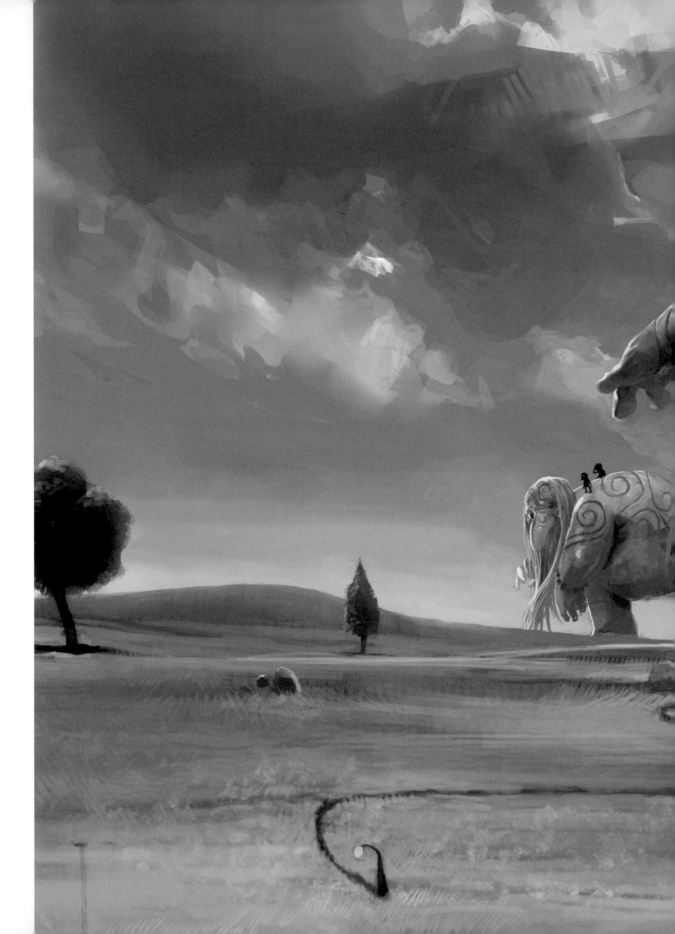

▶ **Unfair Advantage**
*Bjorn Hurri*
Competition entry
Adobe Photoshop
*www.bjornhurri.com*

*"This painting was created for a competition over at www.lastmanart.com. The competition starts off with around 400 participants and in the end only the last man (or woman) stands. The theme of this round was 'Unfair Advantage' and this is my interpretation of it."*

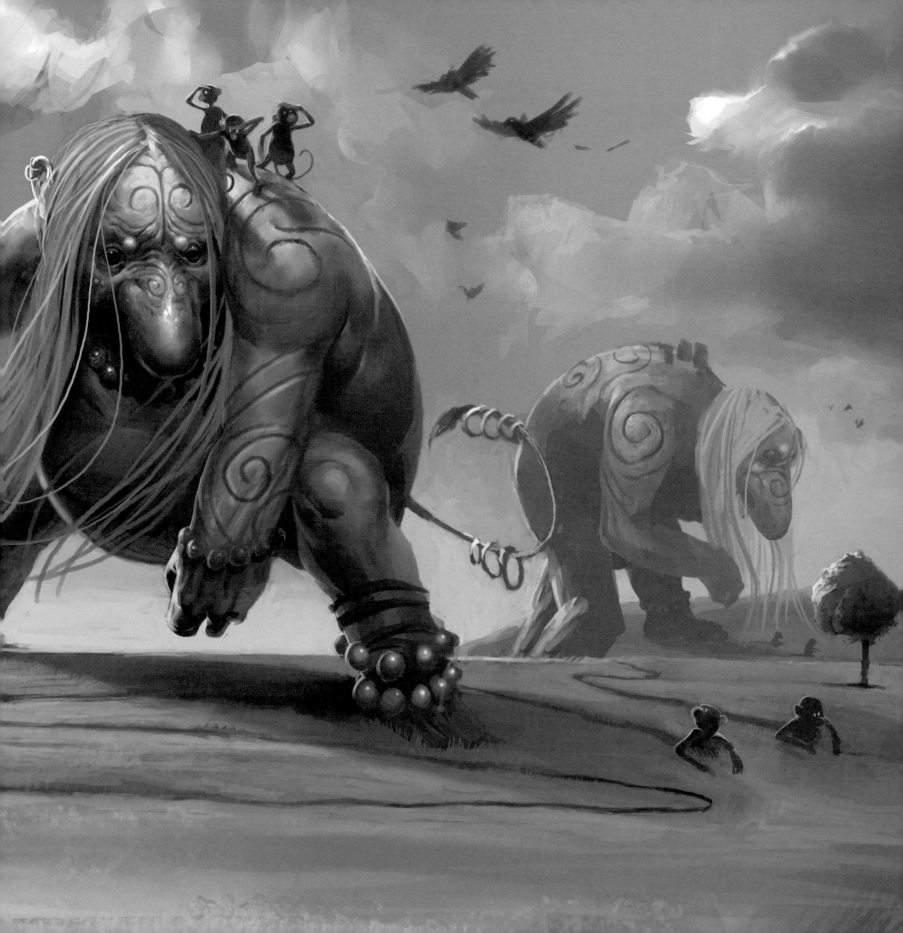

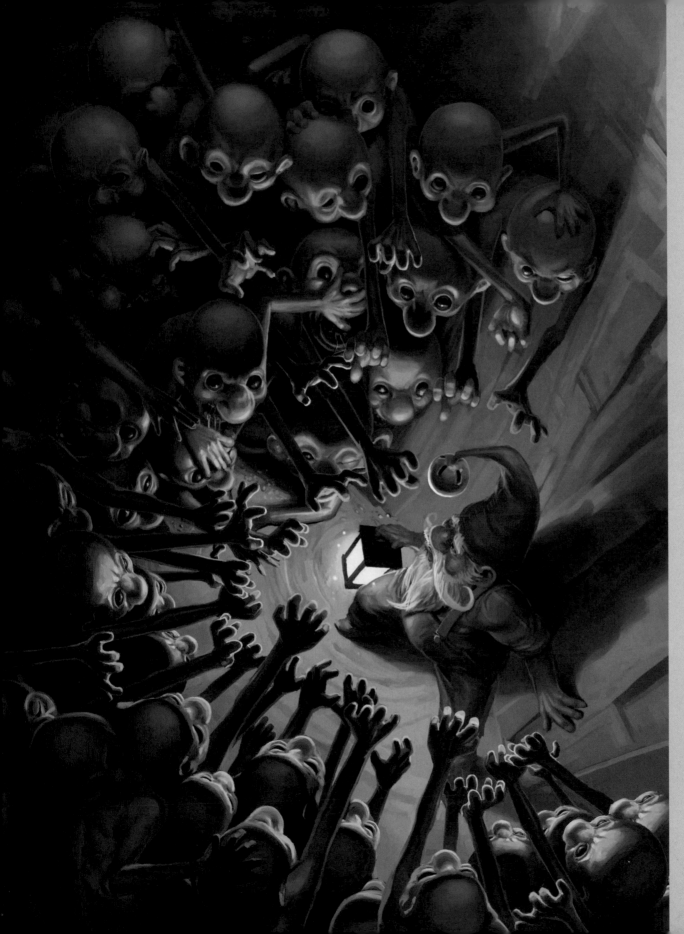

◄ **Cornered**
*Bjorn Hurri*
Competition entry
Adobe Photoshop
*www.bjornhurri.com*

*"This painting was created for a www.lastmanart.com competition. This is my interpretation of the theme 'Outbreak.' It was created in Photoshop from start to finish and it took me around eight hours to complete."*

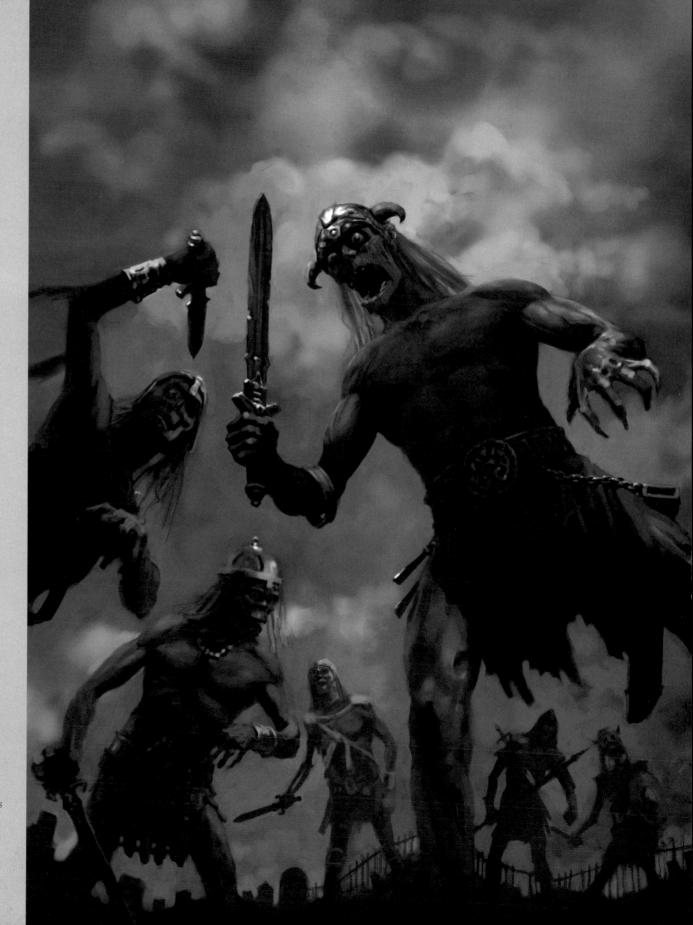

▶ **Undead**
*Chris Beatrice*
Titled Mill Entertainment
Corel Painter
*www.chrisbeatrice.com*

*"A concept piece for the game Hinterland, this shows a band of zombies on the advance. I used a low vantage point so the figures loom over the viewer, invoking a feeling of helplessness and also implying a sense of being in the ground, or in the grave. The green color scheme alludes to the rotting flesh of these lost souls."*

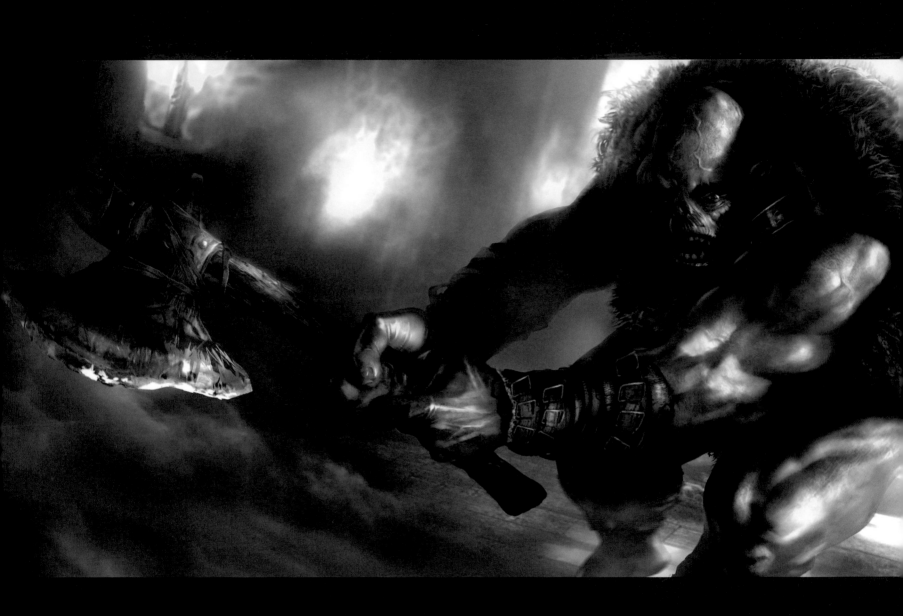

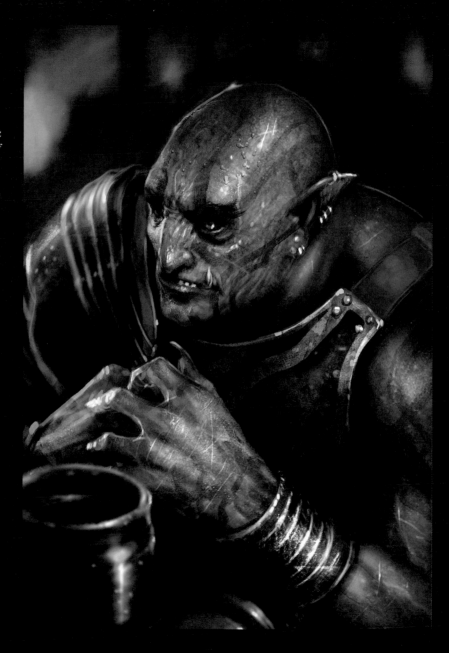

◄ **Orc**
*Daniele Montella*
Personal work
Corel PhotoPaint
*www.dan-ka.com*

*"I love orcs! In my sketchbook there's an orc for every five or six drawings! I started from some of the drawings in my sketchbook and then I painted with Corel PhotoPaint and a Wacom tablet. I usually study a lighting idea using quick hatching with a digital 'pencil.' After I scanned the drawing, I changed the composition a little bit to reach a more dynamic and powerful render. I used some texture effects for the skin and other details. I was influenced by the* Lord of the Rings *and* Hulk *movies, and this piece took me about twelve hours."*

◄ **Merciful and Brooding**
*Trevor Claxton*
Commission
Digital
*www.trevorclaxton.com*

*"These were part of a fun group of illustrations I was working on for a friend's outsourcing company. I was given a free reign on the subject matter. It just had to be a fantasy image. I experimented a lot with this batch (I did twelve in total) eventually leading to my current method of painting in grayscale then coloring in the layers afterwards."*

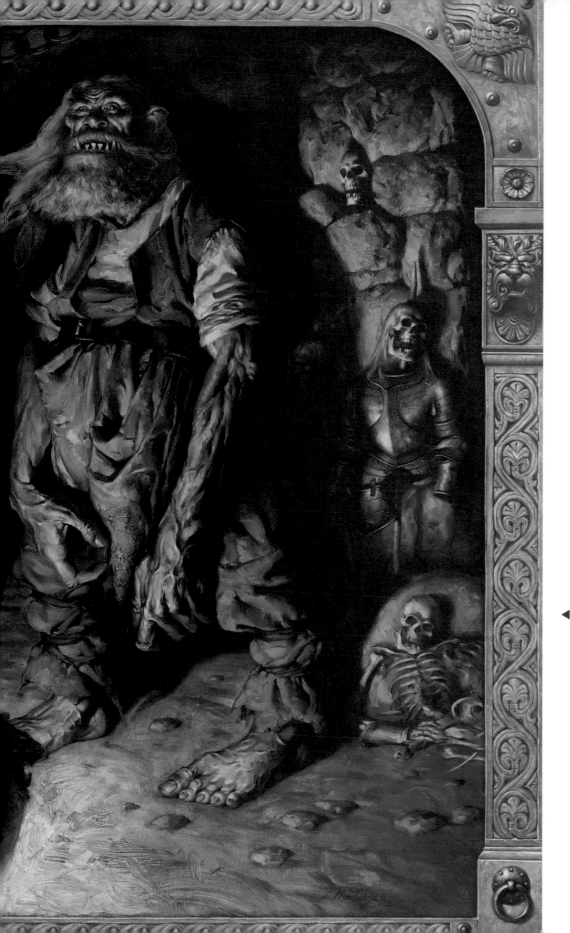

◀ **The Legend of Steel Bashaw 3**
*Petar Meseldzija*
Book illustration
Oils on Masonite
*www.petarmeseldzijaart.com*

*"This painting depicts the scene wherein king Marko accidentally enters the cave of two giants. By creating such a composition I wanted to suggest that the reader/viewer himself is actually the king, who, upon entering the cave, is not facing the 'friendliest' welcome. If he is not cautious enough he could soon find himself boiling in the large cauldron adding an extra flavor to the disgusting giants' supper."*

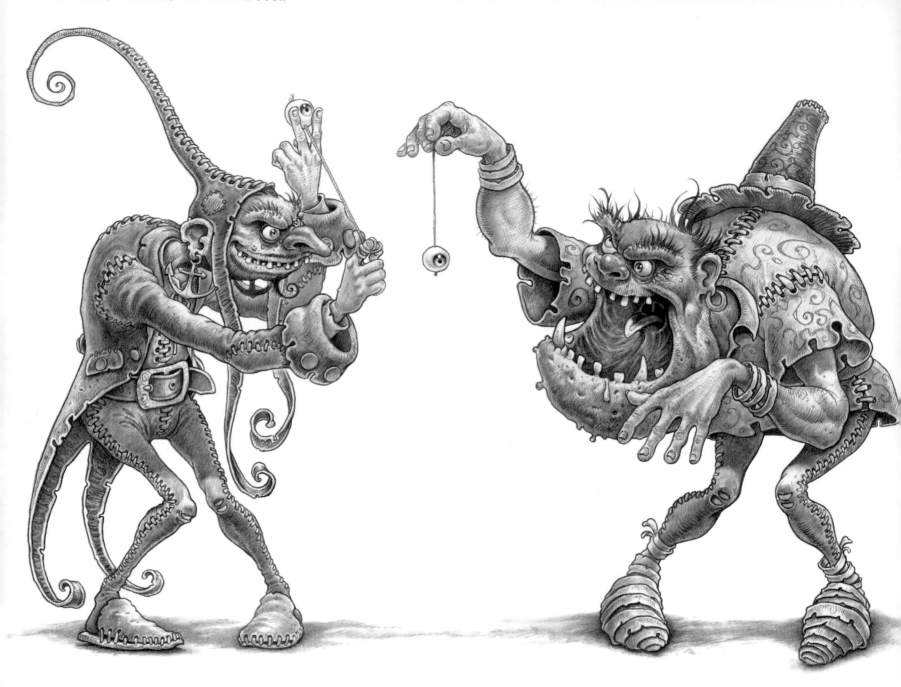

▲ **Beanboi and Peckerpod**
*Douglas Carrel*
Personal work
Pencil
*http://community.imaginefx.com/fxpose/hethabyrs_portfolio*

*"This drawing is based on material from Splengs, Spleebles and Sploons (a small book of complete and utter nonsense). This pair of nefarious ne'er-do-wells are sidekicks to the Manky Bole of Bombus Bour, self-appointed Panjandrum of the scattered tribes of Smoot."*

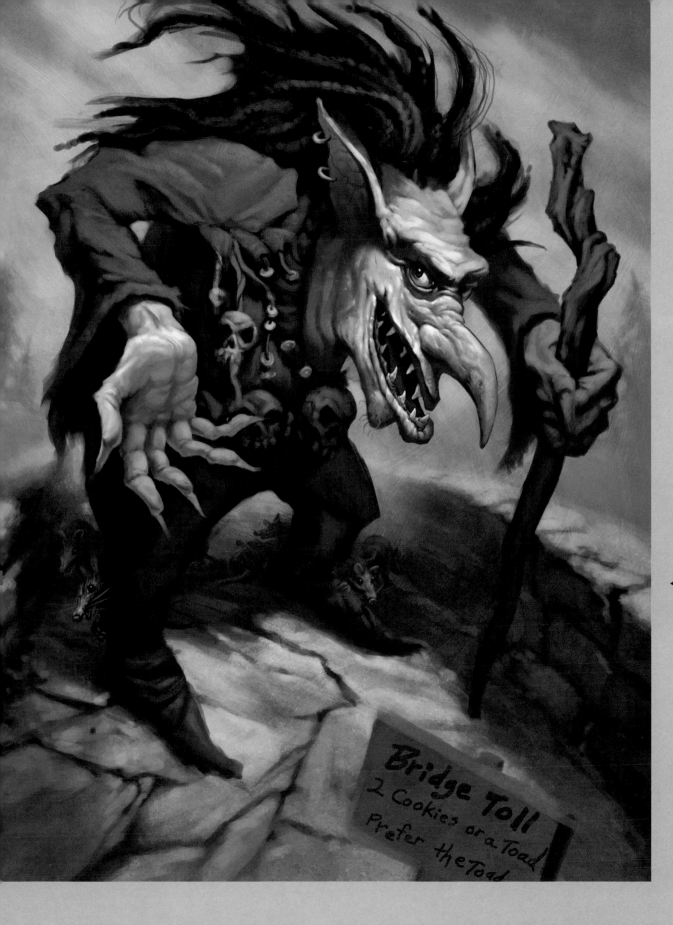

**Bridge Toll**
**2 Cookies or a Toad**
**Prefer the Toad**

◄ **Toll Troll**
*Jeff Haynie*
Personal work
Adobe Photoshop
*www.jeffhaynie.com*

"When I imagined a classic troll
painting what came to mind was
an idea of a short pesky creature
with a long nose who hangs out
on a stone bridge. Since he lives
underneath the bridge, naturally
he would charge a toll to cross
over his habitat! Any troll has
his price; in this case, a cookie
or a toad would do the trick,
although I get the feeling you
would get farther with the toad.
As a secondary element, I added
a group of rat friends around his
feet for moral support."

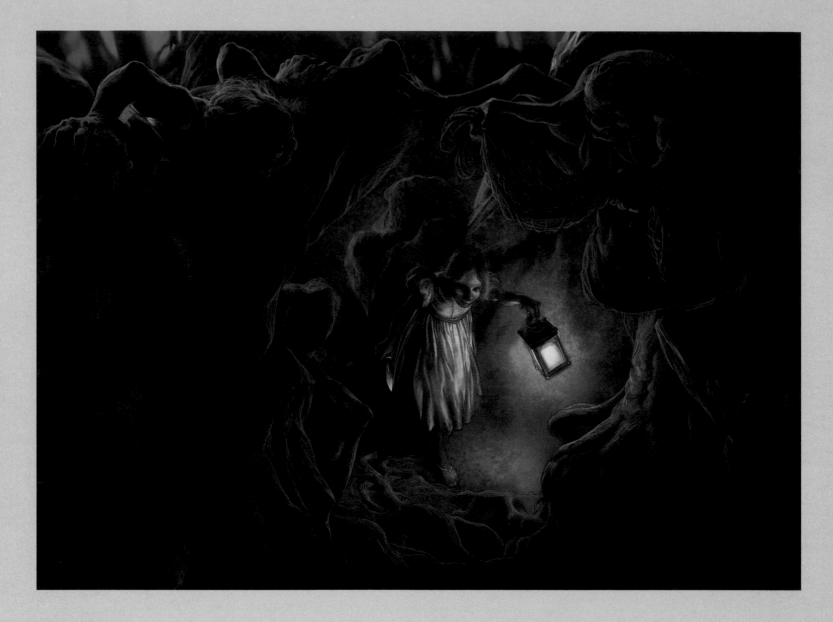

▲ **Ambush**
*Nick Harris*
Portfolio work
Sketchbook Pro
*www.nickillus.co.uk*

*"The fairy tale* The Princess and the Goblin, *by George MacDonald, published in 1872, is full of excitement and humor. It's ripe ground for illustrators. This is a generic scene about the capture of the brave princess, who the gruesome goblin prince has his eye on as a future bride. Sketchbook Pro is wonderfully fluent but did not as yet support layer blending modes or textural brushes. This meant I had to tackle these aspects in a different way, and import photo-textures to layers, incorporating them at various levels of transparency, before working back into them with the drawing tools to conform to the lighting."*

▶ **Portrait of a Troll**
*Jonas Persson*
Personal work
Maya, Mental Ray, Mudbox, and Adobe Photoshop
*www.jfvpersson.com*

*"I made this troll for a school project. I'd started learning 3D techniques ten months previously, so this was my first big project. The troll was modeled in Maya with some additional details added in Mudbox. For the lighting I used three directional lights and one spotlight, and it took ten minutes to render on my old computer. The background is added in Photoshop. My inspiration came from a drawing by the great Swedish artist, Alvaro Tapia."*

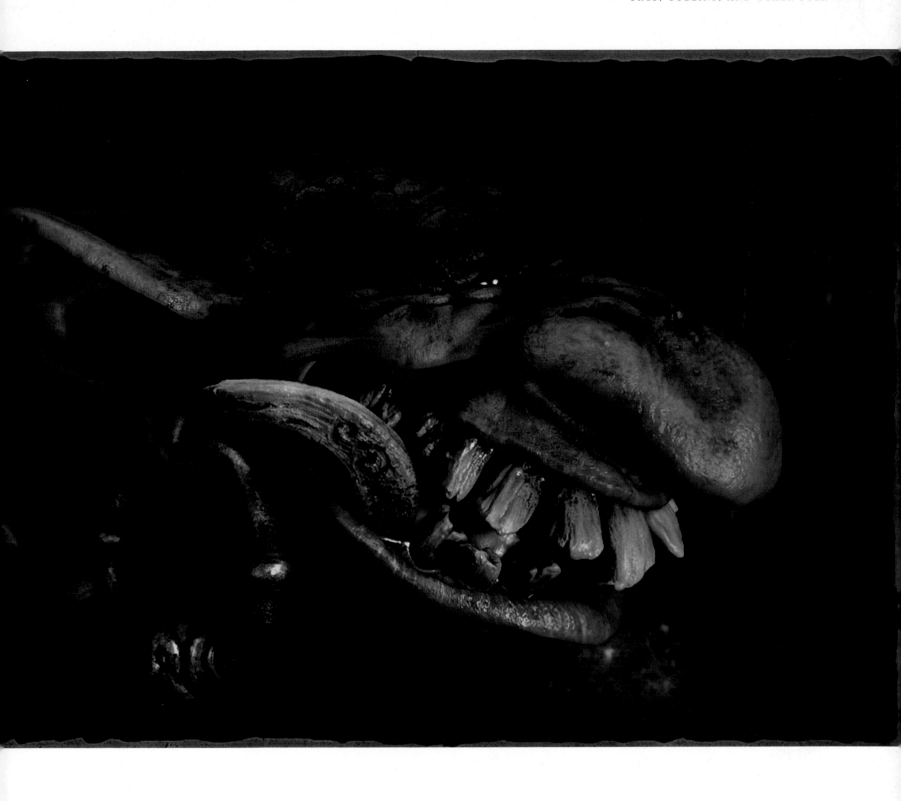

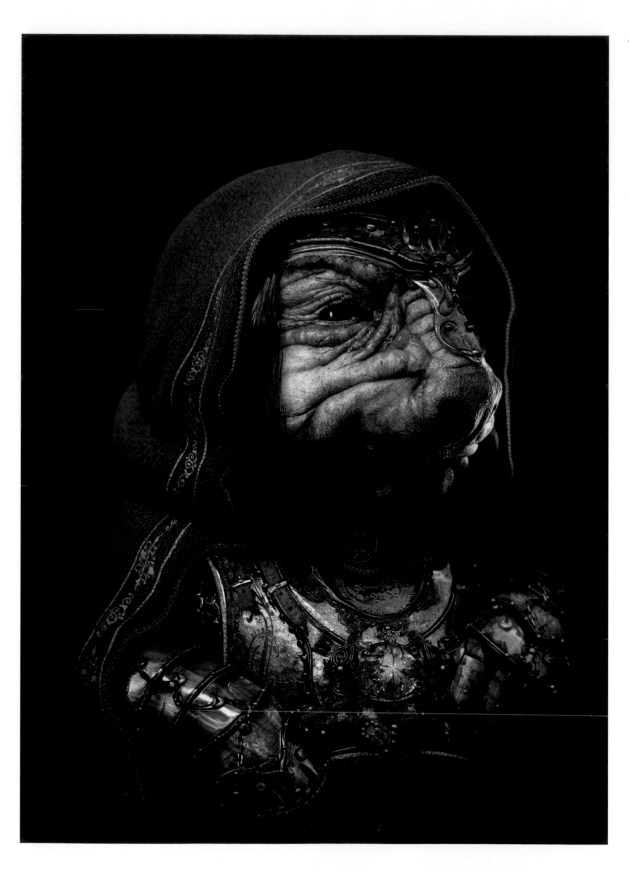

◀ **The Special One**
*Miguel Ângelo Teixeira*
**Portfolio work**
3DS Max, Bodypaint, ZBrush,
Mental Ray, and Adobe Photoshop
*www.malanjo.com*

*"I started this image three years
ago after I saw a sculpture by
the artist Patricia Piccininni,
and last year I finally found
time to complete it. The picture
was also inspired by the* Lord
of the Rings, *and it represents
the power that every creature
(human included) has in their
soul to continue the journey to
the next level."*

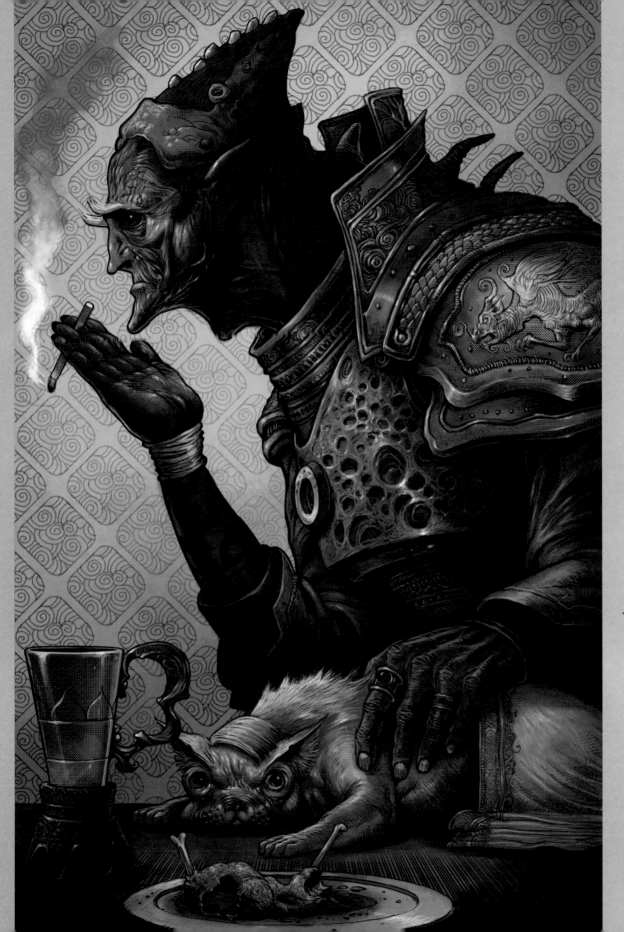

◀ **Smoker With "Cat"**
*Sean Andrew Murray*
Personal work
Digital and pen
*www.seanandrewmurray.com*

*"I like creating images of weirdos and their pets, as well as characters who smoke. There is no meaning or story behind this piece (I'm not a smoker, but I DO have a cat), but I do think that no matter what the smoker's story is, he seeks solace and peace in the absent-minded petting of his faithful...uhh...pet. Like many of my finished pieces, this started as a very quick sketch pulled out of my sketchbook."*

**SCOTT ALTMANN**
www.scottaltmann.com
scott@scottaltmann.com
Fast Ships, Black Sails p.70
Arthur and the Sword p.162

**BROM**
www.bromart.com
morbx@comcast.net
Hellen p.47

**DAREN BADER**
www.darenbader.com
daren@rockstarsandiego.com
Flame Wings p.57
© Wizards of the West Coast
Wow p.134-135
© Blizzard Entertainment/
Upper Deck Entertainment
Zerged p.136-137
© Blizzard Entertainment/
Upper Deck Entertainment

**CHRIS BEATRICE**
www.chrisbeatrice.com
artist@chrisbeatrice.com
Troll Hunters p.114-115
Farm Attack p.130-131
Undead p.179

**SIMON DOMINIC BREWER**
www.painterly.co.uk
simon@painterly.co.uk
The Last Dragon p.68
The Dragon Kytes of Baron V p.104

**OGY BONEV**
www.northflame.com
ogyb99@yahoo.com
Worlds Collide p.100-101
The Outpost p.117
The Alchemist Room p.154

**DAVID BOWERS**
www.dmbowers.com
davidmbowers@comcast.net
Thinking of Medusa p.43

**DOUGLAS CARREL**
http://community.imaginefx.com/
fxpose/hethabyrs_portfolio
douglas@cyrimbal-studio.
freeserve.co.uk
Humphli Pumphli p.148
The Tough Guide to Fantasy
Land p.149
Beanboi and Peckerpod p.184

**JASON CHAN**
www.jasonchanart.com
jason@jasonchanart.com
Steel of the Godhead p.26
© Wizards of the Coast
Wilt Leaf Liege p.90-91
© Wizards of the Coast
Imagine p.144-145

**TREVOR CLAXTON**
www.trevorclaxton.com
trevorclaxton@gmail.com
Smugglers! p.133
Merciful and Brooding p.181
© White Wolf Publishing

**MIKE CORREIRO**
www.mikecorreiro.com
mikecorreiro@gmail.com
Sun Nap p.62L
Samarium Dragon p.62R
The Grimshaw p.63, 192

**DAVID COUSENS**
www.coolsurface.com
david@coolsurface.com
Walkies p.60

**MICHAEL E. DASHOW**
www.michaeldashow.com
mdashow@yahoo.com
Wandering Monsters p.78-79
Sesslyth and Ezekiel p.138
Troll Crossing p.173

**MATT DIXON**
www.mattdixon.co.uk
matt@mattdixon.co.uk
Crow Caller p.170
Pot Belly p.171
Black Orc p.172

**JONNY DUDDLE**
www.duddlebug.co.uk
jonny@duddlebug.co.uk
Dead Dragon p.34-35
The Highland Minotaur p.66

**EMRAH ELMASLI**
www.partycule.com
emrah@partycule.com
Expedition p.11, 112
Faith p.157

**ALY FELL**
www.darkrising.co.uk
alyfell@darkrising.co.uk
Medusa p.36
Lady of Shalott p.37
The Hunt p.80
Soul Catcher p.81

**PETER FERGUSON**
www.uberpete.jitterjames.com
peter.uberpete@gmail.com
Fantasia p.24

**TOM FLEMING**
www.flemart.com
flemart@bellsouth.net
Summer p.94

**MATT GASER**
www.mattgaser.com
mgaser@mac.com
Primrobb's Threshold p.110-111
Griffin Meets the Elders p.166
The Sovereign Miraie p.167

**SVEN GERUSCHKAT**
www.svenger.de
svenger@svenger.de
Evil Witch p.155

**DONATO GIANCOLA**
www.donatoart.com
donato@donatoart.com
Serpent and the Rose p.15
Adventurers p.61
Archer of the Rose p.132

**SCOTT AND PAT GUSTAFSON**
www.scottgustafson.com
For Want of a Nail p.12-13
Under a Hill p.92

**NICK HARRIS**
www.nickillus.co.uk
Contact through agent Virgil
Pomfret: virgil.pomfret@online.fr
Some New Fangled Nonsense p.163
Revolting Ingredients p.164
Ambush p.186

**MARK HARRISON**
www.2000ad.org/markus
sarah.markus@blueyonder.co.uk
The Clockwork King of Orl p.44
The Light of Heaven p.45

**JEFF HAYNIE**
www.jeffhaynie.com
j.haynie@comcast.net
Deep Dive p.113
Toll Troll p.185

**ANDY HEPWORTH**
www.andyhepworth.com
hepworthandrew@aol.com
Yogo Fox-Wife p.40
The East p.102-103
© White Wolf Publishing

**DAVID HONG**
www.davidsketch.blogspot.com
seung_hong@hotmail.com
Knight by the Lake p.18
Dark Castle p.99
Battle Looming p.143

**ALEX HORLEY**
www.alexhorley.com
horley@iol.it
The Glenn Keeper p.42
The Ice Demon p.56
© Wizards of the Coast
Biogiant p.120
© 2009 Mutant Chronicles
International Inc. All Rights
Reserved. Mutant Chronicles
and related logos, characters,
names and distinctive likenesses
are trademarks and registered
trademarks of Mutant Chronicles
International Inc.
Shield Removal p.6, 121
© Blizzard Entertainment/
Upper Deck Entertainment

**RALPH HORSLEY**
www.ralphhorsley.co.uk
email@ralphhorsley.co.uk
Thanquol p.74
© Games Workshop
Shadow Flayer p.75
© Wizards of the Coast
Bosk Banneret p.88
© Wizards of the Coast
Tome of Salvation p.118-119
© Games Workshop
Fellcrest p.165
© Wizards of the Coast

**BJORN HURRI**
www.bjornhurri.com
bjornhurri@hotmail.com
The Bitter End p.168-169
Unfair Advantage p.176-177
Cornered p.178

**STUART JENNETT**
www.stuartjennett.com
stuartjennett@hotmail.com
Big Fin p.140
Jinn Battle p.141

**PATRICK JONES**
www.pjartworks.blogspot.com
www.pjartworks.com
artworksillustration
@earthlink.net
Shadow's Past p.25

**ERIN KELSO**
www.conceptart.
org/?artist=bluefooted
bluefootedb@gmail.com
Unfair Advantage p.76

**MATHIAS KOLLROS**
www.guterrez.com
koil@gmx.at
5 O'Clock in Orkzland p.9

**FASTNER & LARSON**
www.fastnerandlarson.com
mail@fastnerandlarson.com
Gatecrashers p.48

**HENNING LUDVIGSEN**
www.henningludvigsen.com
henlu@online.no
Areo Hota p.19
All Out p.71

**DON MAITZ**
www.paravia.com/donmaitz
donmaitz@paravia.com
Six Paces Turn and Fire p.139
Wizards p.152
Abracatabra p.153
Savage Empire p.156

**LARRY MACDOUGALL**
www.mythwood.blogspot.com
underhillstudio@cogeco.ca
Proximity p.29
Wood Wink p.86
Rainy River p.93

**MALACHI MALONEY**
www.liquidwerx.com
malachi@liquidwerx.com
Tranquil Waters p.49

**TIM MCBURNIE**
www.timmcburnie.com
tim@timmcburnie.com
Archer p.52
Blue Petal p.53

**PETAR MESELDZIJA**
www.petarmeseldzijaart.com
petarmeseldzija@planet.nl
The Legend of Steel
Bashaw 2 p.32-33
The Legend of Steel
Bashaw 3 p.182-183

**CHRISTOPHER MOELLER**
http://mysite.verizon.net/moellerc
High Angel of Freedom p.82
Sower of Temptation p.83
© Wizards of the Coast
Cultbrand Cinder p.150
© Wizards of the Coast

**DANIELE MONTELLA**
www.dan-ka.com
Orc p.180

**LEE MOYER**
www.leemoyer.com
lee@leemoyer.com
The Colossus p.160
Dictionary of the Khazars p.161

**JIM MURRAY**
www.jimmurrayart.com
jim@jimmurrayart.com
Demigod of Revenge p.65
© Wizards of the Coast
Fire Rannet p.67
© Wizards of the Coast
Oaken Brawler p.122-123
© Wizards of the Coast

**SEAN A. MURRAY**
www.seanandrewmurray.com
sean@seanandrewmurray.com
Stroller Baby p.77
Globechaser p.147
Smoker With "Cat" p.189

**WILLIAM O'CONNER**
www.wocstudios.com
wocillo@comcast.net
Nexus p.28
© Wizards of the Coast

**KIP OMOLADE**
www.kipomolade.com
kip@kipomolade.com
Annabel Lee p.39

**GLEN ORBIK**
www.orbikart.com
glenandlaurel@earthlink.net
Arthur Warlord p.20
Viking Battle p.21

**DAVID PALUMBO**
www.dvpalumbo.com
dave@dvpalumbo.com
Footsteps in the Dark p.17

**PATRICK REILLY**
www.preilly.deviantart.com
reilly1138@msn.com
Barbarian King p.30

**JONAS PERSSON**
www.jfvpersson.com
jfvpersson@gmail.com
Portrait of a Troll p.187

**ANDREAS ROCHA**
www.andreasrocha.com
rocha.andreas@gmail.com
Distant Shores p.96-97
Acid River p.98
Beacon p.106-107

**MICHAEL RYAN**
www.michaelryanart.com
Seer of the Throne p.146
© White Wolf Publishing

**DAN DOS SANTOS**
www.dandossantos.com
dsillustration@yahoo.com
Implied Spaces p.16
Far seed p.38
Green p.89
Dead Reign p.151

**DON SEEGMILLER**
www.seegmillerart.com
don.seegmiller@seegmillerart.com
Dragon p.59

**ADRIAN SMITH**
www.adriansmith.co.uk
artist@adriansmith.co.uk
Dante p.14
Leper Uprising p.128-129

**ANNE STOKES**
www.annestokes.com
email@annestokes.com
Drider p.58
© Wizards of the Coast
Winged Companions p.84-85

**JON SULLIVAN**
www.jonsullivanart.com
jonsullivanart@aol.com
Vengeance p.41
Archwizard p.64L
Solaris Fantasy Anthology p.72
The Apprentice p.158

**RAYMOND SWANLAND**
www.raymondswanland.com
raymond@oddworld.com
An Empire Unacquainted with
Defeat p.27
© Night Shade Books
Surrender to the Will of Night p.51
© Tor Books
Storm Song p.54-55
Written in Bone p.159

**JULIAN TOTINO TEDESCO**
www.totinotedesco.blogspot.com
juliantotino@yahoo.com.ar
Spell p.31
Faun p.95
Marine Monster p.116

**MIGUEL ÂNGELO TEIXEIRA**
www.malanjo.com
The Special One p.188

**FRANCIS TSAI**
www.teamgt.com
tsai@teamgt.com
Drow of the Underdark p.46
© Wizards of the Coast
Rhashaak of Haka'torvhak p.64
© Wizards of the Coast
DM Screen p.174-175
© Wizards of the Coast

**DANIELA UHLIG**
www.du-artwork.de
info@du-artwork.de
Blindman's Bluff p.87

**MATT WILSON**
www.mattwilsonart.com
mw@mattwilsonart.com
The Walk p.22-23
Metal on Metal p.124-125
Metamorphosis p.126
Witchfire 3 p.127

**JANNY WURTS**
www.paravia.com/jannywurts
jannywurts@paravia.com
Dawnwatch p.73
Hell's Chasm p.105

**MIN YUM**
www.minart.net
minyum@gmail.com
Warrior Princess p.50
Death Horse p.69
Alien Cave p.108
Sanctuary p.109

# Acknowledgments

Jonny and Aly would like to thank Ellie Wilson and all at Ilex for being so patient with us. Aly particularly, who had a bereavement in the family, which meant he was not always available as and when he was needed. Also, we'd like to thank our wonderful partners, Jane and Rosie, who are forever patient and supportive through both our darker and lighter moments. And finally and most importantly, we would like to acknowledge and thank all the wonderful artists who contributed to this book, which is of course about them, and can only exist with their cooperation.

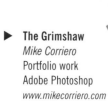

▶ **The Grimshaw**
*Mike Corriero*
Portfolio work
Adobe Photoshop
*www.mikecorriero.com*